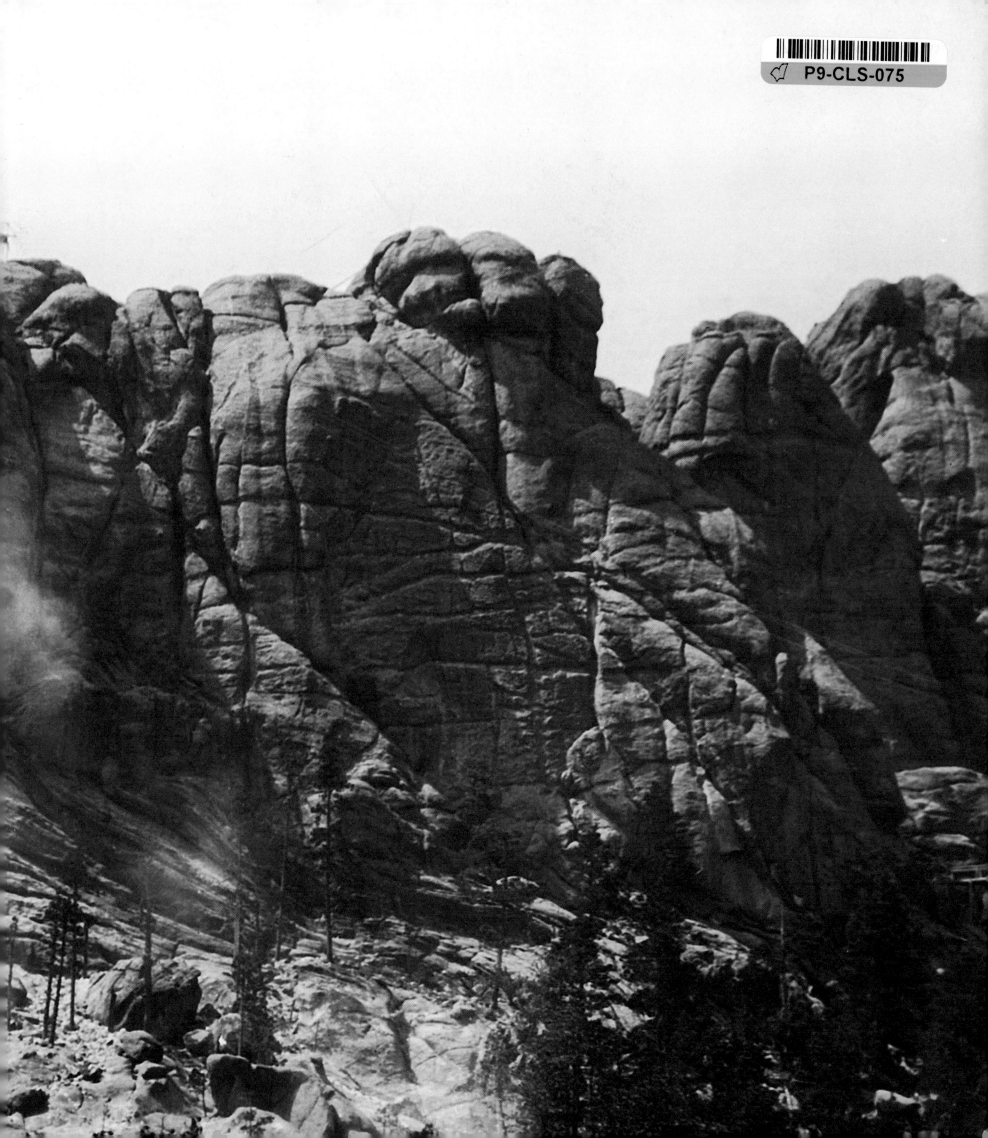

LIFE

AMERICA
A VISUAL HISTORY
FROM THEN TO NOW

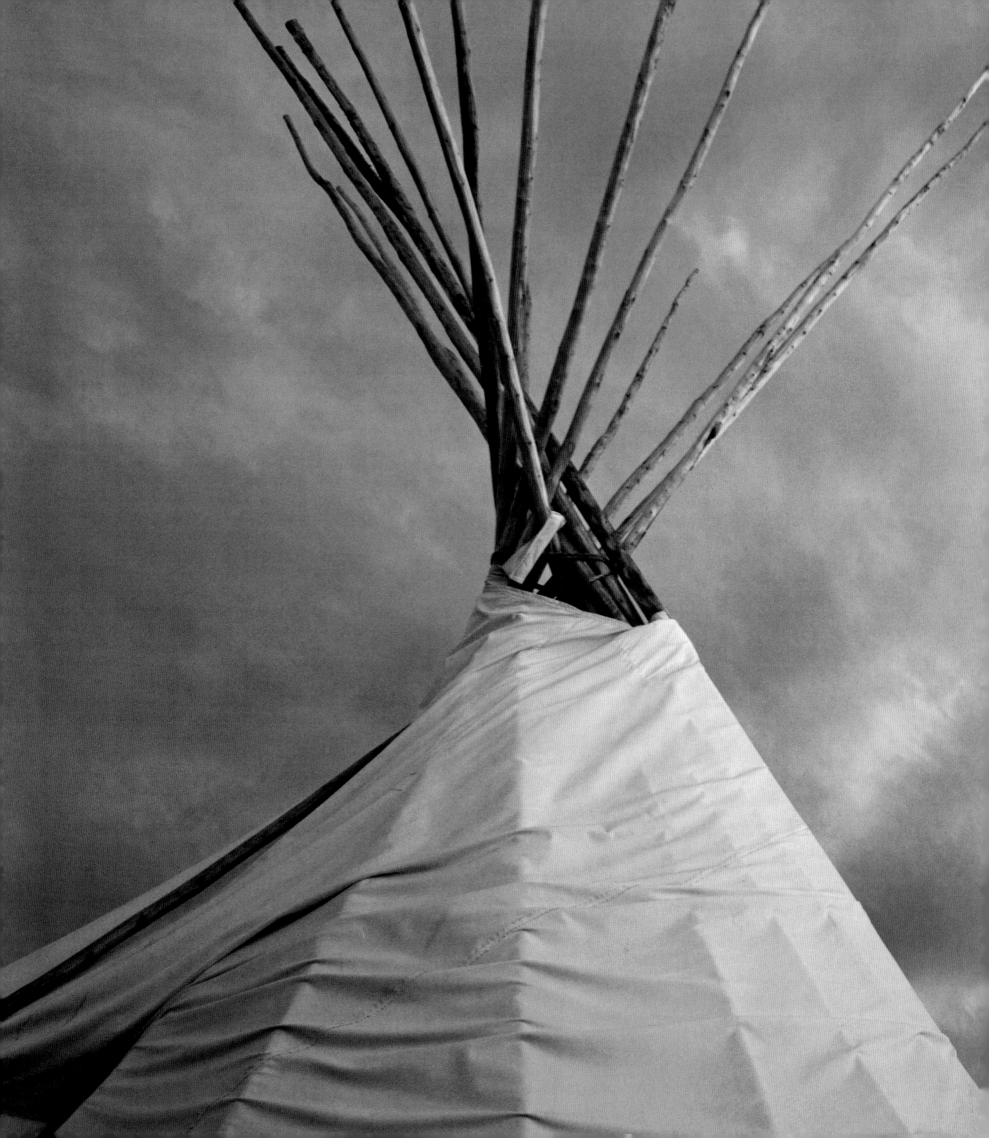

LIFE

AMERICA
A VISUAL HISTORY
FROM THEN TO NOW

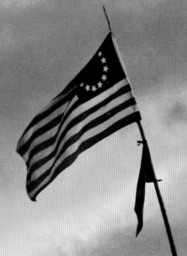

LIFE Books
Managing Editor *Robert Sullivan*
Director of Photography *Barbara Baker Burrows*
Art Directors *Anke Stohlmann, Richard Baker*
Deputy Picture Editor *Christina Lieberman*
Writer-Reporter *Hildegard Anderson*
Copy Editors *Barbara Gogan (Chief), Danielle Dowling, Parlan McGaw*
Consulting Picture Editors *Mimi Murphy (Rome), Tala Skari (Paris)*

President *Andrew Blau*
Business Manager *Roger Adler*
Business Development Manager *Jeff Burak*

Time Inc. Home Entertainment
Publisher *Richard Fraiman*
General Manager *Steven Sandonato*
Executive Director, Marketing Services *Carol Pittard*
Director, Retail & Special Sales *Tom Mifsud*
Director, New Product Development *Peter Harper*
Assistant Director, Bookazine Marketing *Laura Adam*
Assistant Publishing Director, Brand Marketing *Joy Butts*
Associate Counsel *Helen Wan*
Book Production Manager *Suzanne Janso*
Design & Prepress Manager *Anne-Michelle Gallero*
Brand Manager *Roshni Patel*
Editorial Operations *Richard K. Prue (Director), Brian Fellows (Manager), Keith Aurelio, Charlotte Coco, John Goodman, Kevin Hart, Norma Jones, Mert Kerimoglu, Rosalie Khan, Patricia Koh, Marco Lau, Brian Mai, Po Fung Ng, Lorenzo Pace, Rudi Papiri, Robert Pizaro, Barry Pribula, Clara Renauro, Donald Schaedtler, Hia Tan, Vaune Trachtman, David Weiner*

Special thanks to *Christine Austin, Jeremy Biloon, Glenn Buonocore, Jim Childs, Susan Chodakiewicz, Rose Cirrincione, Jacqueline Fitzgerald, Carrie Frazier, Lauren Hall, Jennifer Jacobs, Brynn Joyce, Mona Li, Robert Marasco, Amy Migliaccio, Brooke Reger, Dave Rozzelle, Ilene Schreider, Adriana Tierno, Alex Voznesenskiy, Sydney Webber, Jonathan White*

ISBN 10: 1-60320-123-8
ISBN 13: 978-1-60320-123-0
Library of Congress Control Number: 2009940851

"LIFE" is a trademark of Time Inc.

We welcome your comments and suggestions about LIFE Books. Please write to us at:
LIFE Books
Attention: Book Editors
PO Box 11016
Des Moines, IA 50336-1016

If you would like to order any of our hardcover Collector's Edition books, please call us at 1-800-327-6388 (Monday through Friday, 7:00 a.m.–8:00 p.m., or Saturday, 7:00 a.m.–6:00 p.m., Central Time).

Front Endpapers: Mount Rushmore, circa 1927
Hulton/Getty
Back Endpapers: Mount Rushmore, today
Louie Psihoyos/Science Faction/Corbis
Page 1: Rafters on the Colorado River in the Grand Canyon
Bert Sagara/Stone/Getty
Pages 2–3: The Fort Union Trading Post National Historic Site near the Missouri River, west of Williston, North Dakota
Phil Schermeister/Corbis
These pages: The *Mayflower II*, a replica, sailing off Massachusetts
Joseph Sohm/Visions of America/Corbis

LIFE

AMERICA
A VISUAL HISTORY
FROM THEN TO NOW

From the Native Americans to the newest immigrants . . . from George Washington to Abraham Lincoln to Barack Obama . . . from Babe Ruth to the Williams sisters . . . from the superstar sharpshooter Annie Oakley to the superstar singer Beyoncé—these are the individuals who shaped our nation.

Eons ago there was a land bridge linking Asia to North America . . . Where only yesterday there were fields, cities grow . . . In realms that astounded early explorers of the West, today we visit national parks . . . Touring the country from coast to coast and beyond proves illuminating and often surprising.

Alexander Graham Bell had his telephone, and now our teenagers have their iPhones . . . Where once there was a mountain in the Black Hills, today there is a monument . . . The Wright brothers built an airplane and their successors ride rockets . . . Ours is a land of endless invention, with not even the sky as a limit.

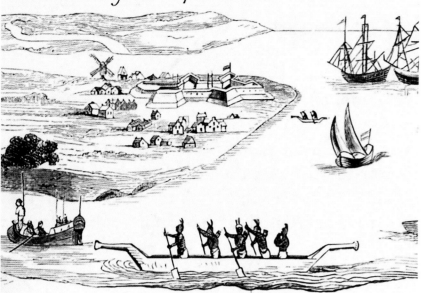

Fort nieuw Amsterdam op de Manhatans.

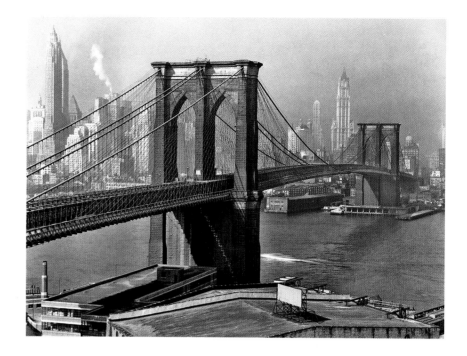

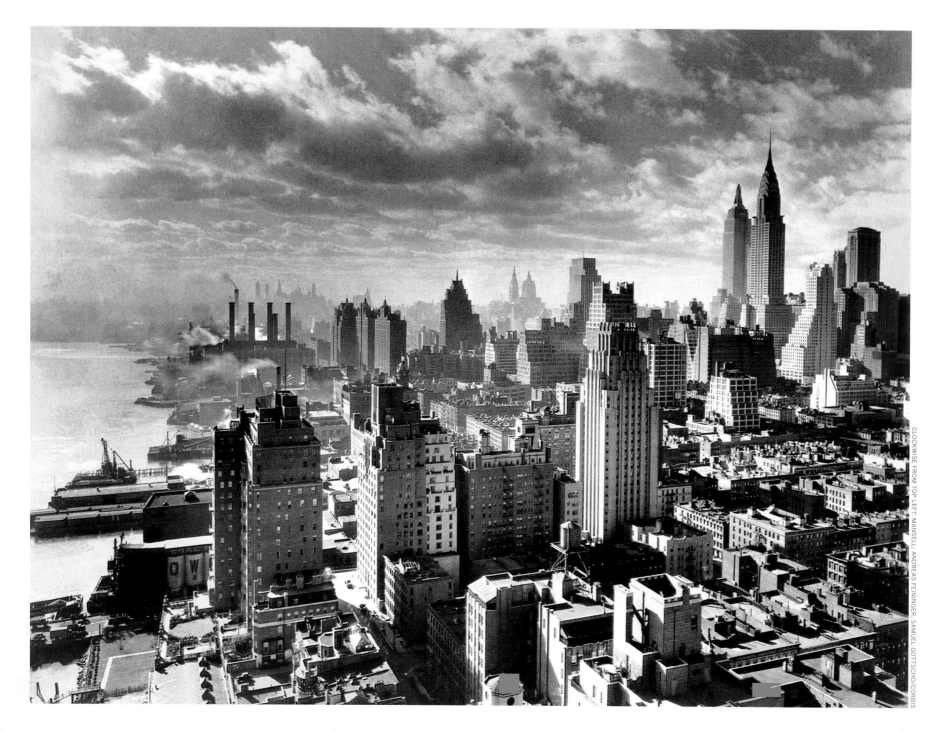

THAT WAS THEN, THIS IS NOW

In putting together this book, which was a task that turned out to be exceedingly fun, interesting and enlightening, LIFE's editors perceived certain themes emerging. If you look at whence we've come as Americans and where we've arrived—not to mention, where we are perhaps headed—you find there are a few principles that have guided us along the way. This is not news, of course: The Founding Fathers have long been credited with laying down our essential rules of the road, and were it not for them it is unlikely that we could have traveled successfully from Then to Now. But what's interesting is the struggle, the constant struggle. Our ancestors envisioned—invented—a democracy, a nation-state as lofty as any Plato might have imagined. Our subsequent task as American citizens has been to realize their good intentions, to seek to fulfill their dream. We have not always succeeded. But we have sometimes succeeded when success was crucially required. We struggle still. We struggle every day.

The themes—the leitmotifs—that we, the editors, saw emerging during our research include the tormented quest for true equality, the fierce desire to preserve our liberty, the unlimited ambition (which might lead to good or bad behavior) that a democracy encourages, the related encouragement of invention, the push-pull between a regard for nature and an aspiration to growth and, finally, a firm stance in regard to the idea of independence—personal freedoms, societal freedoms, global freedoms. These words are meant not to be highfalutin but rather to inspire you to think about the images you encounter in these pages. Drink them in. Think about the people and places and things you are seeing. Think about—to consider just the images on these two pages—how New York City, the nation's largest metropolis, was ever able to rise to the heights it enjoys today, and what it is about America that allowed this to happen and that drew others to New York through time and that, in fact, inflamed still others to attack the city.

Think about the past and the present, and how they are interrelated. Think about how each of these pictures—whether they represent our missteps or our glories—is about America. And, therefore, Americans. In other words: you and me.

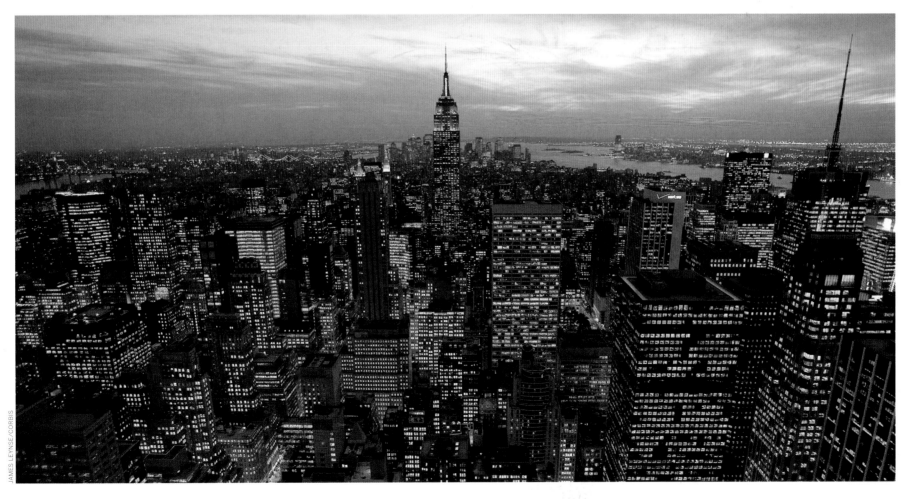

JAMES LEYNSE/CORBIS

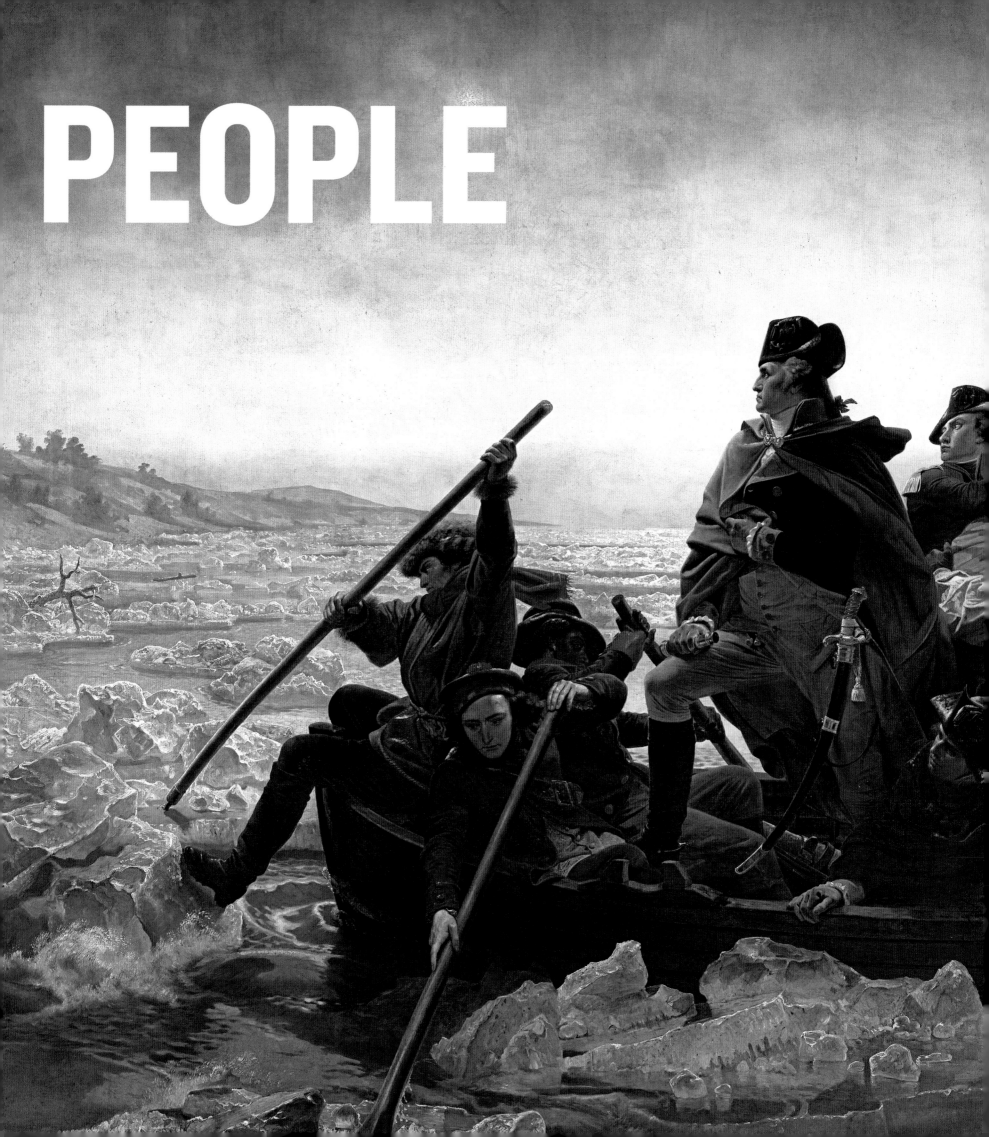

PEOPLE

Preeminent even among the eminences who were our Founding Fathers, George Washington—seen here leading a surprise attack against Hessian forces by crossing the Delaware River near Trenton, New Jersey, on Christmas day in 1776—did as much as any other person to bring our country from the Then that had preceded him and point it toward the Now of the 21st century.

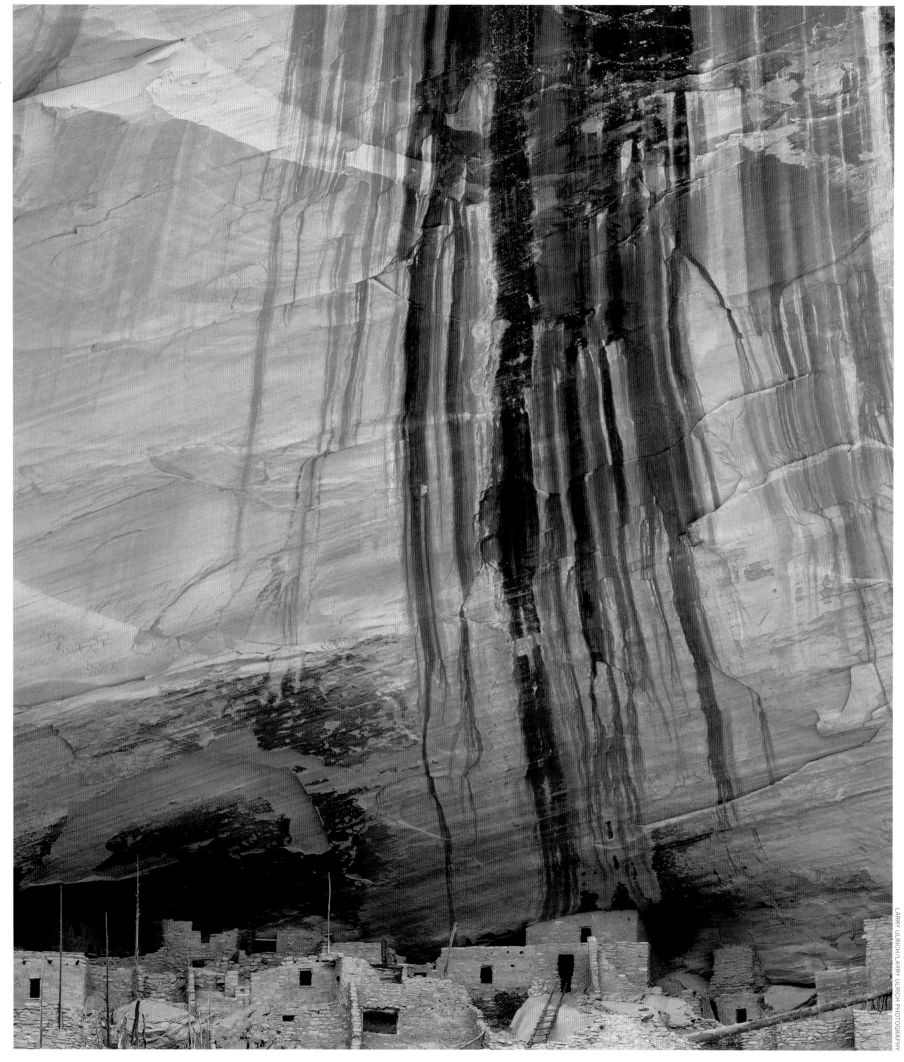

THIS LAND WAS THEIR LAND

During the last ice age, oceans receded when glaciers stole their water. Slowly Asia, which was already populated, and North America, which was not, became joined when a huge land bridge twice the size of Texas connected what are now Alaska and Siberia (please see page 74). New evidence shows that this connecting strip didn't succumb to melting ice and rising seas until as recently as 11,000 years ago. While the bridge existed, traffic was constant; across it walked caribou, musk oxen, wolves, bison, antelopes, brown and black bears, assorted other species—and humans. These first Americans very quickly worked their way south and east, and by the time the land bridge closed, they were sufficient in number to survive, settle, hunt, prosper, thrive. To dominate. And this they did for thousands and thousands of years, dividing into tribes, squabbling occasionally over territory, but essentially owning the continent. Then the Spanish arrived in the West and South and the English in the East, and Europeans turned the Native Americans' existence upside down. The white man's Manifest Destiny became the red man's doom. By the latter half of the 19th century, the fate of the natives on the western plains—many of whom had been relocated there per orders from Washington—was sealed, despite being armed not just with bows and arrows but with rifles. The persecution of the Indians is perhaps, along with slavery, the greatest stain upon the United States of America. Today, Indians can exercise their right to vote in this democratic land but often do so on reservations that are far less well off economically than neighboring communities populated by the descendants of those who pushed their forebears off their land. Opposite, at the Navajo National Monument in northern Arizona, we see cliff dwellings once inhabited by the Anasazi, a sophisticated Native American people who thrived in the Southwest more than 700 years ago before mysteriously vanishing, their lineage bleeding into various Pueblo Indian tribes. On this page, ancient traditions are kept alive on a Menominee reservation in Wisconsin.

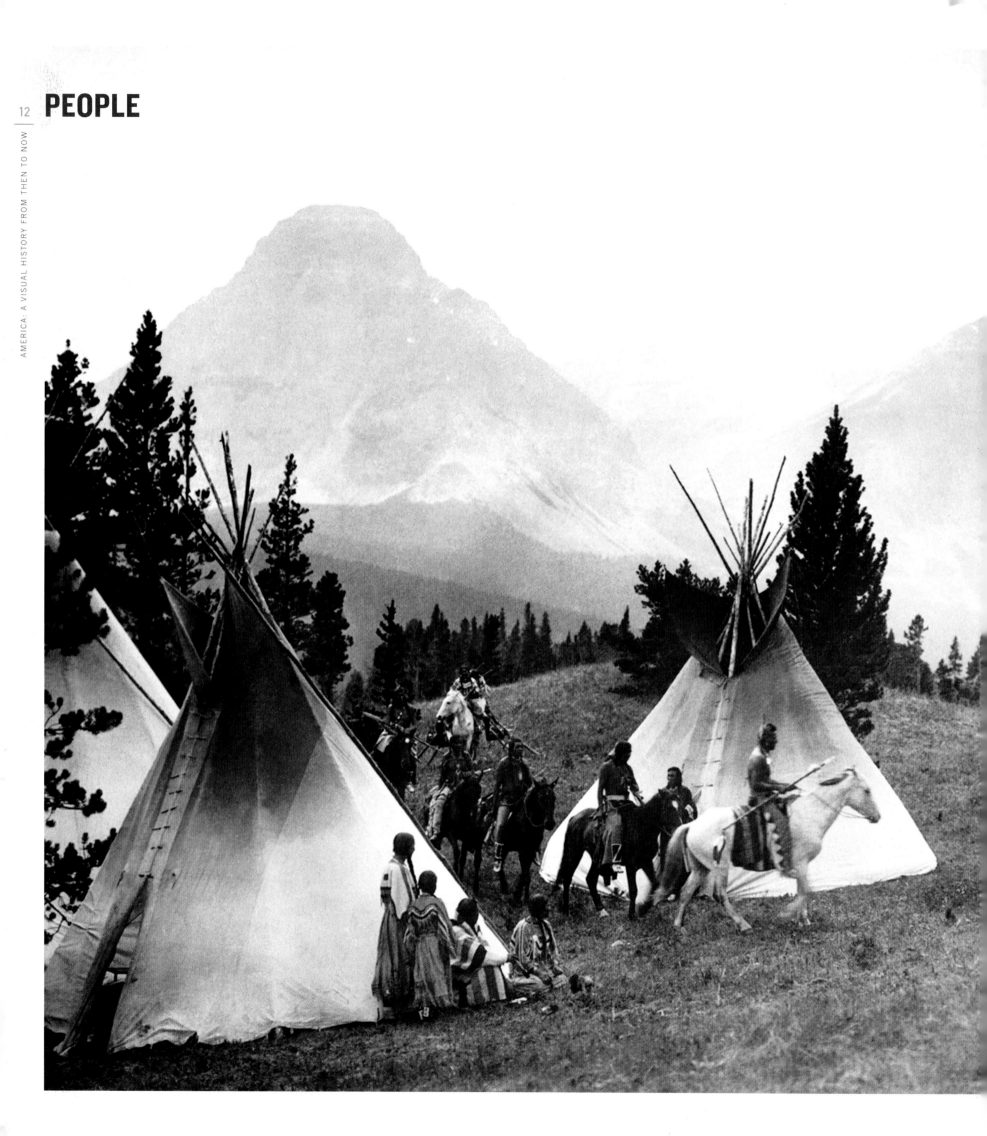

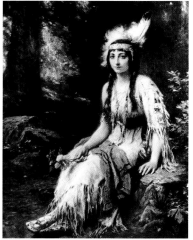

PEACEMAKERS AND WARRIORS

At left, we have Native Americans leaving on a buffalo hunt in Montana, in an area now bounded by Glacier National Park. At right is a gallery of famous Indians, described from left to right, and from the top row down: The Patuxet Squanto (1581–1622) was responsible for helping the English religious refugees known as the Pilgrims through their first, brutal winter in Massachusetts in 1620; Pocahontas (1595–1617) sought to forge peace between the tribes of Virginia and colonists, and she married the Englishman John Rolfe; Tecumseh (1768–1813), a Shawnee chief, tried to unite tribes into an Indian nation and died in the War of 1812; Sacajawea (1788–1812), a Shoshone, assisted Meriwether Lewis and William Clark during their expedition of discovery in the West; Geronimo (1829–1909), an Apache warrior, led his people in defense of their tribal lands for a quarter century and instigated the last great Indian uprising before being conquered and sent to live on a reservation; Sitting Bull (1831–1890), a Lakota Sioux medicine man, led his men to victory over George Armstrong Custer at the Battle of Little Bighorn; Chief Joseph (1840–1904) was the forceful leader of the Nez Perce; and the Oglala Sioux Crazy Horse (c. 1840–1877), a hero of the Great Sioux War of 1876–77, is today being commemorated by a mammoth sculpture on a mountainside in South Dakota, not far from the Presidents' memorial at Mount Rushmore.

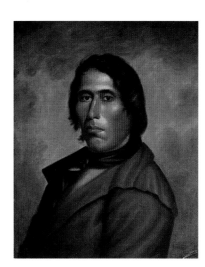

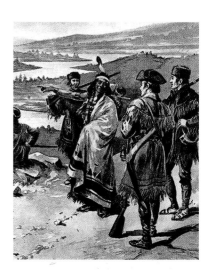

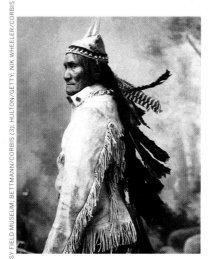

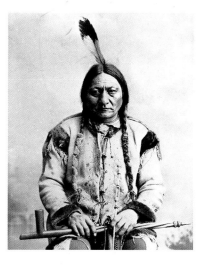

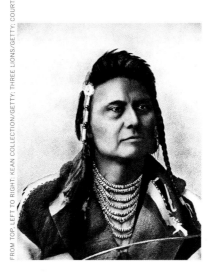

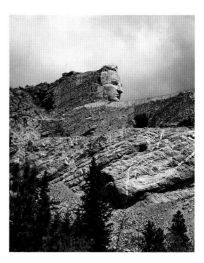

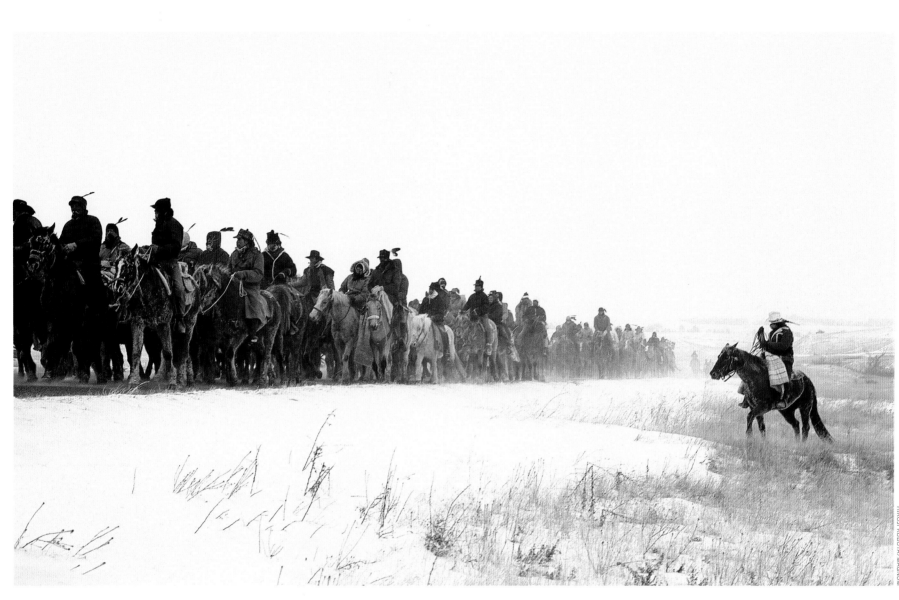

ENDURING STRUGGLE

In 1890 there was a horrific incident at Wounded Knee, South Dakota, in which the U.S. 7th Cavalry killed scores of Lakota Sioux men, dozens of women and 18 children. Because of the Wounded Knee Massacre, the place became freighted with symbolic significance; the writer Dee Brown's 1970 history and memoir was titled *Bury My Heart at Wounded Knee*. In the latter half of the 20th century, Wounded Knee was within the Pine Ridge Indian Reservation, which constituted one of the poorest counties in the entire country. Pine Ridge was, in other words, emblematic of the Native Americans' plight in modern America. In 1973 followers of the American Indian Movement (AIM) occupied the town of Wounded Knee. The question of who was to blame for taking over the town remains contested all these years later, but the siege lasted 71 days and resulted in the deaths of two AIM supporters and the grievous injury of one U.S. Marshal. Above: In 1990, on the centennial of the original massacre, Indians make their way to the grave site to honor those slaughtered by George Amstrong Custer's soldiers. There have been many other tensions between Native Americans and whites in the decades since the Indians' initial subjugation, as well as some enlightened efforts at support. Through the years, several Indians (or folks with predominantly Indian heritage who identified themselves as such) have overcome barriers or simply seized the day to rise to prominence on the American scene, including (on the opposite page, left to right, top row to bottom): Jim Thorpe, the "world's greatest athlete" and an Olympic champion in 1912; Will Rogers, one of America's big stars of stage and screen in the 1920s and '30s; Maria Tallchief, a ballerina with the New York City Ballet from 1947 to 1965 and founder of the Chicago City Ballet; Russell Means, who was born on the Pine Ridge reservation and became the activist leader of AIM in the 1970s; Ben Nighthorse Campbell, senator from Colorado from 1993 to 2005; Leslie Marmon Silko and Louise Erdrich, two esteemed novelists whose narratives chronicle Native American lives in the present day; and Jacoby Ellsbury, centerfielder for the Boston Red Sox and one of three Native Americans currently playing in the big leagues of our country's national pastime.

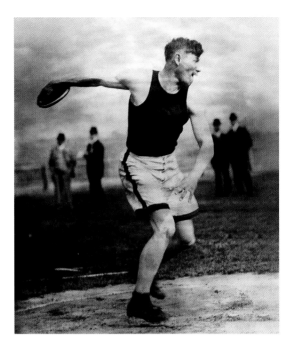

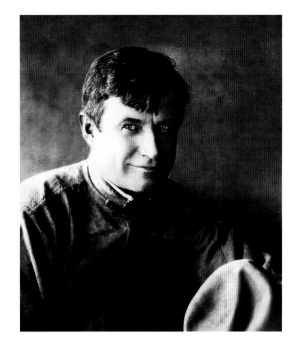

15

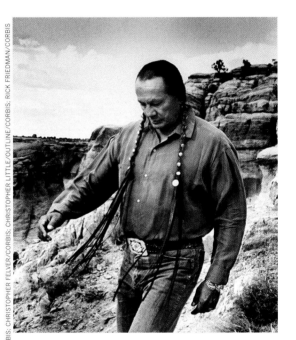

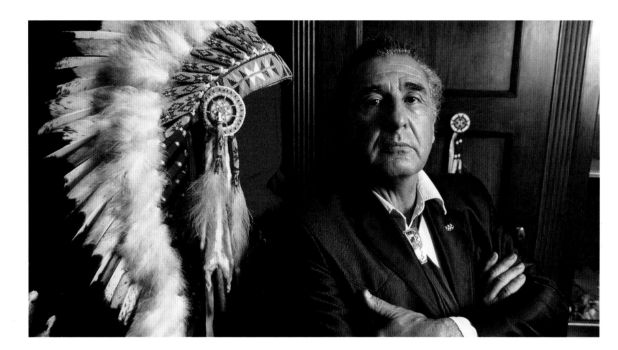

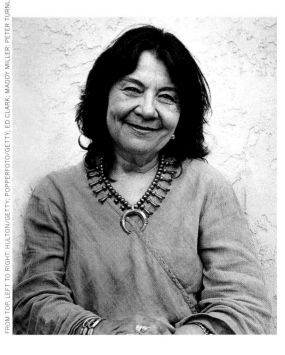

HÆC·EST·EFFIGIES·LIGVRIS·MIRANDA· COLVMBI·ANTIPODVM·PRIMVS· RATE·QVI·PENETRAVIT·IN· ORBEM·

SEBASTIANVS VENETVS·FACIE·

WHO DISCOVERED AMERICA?

The answer to this question has already been given: The indigenous people, who eons ago migrated from Asia and dispersed throughout the land, were the true finders of America. But this question, as it is often put, means: Who was the first from the Old World to discover the New? Who was the first European to successfully navigate the Atlantic and investigate the territories that would eventually become the United States? For decades upon decades, American schoolchildren were taught that it was Christopher Columbus (opposite), an Italian navigator in the employ of Spain, who in fourteen hundred and ninety-two sailed the ocean blue and stepped foot upon islands in the Caribbean now known as the West Indies (he thought he had gone all the way to Asia, to India—hence "Indies" and also "Indians"). Columbus in fact never reached the North American mainland and in larger fact was probably not the first European to cross the Atlantic anyway. Leif Ericsson (top right), a Norse explorer active at the turn of the first millennium, is today widely credited with founding a temporary settlement in Newfoundland (bottom, the theorized site of his "Vinland") five centuries before Columbus set sail, and if a Caribbean island can count as part of "America," certainly Canada can. Moreover, there are cryptic, tantalizing artifacts that are seen as evidence by some that the Vikings made their way south into what is now the United States. Adherents of the Irish monk Saint Brendan (top left), by contrast, point to Celtic-seeming engravings in the Northeast when arguing that his legendary voyage to the "Blessed Isle" in the sixth century is not myth but history, and that Brendan actually made his way from Ireland across the North Atlantic to America. It all represents a delightful argument, and that there are clues on the ground today to support any of these views is simply more spice for the stew.

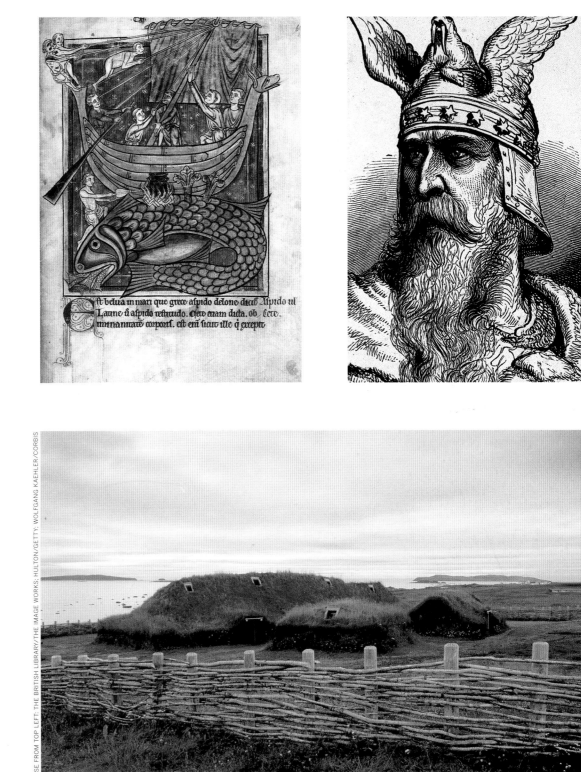

PEOPLE

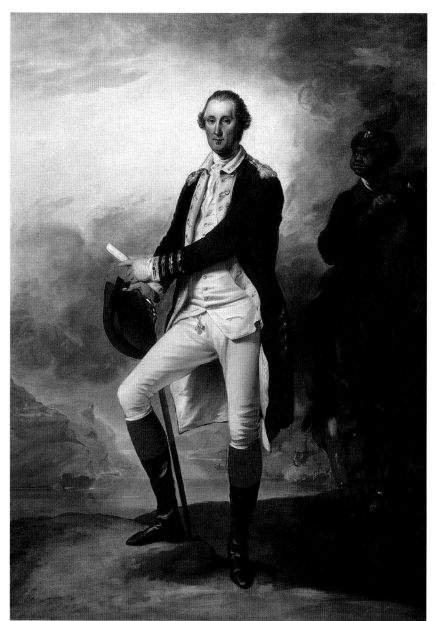

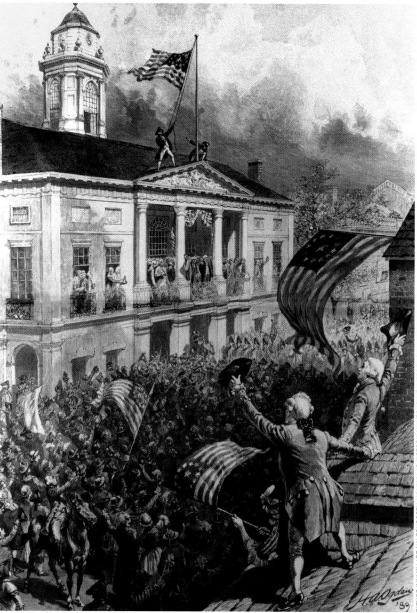

THE PEOPLE'S CHOICE

Perhaps no other two people can illustrate how far the United States has traveled from Then to Now than George Washington (above, in a portrait and being celebrated at his first inauguration) and Barack Obama (opposite, with the Father of Our Country looking over his shoulder). Washington and his fellow Founding Fathers, in their wisdom, laid down democratic rules under which such a person as Obama might rise and thrive—but they never could have imagined him, certainly not as leader of their country. In their day, men and women of dark skin were imported as slaves to the newborn United States, and Washington, for one, as well as Thomas Jefferson, owned them as such. (Jefferson is believed to have fathered a number of children with his slave Sally Hemings.) Of course black men could not vote in Washington's day, and neither could women; the nation and the presidency were controlled by white Anglo-Saxon men. That this narrow fact persisted for such a long time might seem extraordinary (and even unfortunate); that the United States Constitution, as drafted by Jefferson and company, allowed for the fact to ultimately be shattered is equally remarkable. In 1960, John F. Kennedy became the first Catholic to be elected President. Within 40 years, the Democratic party would nominate a woman and a Jew as its vice presidential candidates; strictures were breaking down. And then came 2008. It became evident during the primary season that the Democratic nominee would either be a woman, Hillary Clinton, or a man of mixed-race parentage, Obama; the election of either would set a titanic precedent. In the event, it was the latter, the product of a broken home, born to a Kenyan father and a white mother in Hawaii—our 50th and newest state, a place as foreign to George Washington as Barack Obama himself might have been. Only in America.

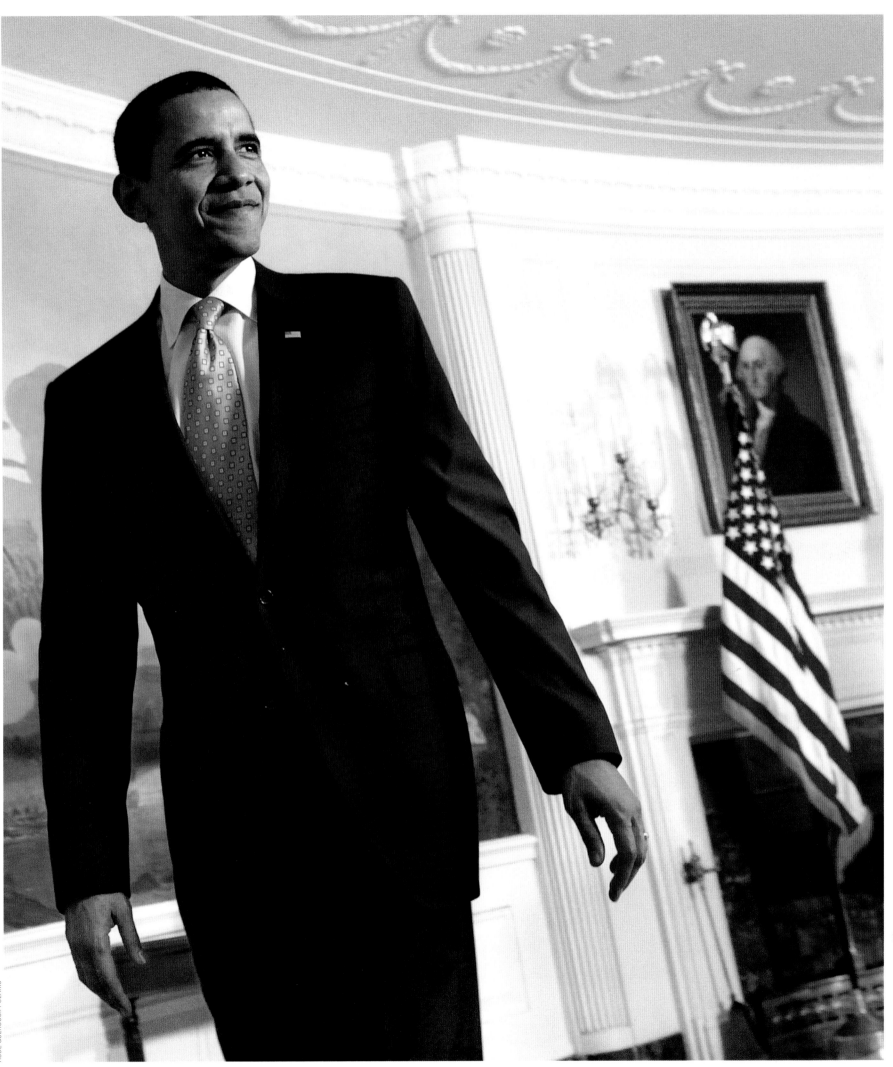

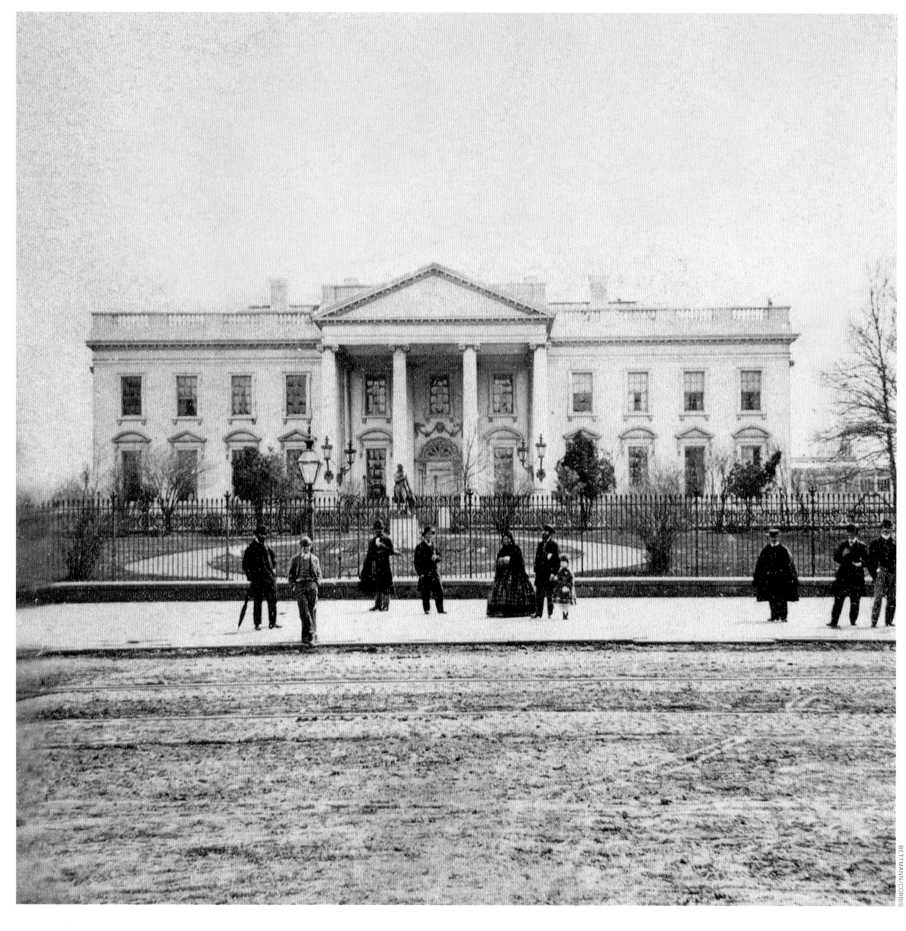

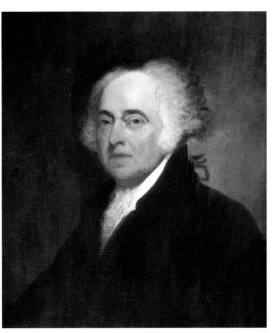

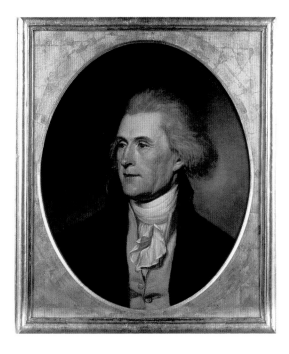

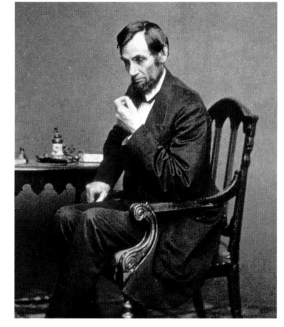

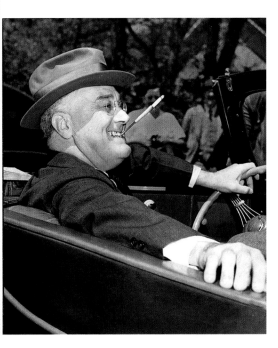

THE CHIEF EXECUTIVES

President Obama is the 44th man to hold the office. Some of his predecessors are remembered better than others. Above, left: John Adams was Washington's successor, and Thomas Jefferson (center) was Adams's; these two, who along with Benjamin Franklin were influential among the Founders, were for a time bitter rivals, but once their political careers were done, they forged a respectful relationship and continued a long correspondence. The two men died, remarkably, on Independence Day, 1826, with Adams uttering his last words in Massachusetts—"Thomas Jefferson survives"—even as Jefferson himself was passing away in Virginia. Above, right: Abraham Lincoln of Illinois was the President who saw the Union through the Civil War (opposite, Lincoln's mourners outside the White House, where all Presidents since Jefferson have lived). In the first half of the 20th century, two distantly related cousins from New York served more than five terms combined as President: Theodore Roosevelt (left) from 1901 to 1909, Franklin (below, left) from 1933 to 1945. The former was a Progressive who won the Nobel Peace Prize for his efforts to end the Russo-Japanese War and boosted the country's conservation movement with national parks initiatives and the creation of the U.S. Forest Service; the latter man saw us through the Great Depression and then World War II. Below, center: In the early 1960s, John F. Kennedy's magnetism energized a nation during his too-brief tenure, which was ended, as Lincoln's had been, by an assassin's bullet. Below, right: In the 1980s, the equally charismatic Ronald Reagan, a former movie star, galvanized the Republican right.

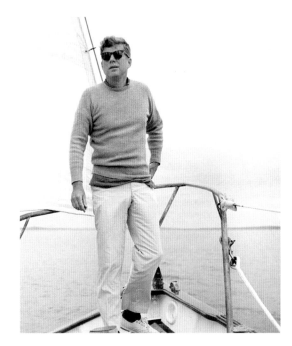

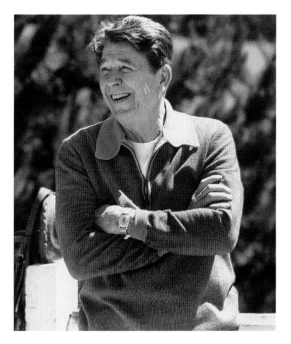

PEOPLE

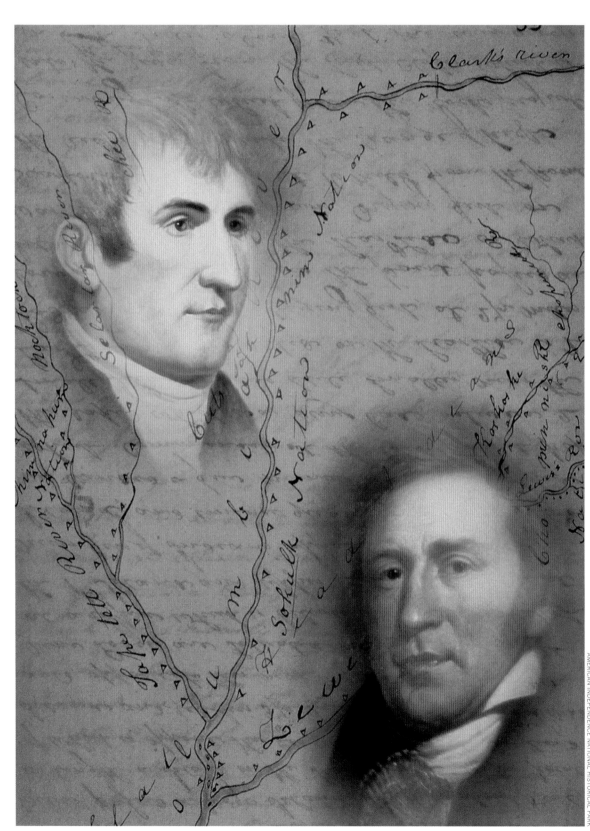

WESTERING MEN

Wrote the scholar Henry Nash Smith: "The importance of the Lewis and Clark expedition lay on the level of imagination . . . [I]t was drama, the enactment of a myth that embodied the future." When Thomas Jefferson became President in 1801, he wondered about the West: Might there be a water passage to the Pacific? How vast is that territory? Like other Virginia planters, he made his living with tobacco and wheat and, as noted earlier, with slavery—which demanded ever more land. Also, Jefferson, a man of many parts, burned to learn about the flora and fauna of the unseen West. To that end, he turned to Meriwether Lewis (left, at top) and presented the great frontiersman with the wherewithal to record his experience. Lewis had spent two solid years with Jefferson, as his secretary, and it was from him that he learned how to be a writer. As historian Stephen E. Ambrose said of Lewis's style: "He sharpened his descriptive powers. He learned how to catch a reader up in his own response to events and places . . ." Lewis had also been schooled by experts in the fields of navigation and geography and the ways of the American Indians. And scholars in Philadelphia had taught him the intricacies of classifying plants and animals. He was ready to go. After Jefferson negotiated the Louisiana Purchase in 1803, the notion of a westward expansion of the United States became an interesting prospect. Meriwether Lewis would depart on his exploratory trek the following year, having tapped his former army officer, the resolute William Clark (at bottom), to colead their Corps of Discovery. The successful 8,000-mile journey to the Pacific Ocean and back, with the Columbia River Gorge between Washington and Oregon (opposite) being a crucial path to the coast, took two years, four months and 10 days. Subsequently, primarily through the corps's immortal journals (a page of Lewis's is seen at left), America's eyes were opened to what was out there, and to what might be possible.

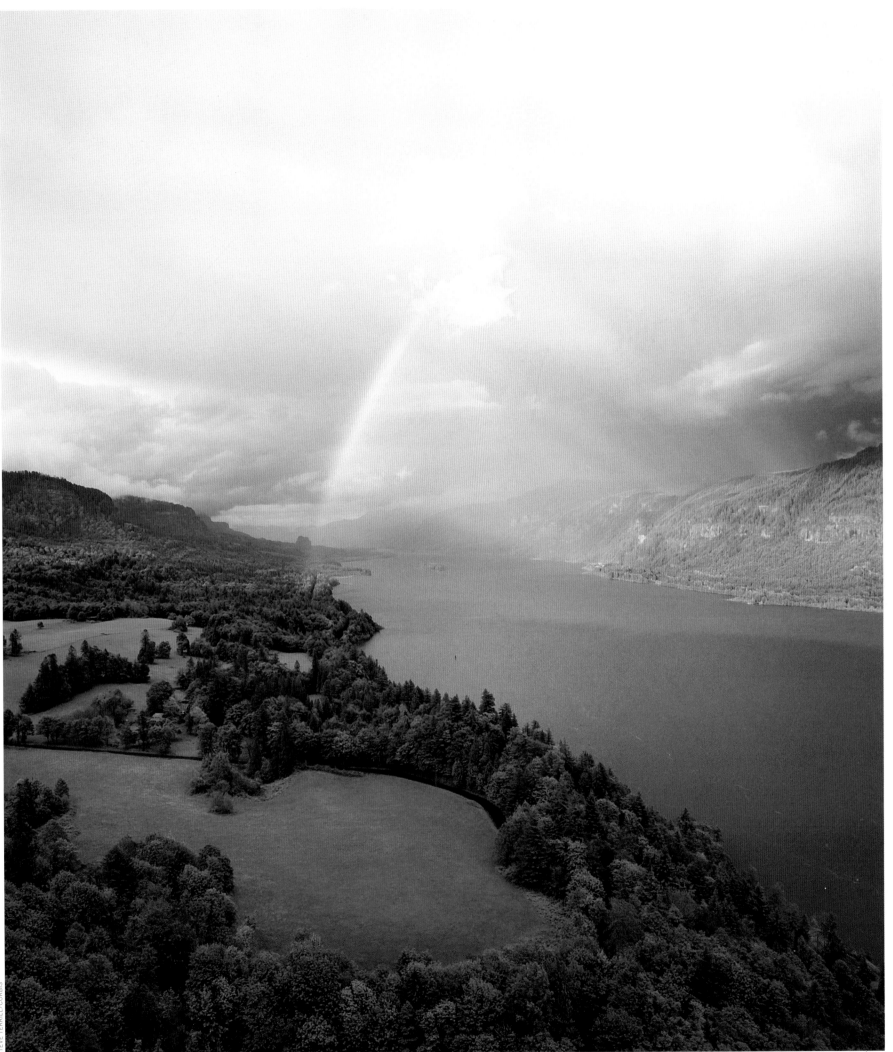

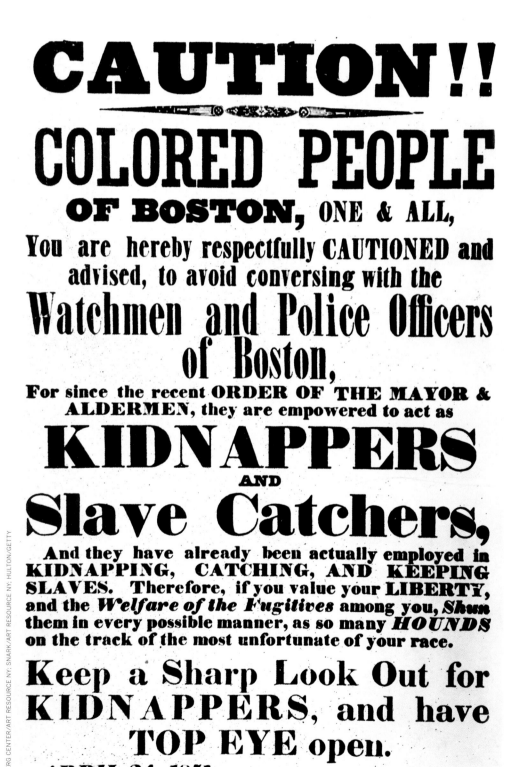

CAUTION!!

COLORED PEOPLE

OF BOSTON, ONE & ALL,

You are hereby respectfully CAUTIONED and advised, to avoid conversing with the

Watchmen and Police Officers of Boston,

For since the recent ORDER OF THE MAYOR & ALDERMEN, they are empowered to act as

KIDNAPPERS

AND

Slave Catchers,

And they have already been actually employed in KIDNAPPING, CATCHING, AND KEEPING SLAVES. Therefore, if you value your LIBERTY, and the *Welfare of the Fugitives* among you, *Shun* them in every possible manner, as so many *HOUNDS* on the track of the most unfortunate of your race.

Keep a Sharp Look Out for KIDNAPPERS, and have TOP EYE open.

APRIL 24, 1851.

THEODORE PARKER'S PLACARD

Placard written by Theodore Parker and printed and posted by the Vigilance Committee of Boston after the rendition Thomas Sims to slavery in April, 1851

TO BE BLACK IN AMERICA

For the longest time, that phrase *to be black in America* most often meant to be a slave. Spanish explorers brought African captives to Florida as early as the mid 16th century, and as soon as English colonies sprouted in Virginia in 1607, slavery became part of that equation. Of the 12 million Africans taken from their homeland against their will and transported to the Americas between the 16th and 19th centuries, perhaps 645,000 were brought to what is now the United States. By the eve of the American Civil War, they had multiplied and their number had grown to four million. The outcome of that war, in which black battalions fought valiantly for the Union cause (opposite, a young corporal in the Negro Union Infantry, in the 1860s), of course changed the prospects of the country's African Americans, but the passage of the Thirteenth Amendment to the United States Constitution, which became law in 1865, was at first more a legal than a practical measure. The American South, where slavery had become deeply entrenched (slave labor was vital to the large tobacco and cotton industries), was compelled, kicking and screaming, to grant black Americans their legal rights—though all too often on paper only. In the North, where an immigrant workforce sought to protect jobs from being taken by suddenly free blacks, poverty-plagued ghettos grew in urban centers, and segregation of many types, including in education, was de facto where it wasn't explicit. The Thirteenth Amendment was on the books by 1865, yes, but it would be another century before a new civil rights movement began to address the injustice and indignity that African American citizens continued to suffer. Affairs remain far from perfect in the 21st century, but a long, hard road has been traveled since the days when *to be black in America* meant one thing, and one thing only.

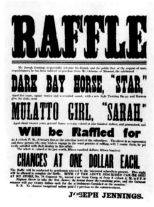

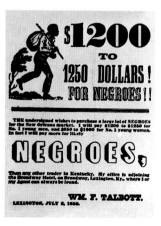

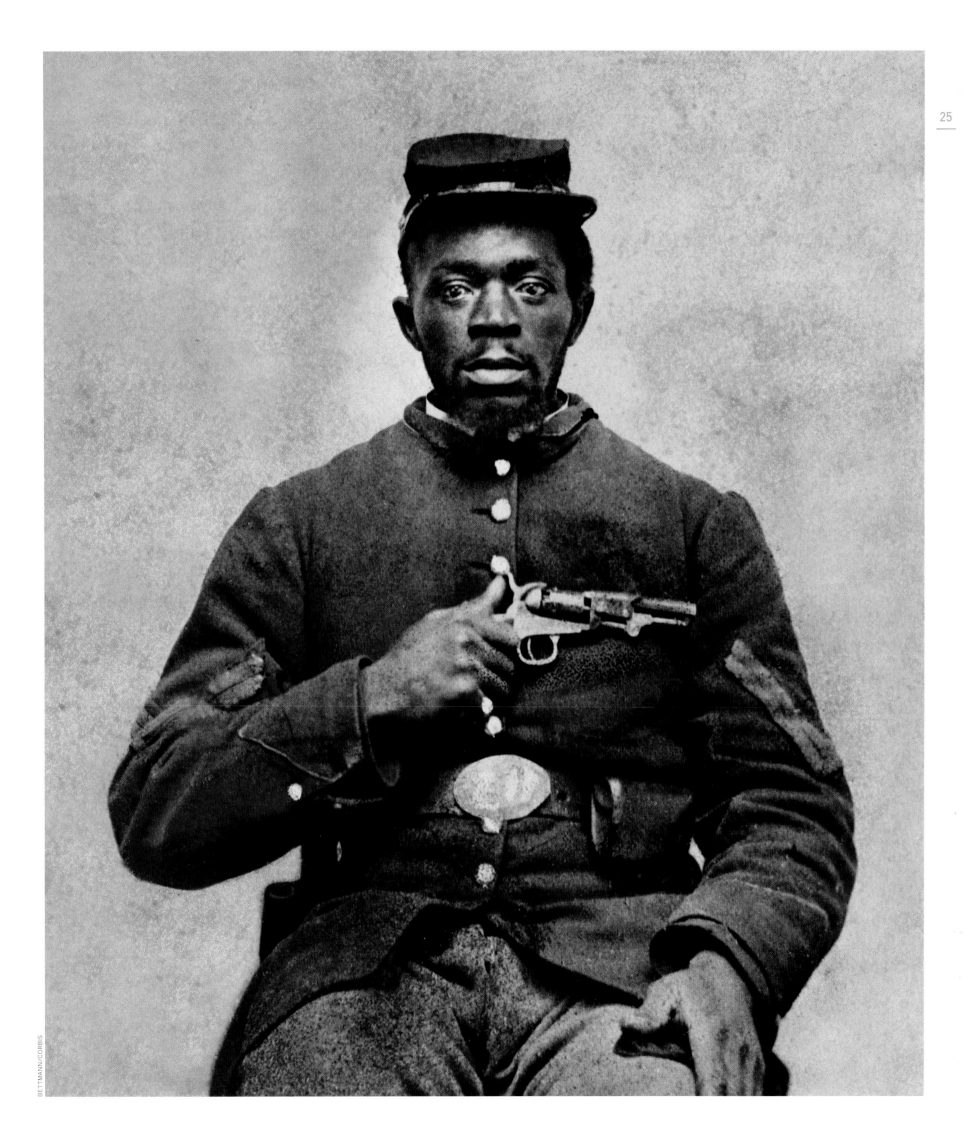

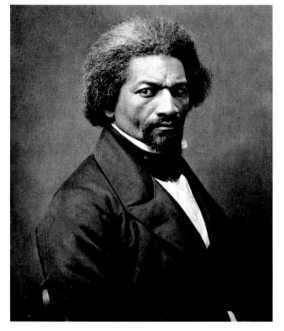

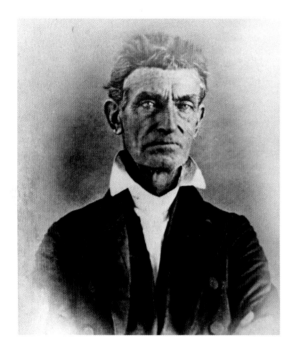

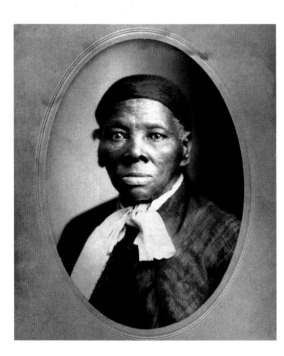

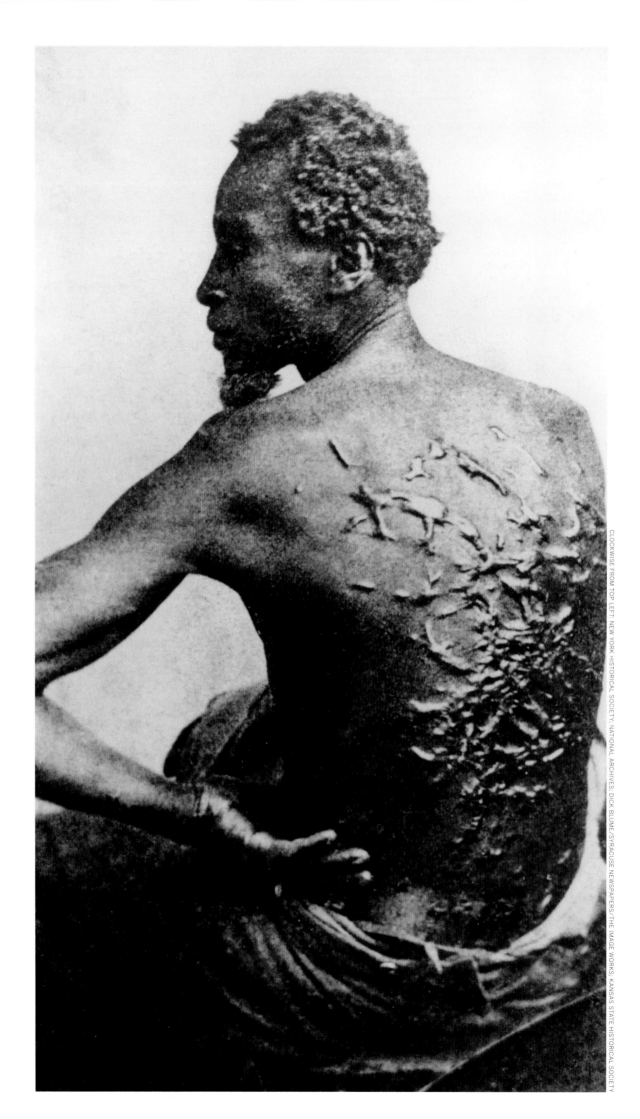

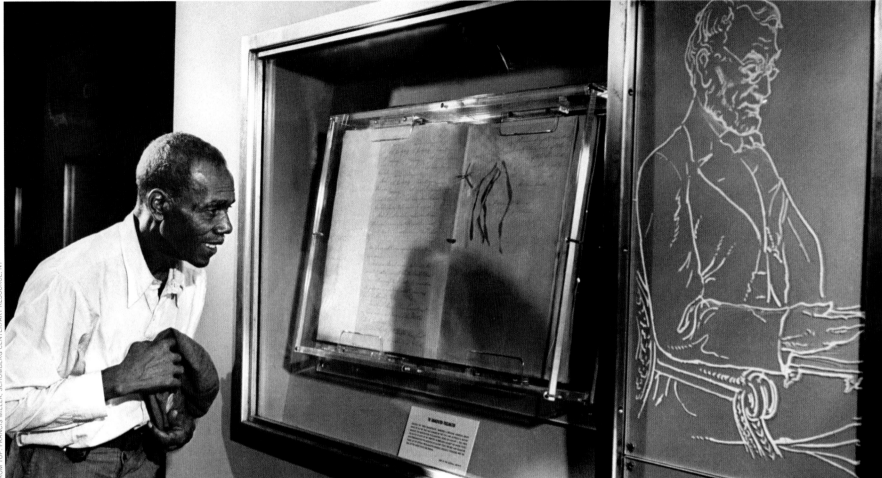

FEARLESS

To free an entire people, brave individuals were required to say and do what was right. Not all of them were black; Abraham Lincoln, most prominently, was one of the intrepid white men. Whether what John Brown (opposite, center left) said and did was the best way to end slavery was debated in his day and still is today, but it was indisputably bold and galvanizing. Brown, raised in the Midwest, was a lifelong zealot, virulently opposed to slavery. He consulted, among others, Frederick Douglass (top left), a former slave who, as an eloquent journalist and speaker, was the most respected black American of his time; in 1847, Brown told Douglass that he intended to free the slaves by force. Over the next decade, Brown devoted himself to vio-

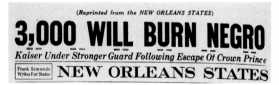

lent missions that culminated in October of 1859 with a raid on the U.S. arsenal at Harpers Ferry, in what was then Virginia and is now West Virginia. This was apparently part of a plan to foment a slave rebellion. He was captured and on December 2 of that year was hanged in Charlestown (now Charles Town). Ralph Waldo Emerson said that Brown would "make the gallows as glorious as the cross," and although Lincoln downplayed Brown, for many Southerners the raid was proof of a Northern plot to use force to wipe out slavery. The Civil War loomed, and once it had begun, traffic picked up along the Underground Railroad, a system active since roughly 1830 to sneak slaves into the free states. Lyrics of spirituals were often coded—"Run to Jesus/Shun the danger"—giving directions to secret rooms and safe houses. Harriet Tubman (bottom left), an escaped Maryland slave, was a Railroad engineer and helped some 300 slaves flee. The efforts of these fearless people, along with the blood of thousands (including the beaten "Gordon," opposite, of Baton Rouge, Louisiana) led to the Emancipation Proclamation (being viewed above during an exhibition in 1947) and then freedom . . . of a sort. The Ku Klux Klan rode by night, and lynchings were not uncommon. The headline seen above announces a mob-rule lynching in 1919, and the article details the case of a man accused of rape in Mississippi who was chased by dogs, shot a number of times and captured. He will get no trial; authorities are powerless to protect him: "3,000 WILL BURN NEGRO," the newspaper shouts. "JOHN HARTFIELD WILL BE LYNCHED BY ELLISVILLE MOB AT 5 O'CLOCK THIS AFTERNOON. NEGRO JERKY AND SULLEN AS BURNING HOUR NEARS." The crowd at this lynching arrives with picnic baskets to witness the deed. Some leave with souvenirs from the body. Clearly, if technical freedom had been gained by black Americans, true liberation and any semblance of equality were distant dreams.

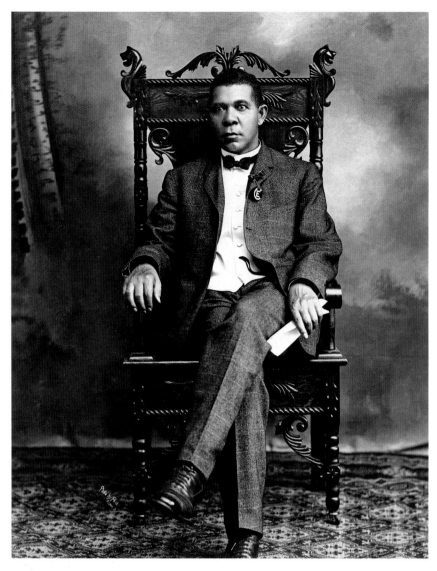

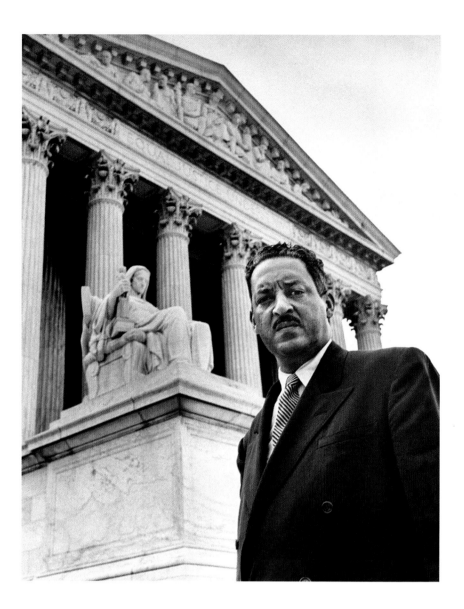

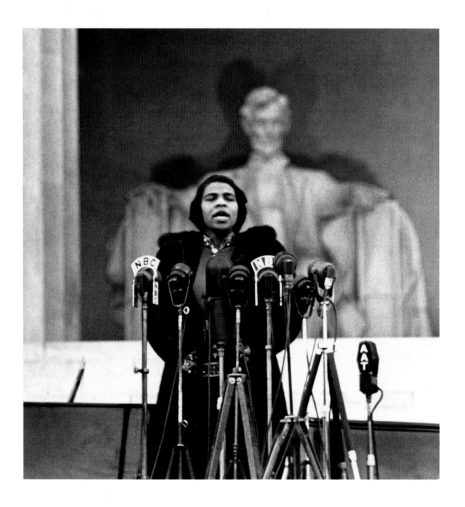

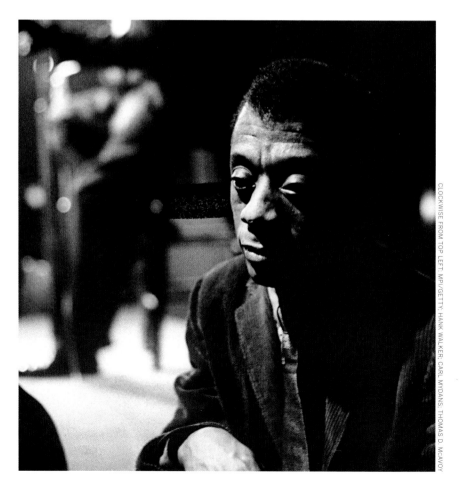

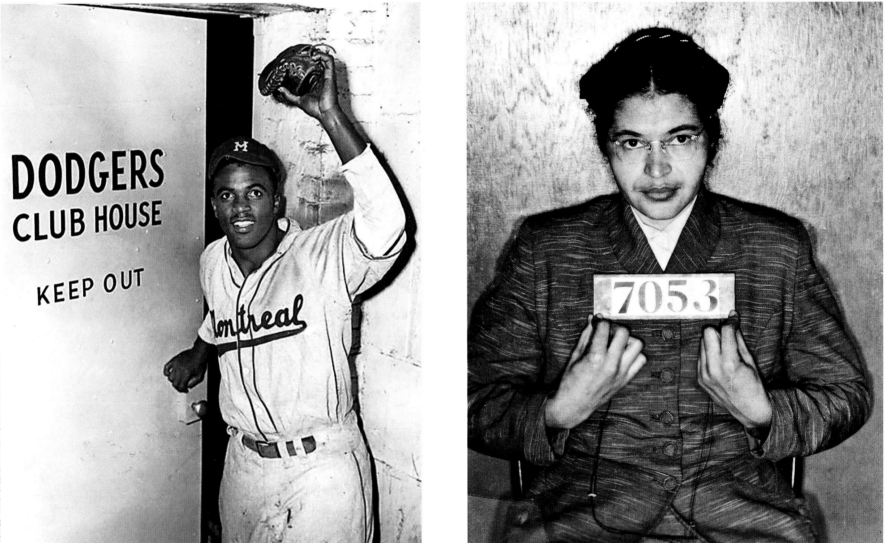

ENOUGH IS ENOUGH

With the Great Depression having been survived and the war against fascism won in Europe, the United States settled down—but not really. The ever-brewing question of racial inequality hadn't been solved or even really dealt with in any kind of enlightened fashion, and now was the time. What was about to happen was, interestingly, in refutation of the solutions advanced earlier by one of the black community's most esteemed thinkers. At the turn of the century, the educator Booker T. Washington (opposite, top left, circa 1890) had advocated tolerance and had drawn plans for a society where African Americans might thrive in their own parallel universe—a doctrine amounting to, it could be said, "separate but equal." W.E.B. Dubois was among early critics of this thinking, and in 1954, the landmark Supreme Court decision in *Brown* v. *Board of Education*, which was argued by an eloquent Thurgood Marshall (who would later ascend to the Supreme Court as the first-ever black justice and is seen outside the courthouse in the 1955 photograph opposite, top right) said firmly that segregated black schools were unequal. National Guard and Army troops were called to college and public school campuses to put down protests as blacks crossed the thresholds. Barriers were falling or being brought into question everywhere in the mid 20th century. In 1939, the black contralto Marian Anderson sang to 75,000 at the symbolically resonant Lincoln Memorial (opposite, bottom left); writers such as Richard Wright and James Baldwin (bottom right) detailed the black experience for a wide audience; Jackie Robinson broke baseball's color line when he debuted with the Brooklyn Dodgers in 1947 (above, left); and in 1955, Rosa Parks (above, right) refused to give up her seat to a white man and move to the back of the bus in Montgomery, Alabama, spurring a boycott of public transportation in that city lasting more than a year. The boycott was led by a young man from Atlanta, 26-year-old Martin Luther King Jr., pastor of Montgomery's Dexter Avenue Baptist Church and someone destined for the history books.

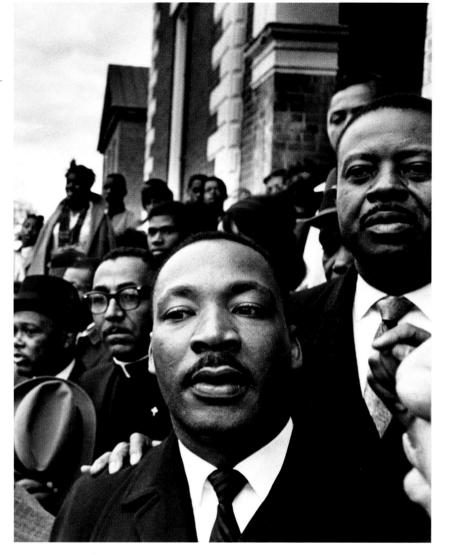

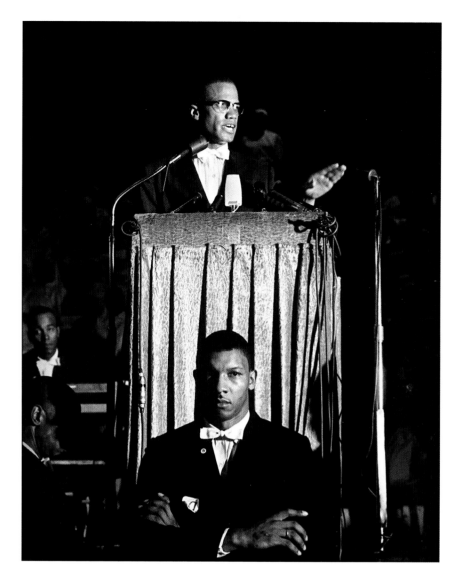

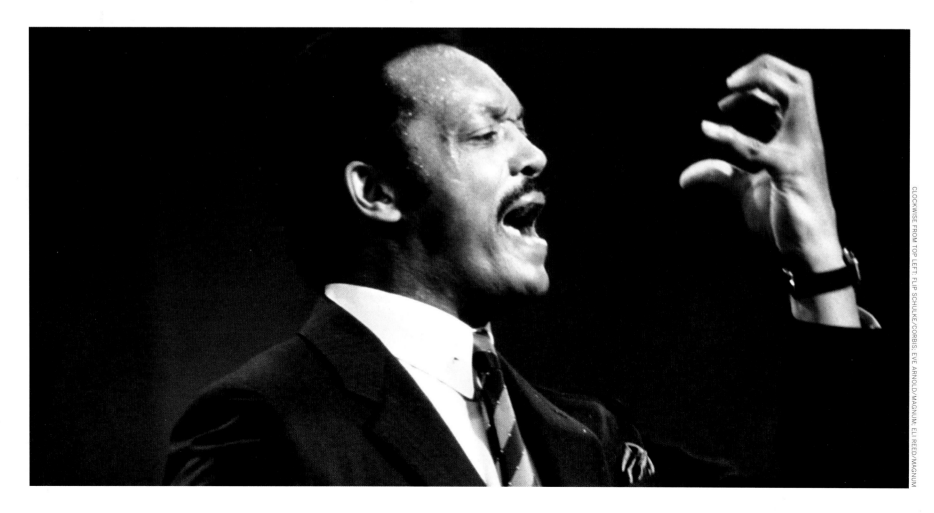

THEY HAD A DREAM

The Reverend King (opposite, top left) fol-lowed on from the Montgomery bus boycott (right), which climaxed in the integration of the service after 381 days, to become a resolute and effective leader of the civil rights movement of the early 1960s. Nineteen sixty-three was a semi-nal year. In Birmingham, Alabama, King and his Southern Christian Leadership Conference put in place their Confrontation project, with racist Police Commissioner Eugene "Bull" Connor and Alabama governor George Wallace as their adver-saries; when violence erupted and fire hoses and police dogs were trained on demonstrators, they turned the nation's attention to the issue at hand. Later that year, during the March on Washington, King would declare: "I have a dream that my four little children will one day live in a nation where they will not be judged by the color of their skin but by the content of their character. I have a dream today!" He would live to see the Civil Rights Act signed in 1964, to be awarded the Nobel Peace Prize that same year and to lead the critical Selma to Montgomery marches of 1965; then, in 1968, he was assassinated in Memphis. Also gunned down during that turbulent time, in 1965, was the black nationalist leader Malcolm X (opposite, top right), one of several—Stokely Carmichael, the comedian/activist Dick Gregory, the radical Black Panthers—who were presenting various strategies, ranging from civil disobedience to bloodshed, for confronting the racist authority. Emerging from the fray were such as the Reverend Jesse Jackson (opposite, bottom, addressing the 1984 Democratic National Convention), who had walked with Martin Luther King Jr. and ran cred-itably for President twice in the 1980s, helping pave the way for Barack Obama.

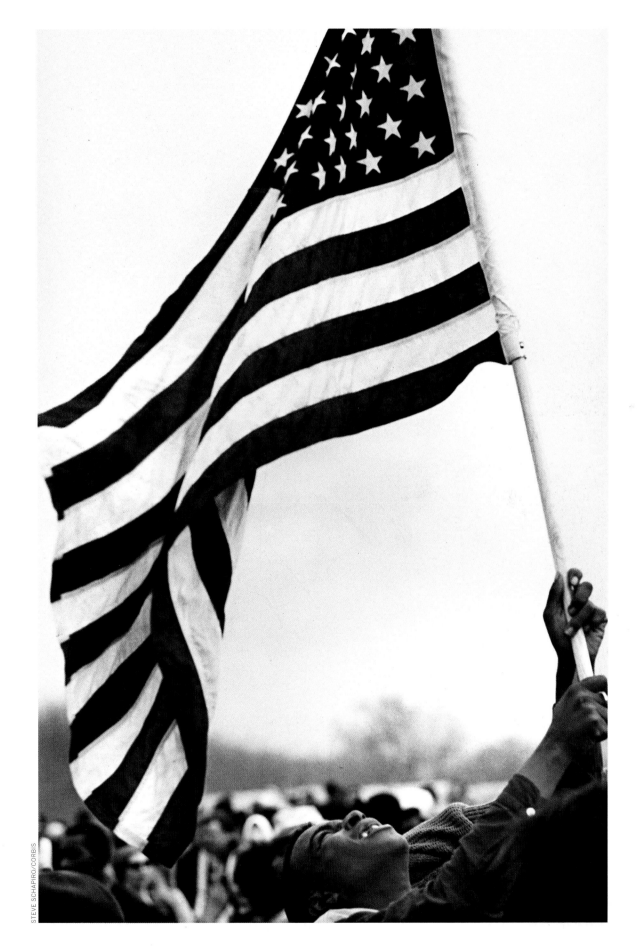

STEVE SCHAPIRO/CORBIS

PEOPLE

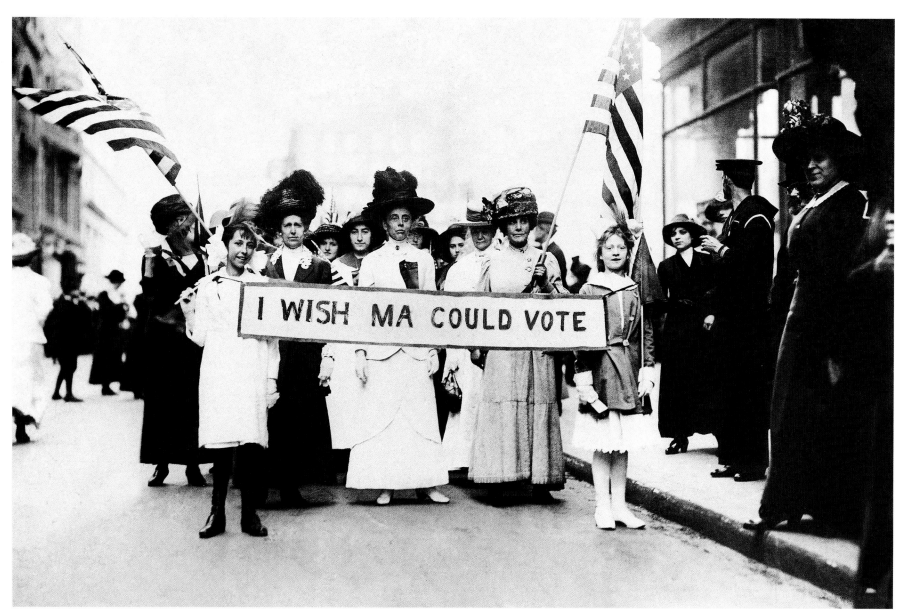

THE WOMEN'S MOVEMENT

It did take some time for women to organize, ask for and then demand equal rights in a land that professed to stand for equality. The first women's rights convention was held in 1848 in Seneca Falls, New York, 59 years after George Washington had been elected President. The "Declaration of Sentiments" that would emerge from that two-day meeting set forth a dozen requests, principal among them voting rights for women. Two years later, the National Women's Rights Convention opened in Worcester, Massachusetts, with more than 1,000 people in attendance. In 1869, both the National Woman Suffrage Association and the American Woman Suffrage Association were formed (they would merge in 1890). Rallies and marches (such as this one, above, in 1917) drew ever larger and more fervent crowds, and territories and states moving eastward from the West—Wyoming, Colorado, Utah, Idaho, Washington, California, Oregon, Kansas, Arizona, Alaska, Illinois, Montana, Nevada, New York—began to pass woman's suffrage laws. In 1896, the National Association of Colored Women was formed, and in 1903, the National Women's Trade Union League was founded and began arguing for improved working conditions and wages. In 1919, the federal woman suffrage amendment, which had in fact been authored way back in 1878 by pioneering activist Susan B. Anthony (whom we will meet on the following pages), was passed by Congress and sent to the states for ratification. In 1920, it became law. But as had been the case with the Thirteenth Amendment and the African American experience, it didn't make everything right. In the years following the First World War, the feminist cause again came to the fore, seeking real as well as legal equality. Women gained seats in the boardroom and in legislatures local, state and national. In 2008, Senator Hillary Clinton of New York mounted a formidable campaign for President (opposite, a rally in New York City after she won her home state's primary on February 5), and today it seems clear that any job in the land is open to women.

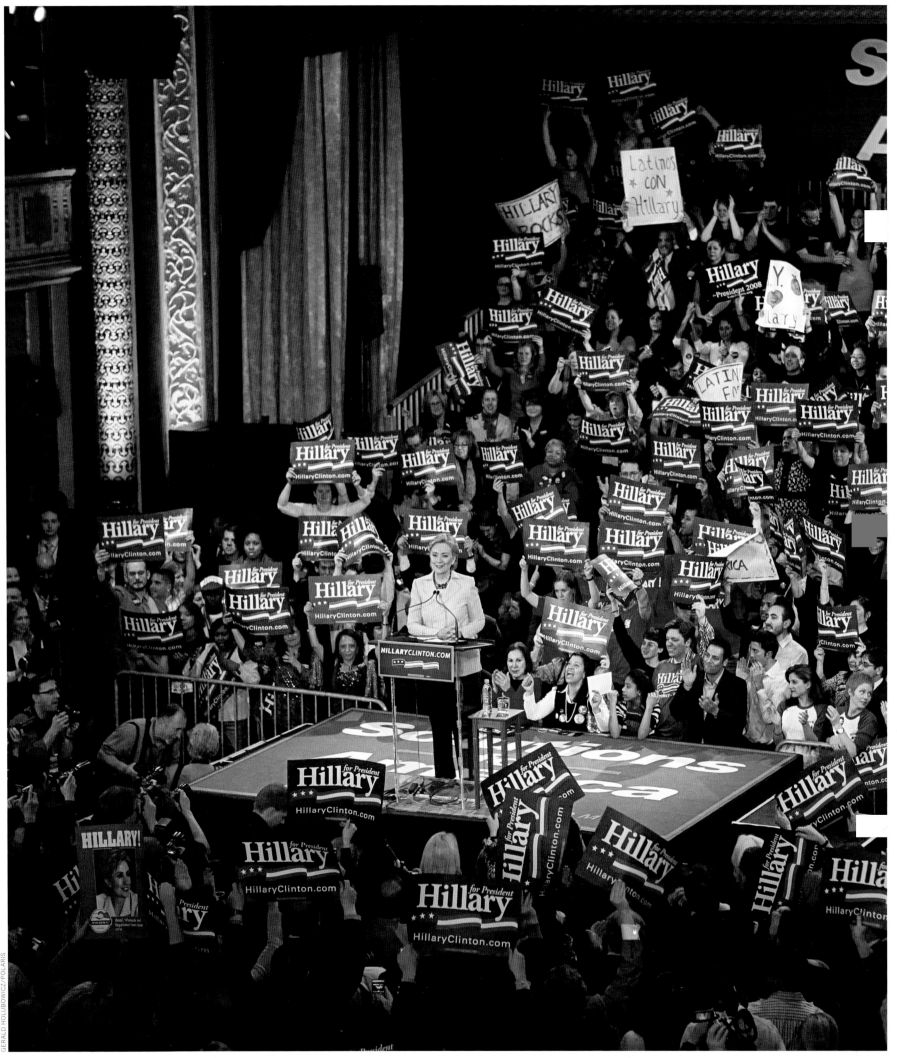

PEOPLE

CHANGING EXPECTATIONS

There has long been a saying in America that has proved stubbornly difficult to remove from the lexicon: "A woman's place is in the home." It has often been taken to say (or meant to imply) that a woman's place is to support her husband, to raise her kids, to feed her family, to suppress her opinions, to willingly sublimate or altogether snuff out her aspirations. A woman's place was not to be carrying signs at suffrage rallies or getting herself arrested for causing a ruckus. In the early days of the republic, the exemplary woman was personified by Dolley Madison (below, left), who served as First Lady for two Presidents and was married to one of them. When the widower Thomas Jefferson tapped James Madison as his Secretary of State in 1801, he also gained Dolley's renowned charm and considerable talents as a hostess in the bargain; she was called on to help receive ladies at the spanking new White House, meanwhile establishing her own social salon at the Madison estate. She presided at the first Inaugural Ball held in Washington, D.C., for her husband, the nation's fourth President, in 1809. "She looked like a Queen," her biographer and contemporary Margaret Bayard Smith wrote. "[I]t would be absolutely impossible for any one to behave with more perfect propriety than she did." Only 42 years later, the writer, abolitionist and women's rights advocate Sojourner Truth (below, right, in 1850), who had been born into slavery in New York state as Isabella Baumfree, would be wildly cheered at the Ohio Women's Rights Convention as she delivered her most famous speech, "Ain't I a Woman?" Also in the mid 19th century, Elizabeth Cady Stanton drafted the "Declaration of Sentiments," alluded to earlier, and was introduced to Susan B. Anthony, who became her friend and colleague in a multifaceted campaign for temperance, the abolition of slavery and woman's suffrage. The two resolute women, pictured on the opposite page circa 1900 with Anthony on the left, would win some battles, and lose some. The nation became better for the fight.

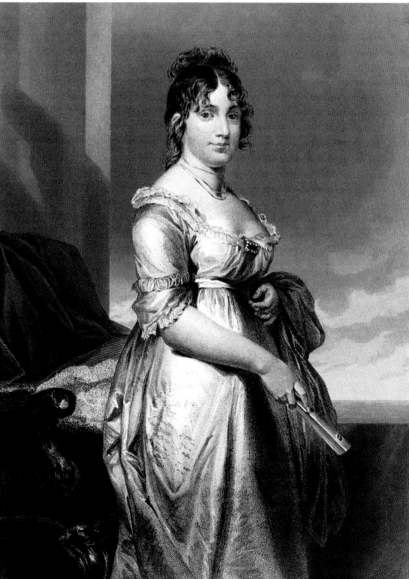

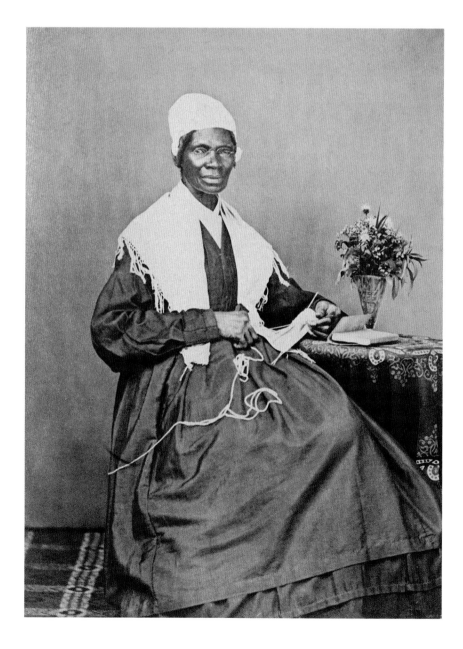

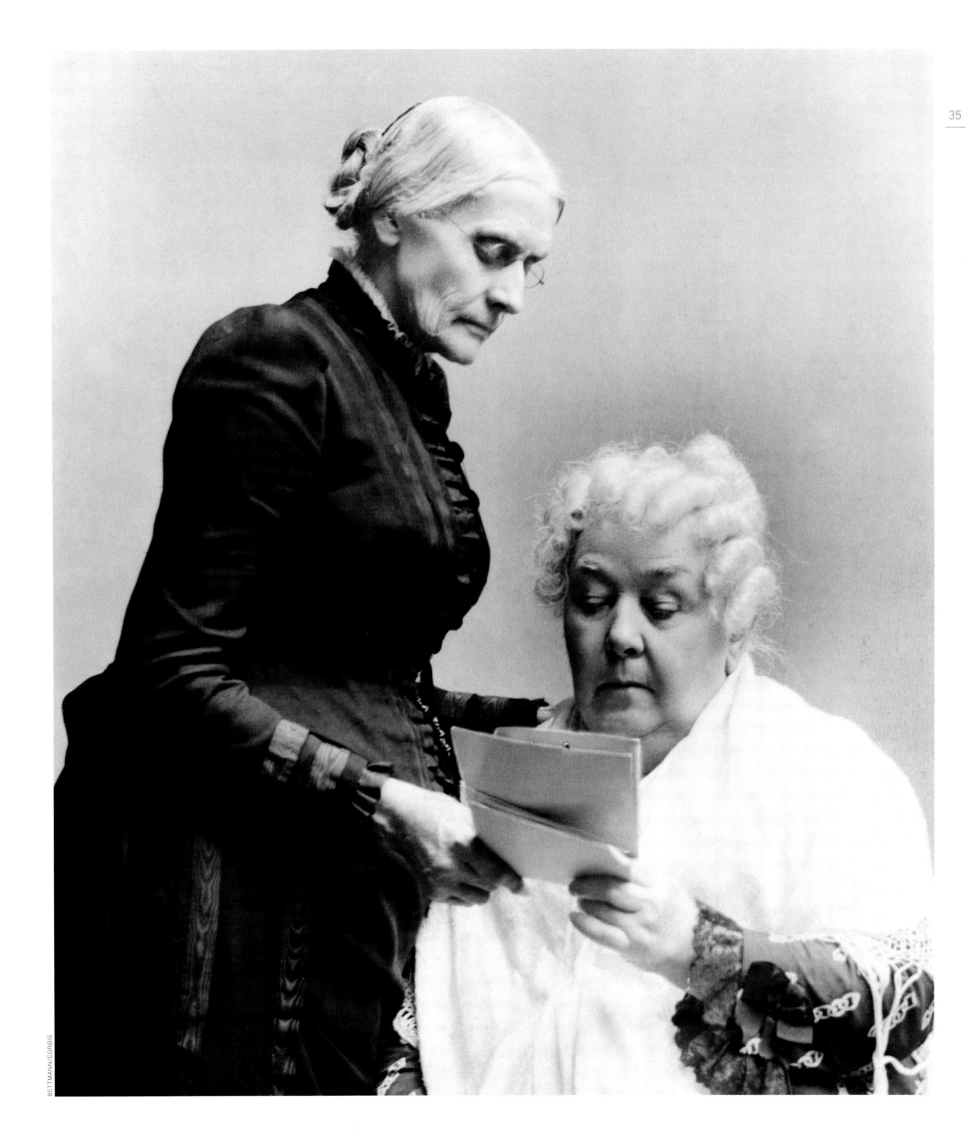

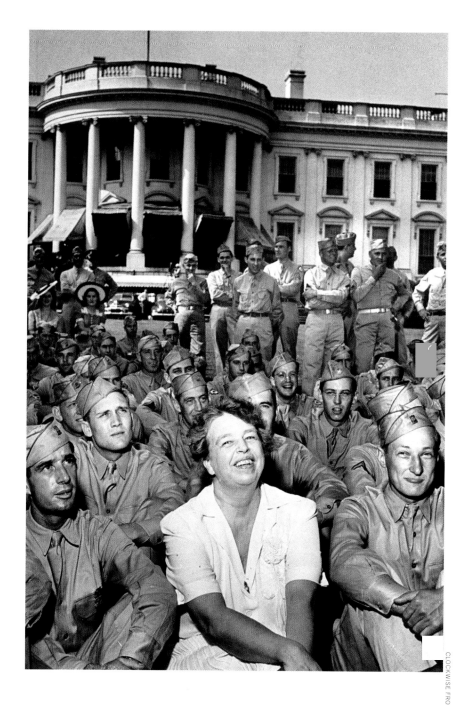

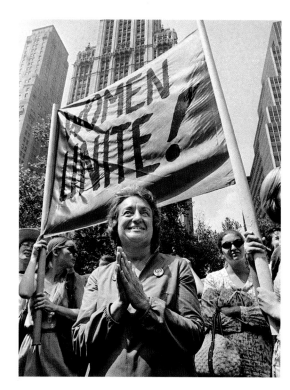

FEMINISM

In the 20th century, it was made clear to all that women in America were capable of anything and everything that men were, and that no job or office should rightly be beyond reach. But this consciousness did not come in an epiphany, it crept in over time, with strong women reminding us every so often that it was so. Opposite, top left: Edith Wilson has been called the "first woman President of the United States" and also, more tellingly, "the secret President." In 1919, her husband, Woodrow Wilson, had a stroke while in office and was paralyzed; from then until his death in 1924, Edith served as his protector, his filter and, some have said, his surrogate. She decided which issues and measures were brought before him and which were dismissed. She oversaw White House protocol, and it is certain that no man was running the country more than she was. In the 1930s, '40s and after, Eleanor Roosevelt (opposite, top right), initially as First Lady and then as a private citizen and champion of causes, could be much more public than Edith Wilson about the power she wielded and the influence she enjoyed. If some of her stature was attributable to her being Franklin's wife, as much of it and more was of her own doing. Opposite, bottom, left to right: Betty Friedan, Gloria Steinem and Shirley Chisholm were solo stars in their own stories and instrumental in launching the "second wave" of the country's women's rights movement in the 1960s. These writers and thinkers and doers (Friedan wrote *The Feminine Mystique* in 1963 and was the first president of the National Organization for Women; Steinem was founding editor of *Ms.* magazine; Chisholm was a seven-term congresswoman from New York from 1969 to 1983) were sometimes criticized, derided and even satirized, but they changed the way we think today. Which is why, in 1981, Sandra Day O'Connor (below) could become the first-ever female jurist on the U.S. Supreme Court, nominated by Ronald Reagan, and why in 2009 Sonya Sotomayor could become the third.

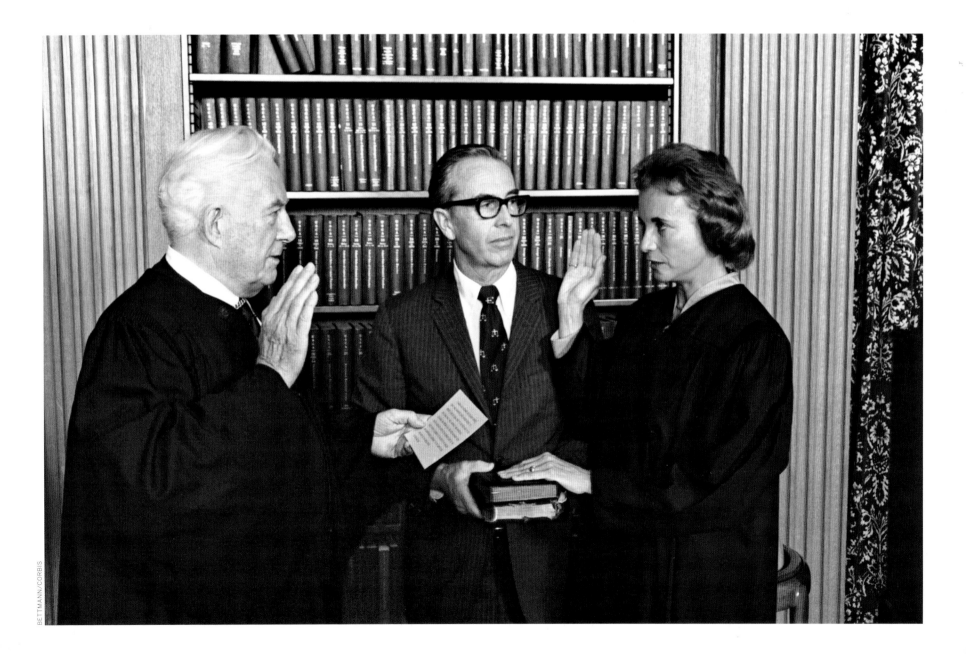

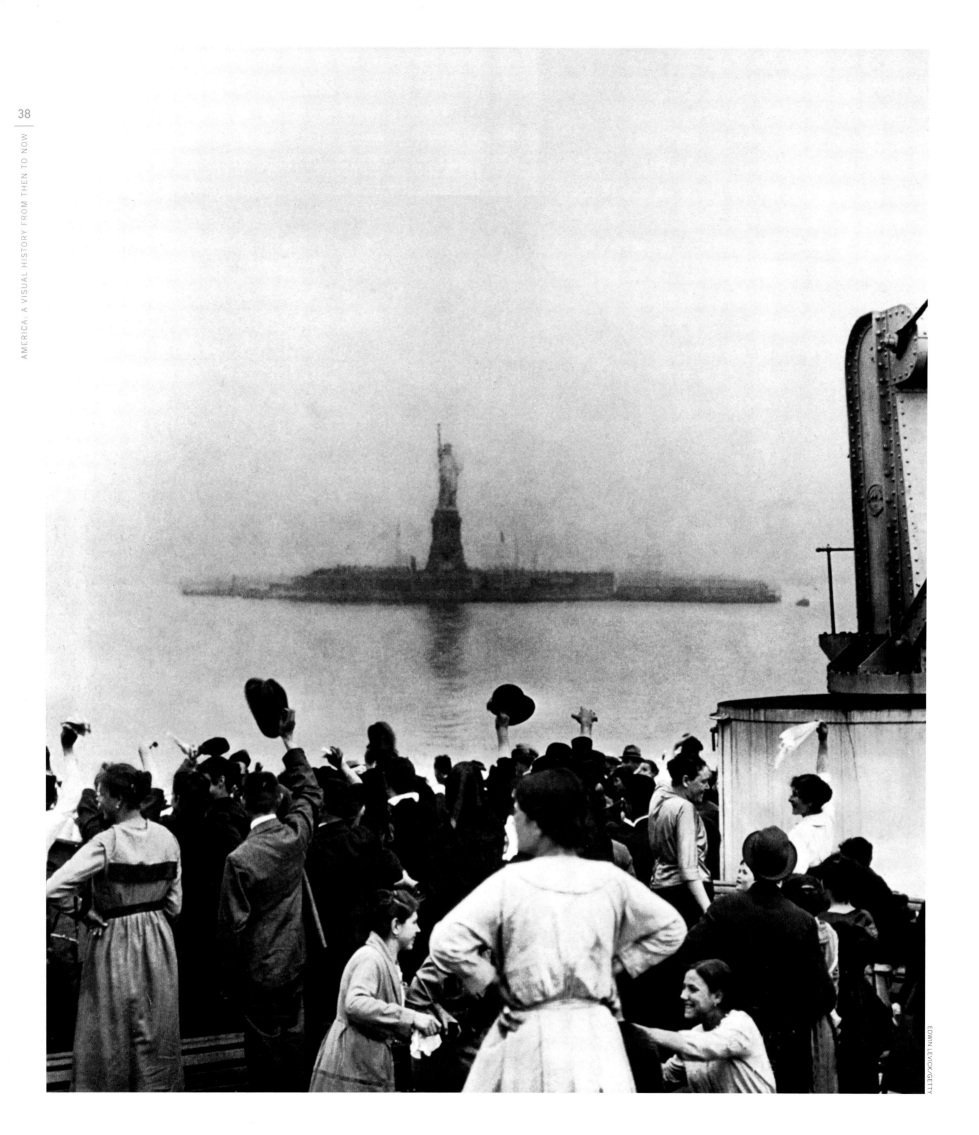

"GIVE ME YOUR TIRED, YOUR POOR . . .

. . . your huddled masses yearning to breathe free." Those are the words of the famous Emma Lazarus plea inscribed on a bronze plaque on the pedestal of the Statue of Liberty. The 19th century poet was seeking to plumb the warm heart of what she called, in the title of her sonnet, "The New Colossus"—that is, the open-armed United States of America. The story of our nation is, at bottom, a story of immigration and assimilation. It is the sometimes difficult, sometimes ugly and occasionally bloodstained story of the Melting Pot. Not long after the American Revolution ended, immigrants from Europe began traveling west, seeking largely what the colonists already had: freedom from religious persecution, cheap property, jobs, opportunity, hope. From 1855, after the height of the Irish potato famine that spurred a massive exodus of refugees from that island, until 1890, the Castle Garden immigration depot at the southern tip of Manhattan island, a state- and city-run facility, processed the huge influx of humanity into New York City, while similar establishments in Boston, Philadelphia and elsewhere performed the same task. On New Year's Day of 1892, the federal inspection and processing center on Ellis Island, in New York Harbor at the mouth of the Hudson River, opened for business (opposite, immigrants heading for the island view the Statue of Liberty in 1915). And what considerable business it was! Irish, Italians, Germans, Russians, Poles—all came through Ellis Island, while out in San Francisco, Chinese, Koreans and Japanese traveling east entered their new country at a similar certification center on Angel Island. The chaos of the early immigration process has settled considerably (although illegal border crossings remain a hot-button issue). Today, the bodybuilder Arnold Schwarzenegger can calmly emigrate from his native Austria, become a world-famous movie star, become a citizen (right, September 16, 1983, with future wife Maria Shriver), and then become governor of the nation's most populous state. Again: only in America.

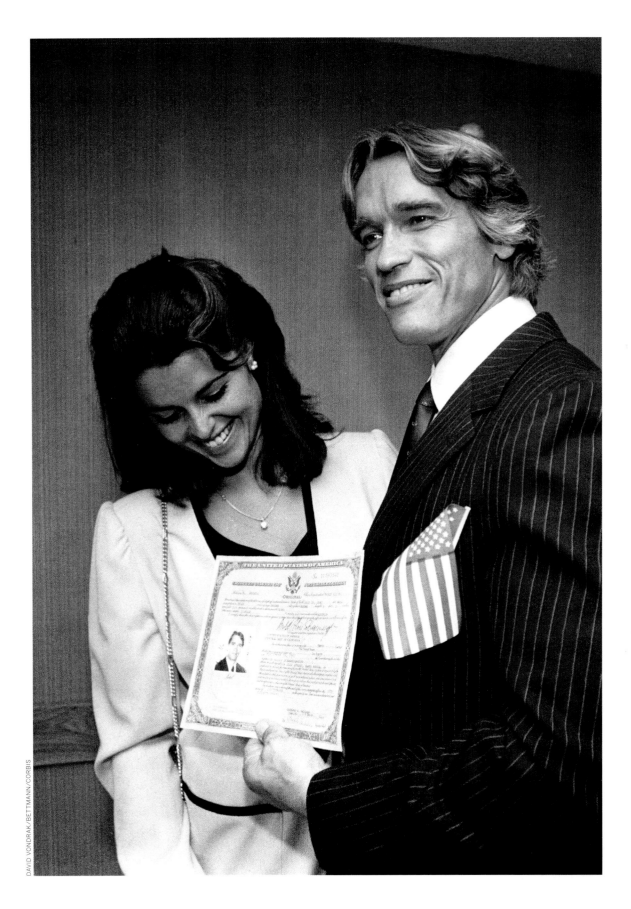

PEOPLE

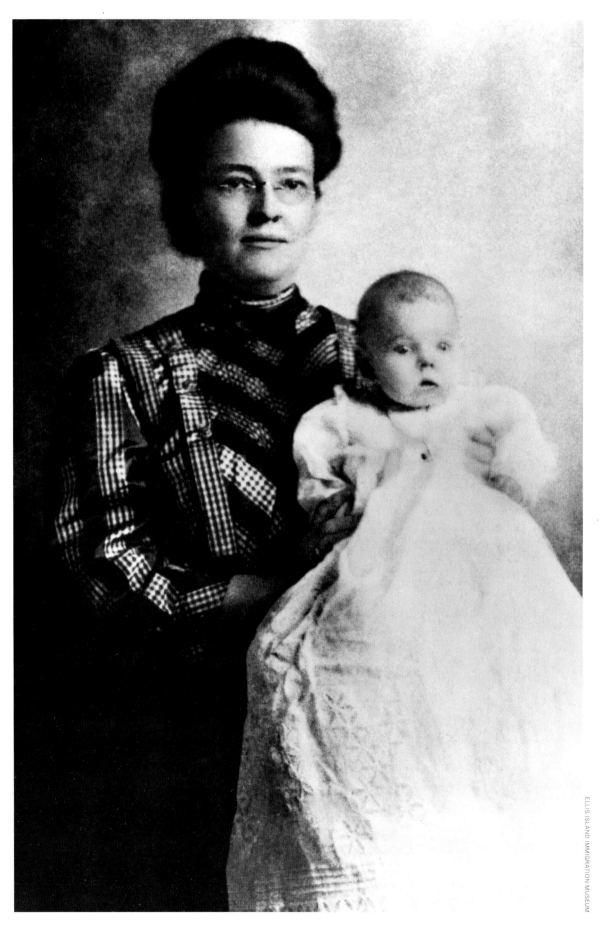

AMERICANS, FOREMOST

We are the sum of our parts—which is to say, our people—and some of the best of them came from elsewhere. Of the famous folks pictured here, one is technically not an immigrant: Marie-Joseph Paul Yves-Roch Gilbert du Motier, Marquis de La Fayette (opposite, top left), who as "Lafayette" has had dozens of American towns, streets, institutions and buildings named after him. This is for good reason. The French aristocrat was a brilliant and brave general serving under George Washington (who became his lifelong friend; the Frenchman named his son George Washington Lafayette), was as great a hero as any during the American Revolution, and was the first official "honorary citizen" of the U.S. La Fayette is buried in his homeland under soil brought from Bunker Hill, the famous battle site near Boston. Not long after the Revolution, John Jacob Astor (top center), a flutemaker from Germany, immigrated and built a fur-trading business, later speculating in New York City real estate; he died in 1848 the richest person in the country, and in today's dollars he would still be considered the fourth wealthiest ever. Even wealthier, though no John D. Rockefeller, was Andrew Carnegie (top right), born in Scotland in 1835 and brought to America as a child by his parents. Carnegie was a robber baron, building an immense fortune in the steel industry, and like Astor, he was a patron of the arts and a philanthropist. John James Audubon (center row) was born in Haiti in 1785 to a Creole woman and a French naval lieutenant, Jean Audubon. He became a famous painter, and his *Birds of America* is among the very greatest of his adopted land's cultural achievements. Another lover of nature was John Muir (bottom), who was born in Scotland in 1838 and immigrated to America with his family 11 years later. He grew to become one of his new homeland's first, most influential and altogether greatest naturalists, and is credited with saving much extraordinary wilderness, including Yosemite Valley (seen here, Gates of the Valley), in his beloved California. Finally, we meet the Irish immigrant Annie Moore, seen on this page in 1910 with daughter Mary Catherine. As a girl of 15 in 1892, Moore had been the first person to pass through the Ellis Island processing station.

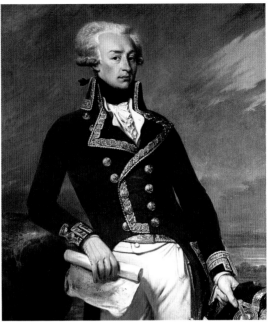

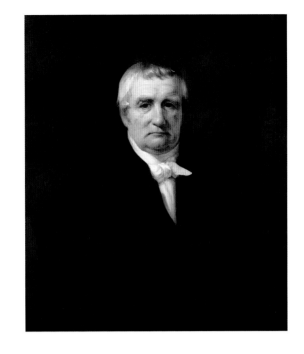

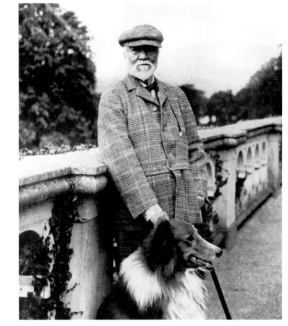

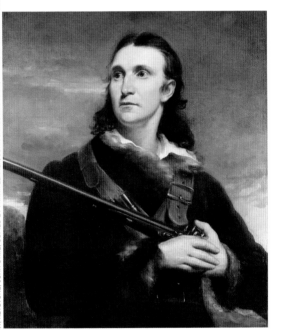

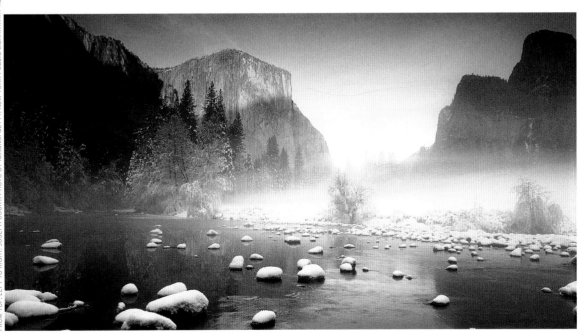

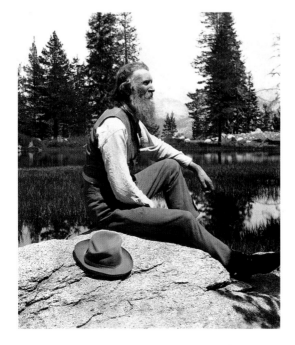

41

PEOPLE

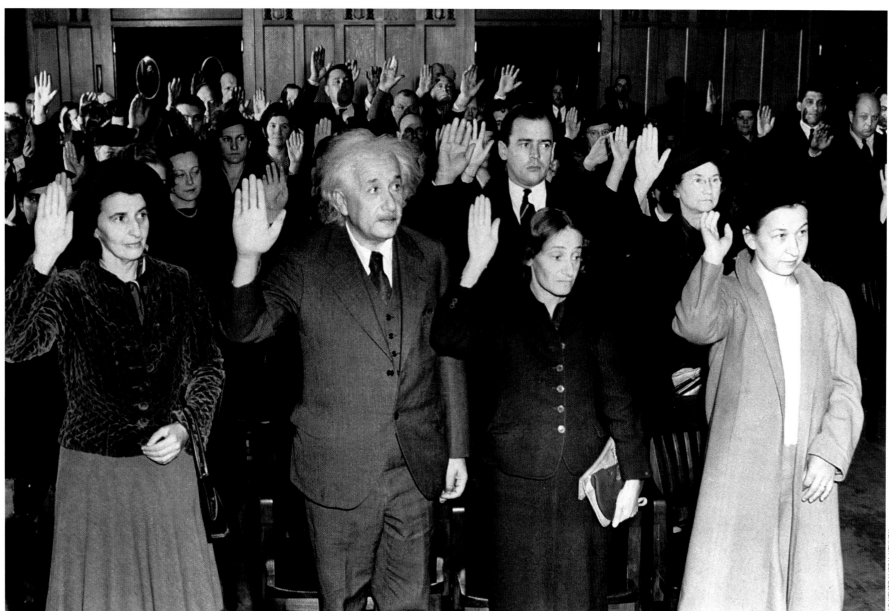

WERNER WOLFF/BLACK STAR

PART OF "THE AMERICAN CENTURY"

Henry Luce so dubbed the 20th century, and his argument wasn't specious. As a critical component on the winning side of two world wars and a major player in the global economy, as well as a leader in advances in technology, culture and social reform, America was nonpareil. The people on these pages played a part: Jewish immigrants from Eastern Europe included Irving Berlin from Russia (opposite, top left), who wrote classics of the American Songbook, such as "God Bless America"; Samuel Goldwyn from Poland (top center), who made a fortune as a Hollywood producer (as did Russian-born Louis B. Mayer and Jack Warner, born in Canada to Polish immigrants). Albert Einstein, who had renounced his German citizenship, took the U.S. oath in 1940 (above) along with his stepdaughter Margot (to his left) and his secretary, Helen Dukas (to his right). As a scientist, Einstein changed our understanding of the universe; as a pacifist and a proponent of social justice, he spoke for understanding among peoples. America proved an ideal haven for him, and he once wrote, "Everything that is really great and inspiring is created by the individual who can labor in freedom." Certainly sharing that sentiment were his fellow deep thinkers Enrico Fermi (opposite, top right), who arrived from Italy in 1938 and directed tests that led to the first controlled nuclear chain reactions, and Wernher von Braun (center left), who came from Germany after World War II and helped ignite America's effort in the space race. Comedian, movie star and friend of a million servicemen Bob Hope (center) was British-born but became true red-white-and-blue, as did movie star Cary Grant (center right). Bottom row: Martina Navratilova was from Czechoslovakia but won most of her record number of tennis titles as an American, and the cellist Yo-Yo Ma, of Chinese descent, was born in Paris but also calls the U.S. his home.

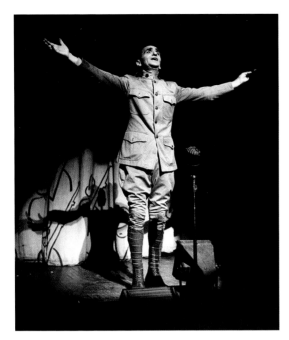

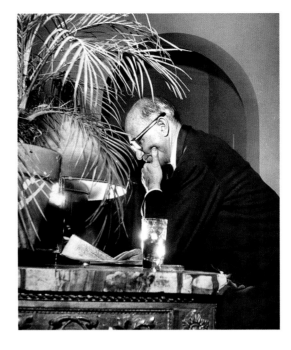

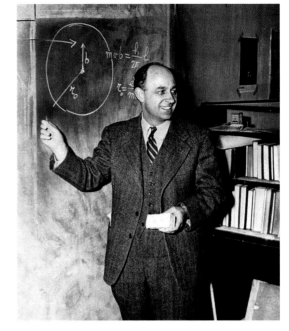

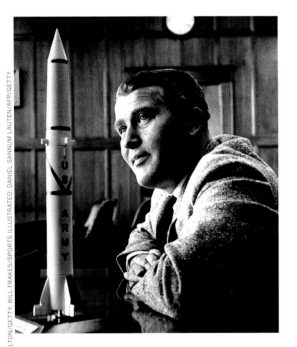

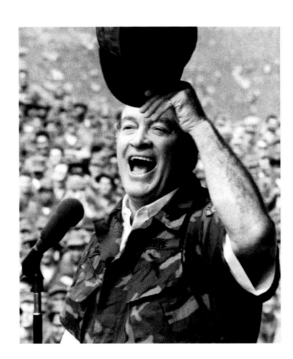

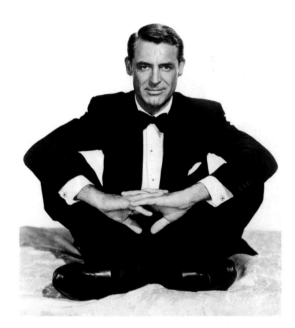

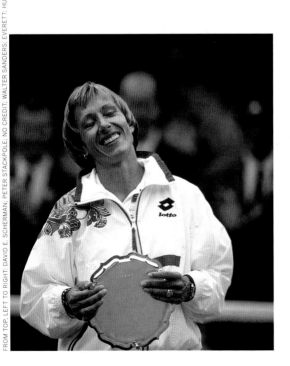

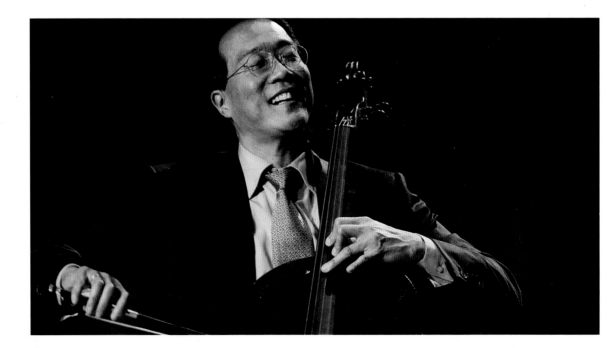

PEOPLE

THE LITERARY LIFE

Ancient Native Americans etched stories on the walls of their dwellings, early narratives in this land's saga. But as our new world of the United States grew in confidence and power, we developed our own distinctly flavored literature. This began, as did so many things, with one of our Founding Fathers. Much of how we feel about ourselves was born in late–18th century Philadelphia, where the titan of the intelligentsia was Benjamin Franklin. The journalism he practiced greatly entertained his fellow colonials; his *Poor Richard's Almanack* was the *USA Today* of its time. In his *Art of Virtue Journal*, he assessed his daily behavior in areas he considered key to a successful life: temperance, resolution, frugality, etc. Franklin's *Autobiography*, a page of which is seen here, is infused throughout by lessons laid down in the journal, and its ideas about self-reliance, hard work and independent thinking have colored the American sense of self since its publication in 1791. There were writers of fiction in Philly as well, even if they are largely forgotten today; they, too, were attempting to write in a new way for a new nation. The novelist Charles Brockden Brown crafted florid melodramas, but with a twist. The critic Van Wyck Brooks, while acknowledging Brown's relative and pretty much deserved anonymity, wrote in *Our Literary Heritage:* "He added a third dimension to the Gothic novel. Analyzing human emotions … he further explored the inner world of man. He was a precursor, in more than one respect, of Poe, Melville, Hawthorne and Henry James. Brown represented the native American wild stock that produced these splendid blossoms in the course of time." The wild stock that produced those earlier blossoms would later animate the writings of Mark Twain and Willa Cather and Ernest Hemingway and Richard Wright and Carson McCullers and Jack Kerouac and Philip Roth and … the wild stock that today inspires the old and young to strut their stuff at poetry slams, such as the one on Manhattan's Bowery, where scorers can be generous or rough (opposite, top), or the one at Bean Town Coffee in Sierra Madre, California (bottom), where the audience is rapt as third-grader Noah Eriksson versifies. Franklin, who so valued words, would be proud.

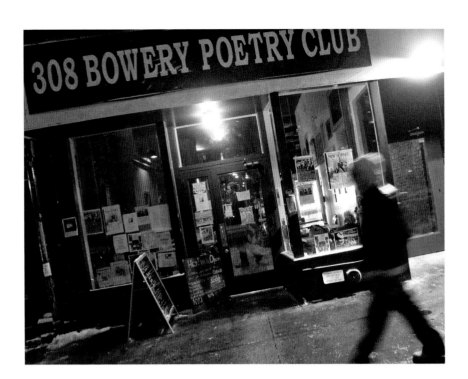

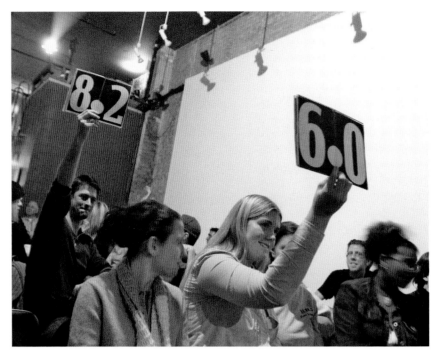

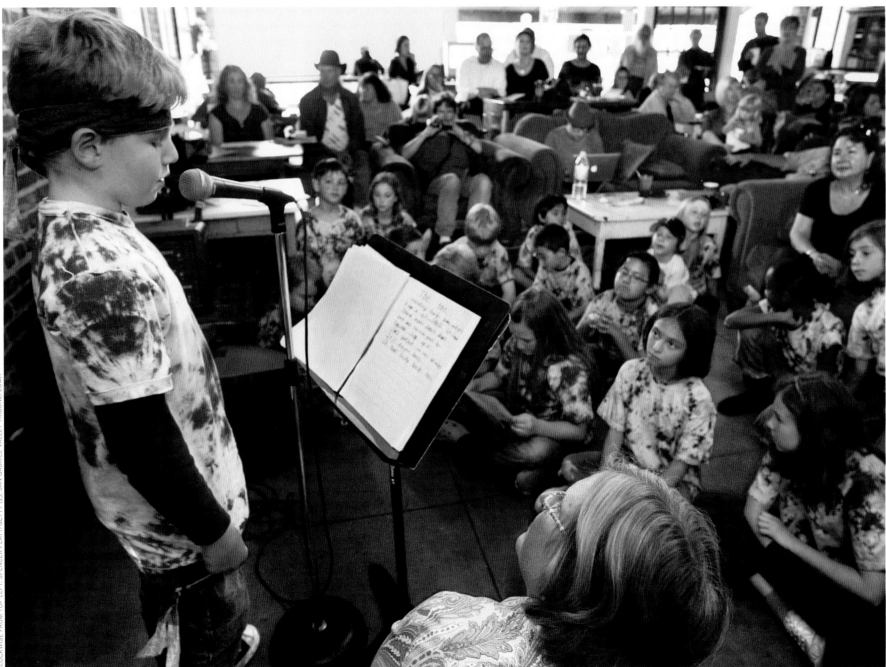

PEOPLE

PIONEERS OF THE AMERICAN PEN

One of the first American poets of note was, remarkably enough, a young woman who had been kidnapped as a girl in Africa in 1761 and taken to North America as a slave. Called "Phillis," she was sold to a Boston merchant, John Wheatley, who made sure to provide for her education. When *Poems on Various Subjects, Religious and Moral,* by Phillis Wheatley (below, left), was published in 1773, one of the New World's first literary sensations was launched. Wheatley, having been granted her freedom, toured England at one point. But it is Washington Irving (right) who is regarded as America's first internationally famous writer (excepting political luminaries such as Franklin and Jefferson). In the most famous of his many successful works, *The Sketch Book of Geoffrey Crayon, Gent.,* published in 1820, he not only created enduring American myths such as "Rip Van Winkle" and "The Legend of Sleepy Hollow" but reported back to his countrymen of his travels in England; many of our notions of a "traditional" Christmas, for instance, were first sketched by Irving, who had enjoyed the holiday at a manor house in the English countryside. Irving, eloquent as he was, was an entertainer; the writers who emerged in Massachusetts later in the century had something else on their minds. Opposite, top, from left: Ralph Waldo Emerson challenged his readers to think about their place in the world; his friend Henry David Thoreau forwarded radical notions concerning nature that became part of the American debate; Nathaniel Hawthorne created fictions of such moral depth that they would live forever. Also in Massachusetts were two women doing brave new work: Louisa May Alcott, who spoke to younger readers with her novel *Little Women,* and the poet Emily Dickinson (middle row, left), whose daring verse was published only after her death in 1886. Walt Whitman (center) essentially exploded classical notions of what poetry was, meantime presenting a vibrant new vision of America. Harriet Beecher Stowe (middle row, right) addressed the question of slavery and showed, as Charles Dickens had in London, the extent to which popular fiction could affect the social debate. Bottom left and center: Herman Melville wrote monumental novels, but his masterpiece, *Moby Dick,* was not well received by the public, while Mark Twain was celebrated as an American original for his often humorous and beguilingly profound fictions. In the writings of such as Henry James and his dear friend Edith Wharton (bottom right), we see an America looking back whence many of us came—England and Europe—and to where we were headed. Here we enter the 20th century, and Americanism becomes very much its own, confident thing.

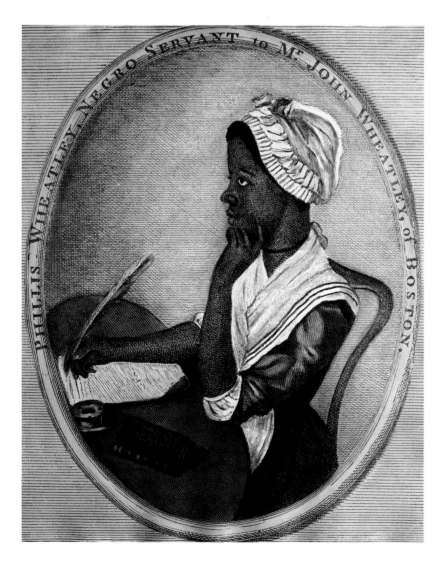

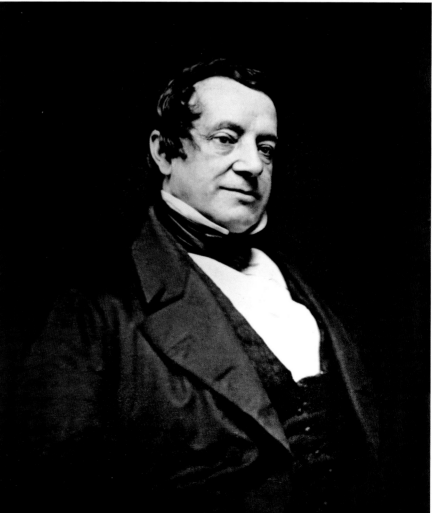

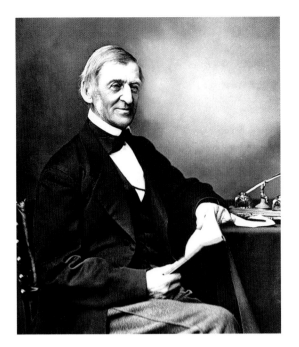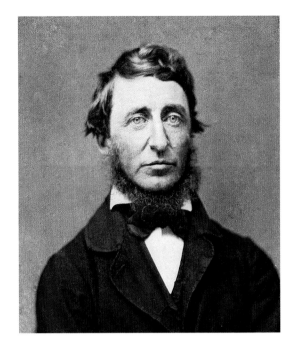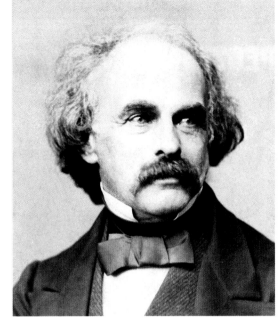

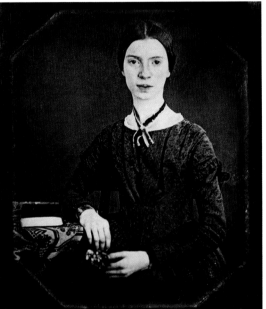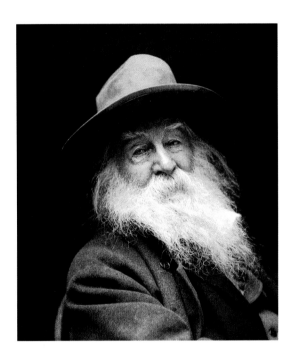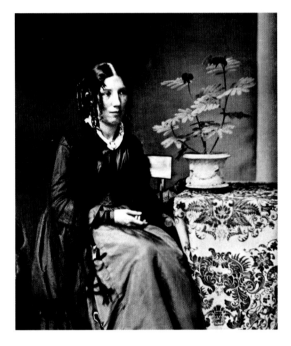

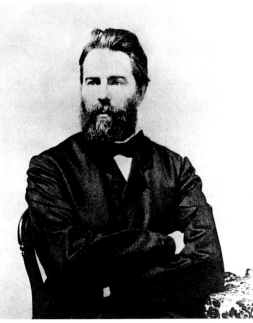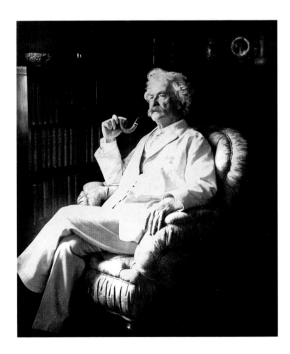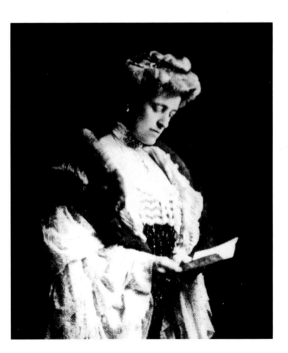

PEOPLE

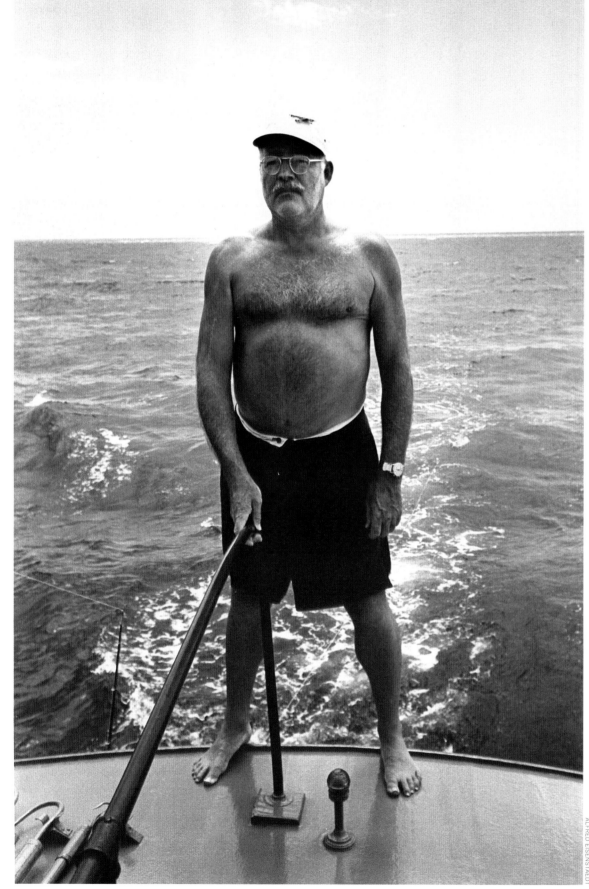

ALFRED EISENSTAEDT

NO HOLDS BARRED

In the American Century, writers clearly felt emboldened to test (or ignore) boundaries. Of course, experimentalism and the avant garde were hardly American inventions, and few were more influential or more *out there* than James Joyce and Samuel Beckett, Jean-Paul Sartre and André Gide and Franz Kafka, not to mention writers such as Gabriel García Márquez and the poet Pablo Neruda playing with surrealism. But the "wild stock" that Brooks wrote of was still evident in the United States, and writers, poets and playwrights conspired to forge in the smithy of their collective soul the uncreated conscience of their race. T.S. Eliot, born in St. Louis in 1888, moved to England at age 25 but said of his earth-shaking poetry: "[I]n its emotional springs, it comes from America." Others who, like Eliot and the Irishman Joyce, went away to write about their homeland included Lost Generation icons F. Scott Fitzgerald and Ernest Hemingway (left). Staying home and capturing the moral complexities of the American South were William Faulkner and Flannery O'Connor (opposite, top row, left). The poet Robert Frost (center) examined his native New England minutely, and found the universal. The harrowing plays of Eugene O'Neill (right) stunned American audiences in the same way Beckett was stunning Paris and Dublin. Poetry was so up for grabs in the land of Whitman that we had Langston Hughes (center row, left) singing of the black experience, Sylvia Plath (center) expressing a woman's pain and passions in a very personal mode that extended from Emily Dickinson, and Allen Ginsberg, a true son of Whitman, howling at the moon. Ginsberg's Beat Generation confrere, Jack Kerouac (right, in a photograph taken by Ginsberg circa 1953) tried in his experimental novels to capture America's promise and its loss. John Updike (bottom row, left), his friend John Cheever, Raymond Carver and others wrote of the triumphs and travails of the postwar United States, a people struggling to do what was right and only sometimes succeeding. Alice Walker (center), Toni Morrison and Maya Angelou are three women who have movingly commented on societal inequalities. Michael Chabon, Dave Eggers (right) and the late David Foster Wallace speak for newer generations, and the wild stock remains in force.

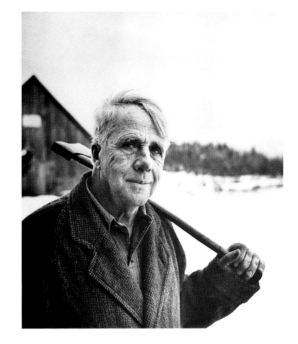

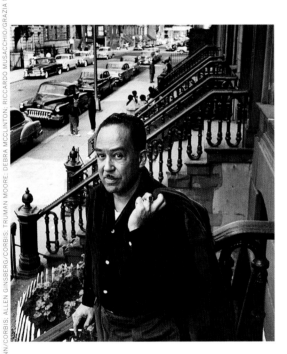
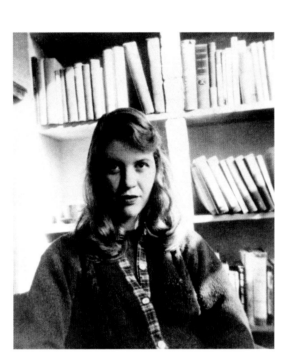
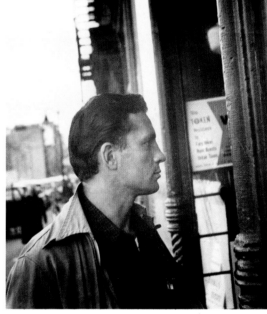
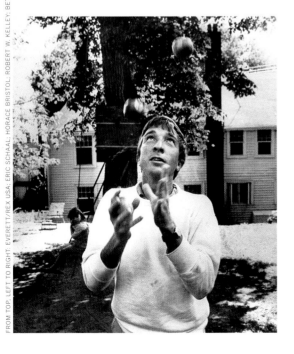
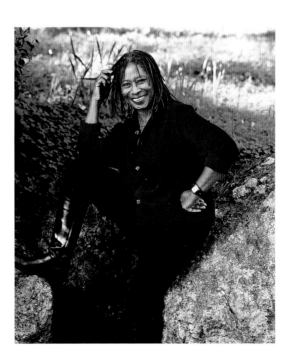
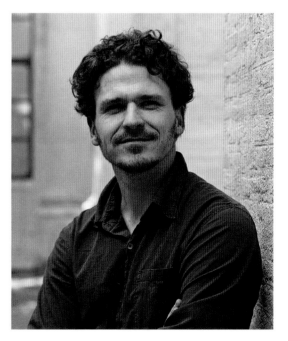

PEOPLE

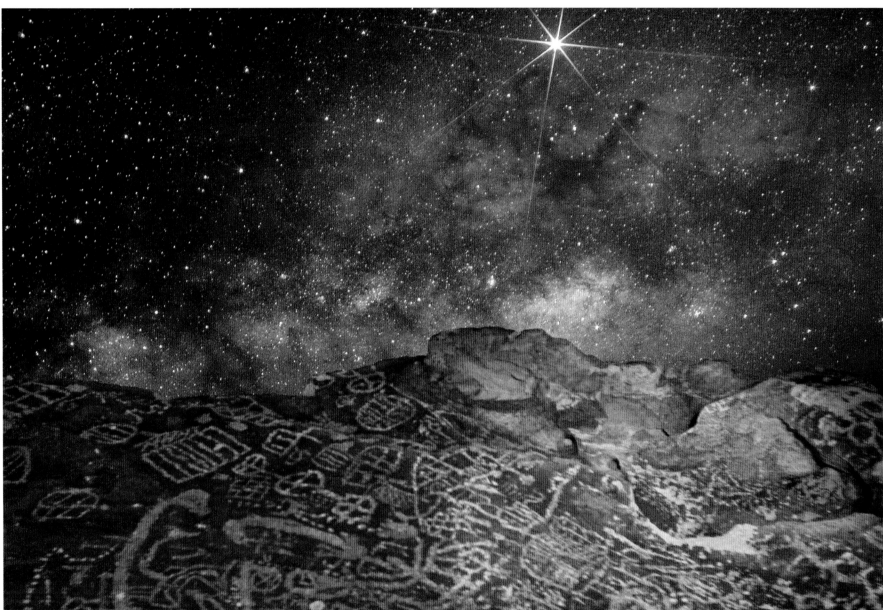

WALLY PACHOLKA

THE AMERICAN ARTIST

It might appear that the journey from the petroglyphs of an anonymous forebear of the Paiute Indians in Chidago Canyon near Bishop, California (above), to the subterranean graffiti of the late Keith Haring, who posed in his New York studio circa 1988 (opposite), is a short one. Nothing could be further from the truth. In creating his disarmingly stark and seemingly simplistic street art and finding resonance and humor therein, Haring was standing on the shoulders of giants: generations of American artists who had begun in emulation of the European masters and proceeded to continually challenge and sometimes refute standard ideas of "Is it art?" As a relatively new country and culture, 19th century America was not necessarily at the vanguard of the early seismic shifts; for instance, the Impressionistic movement was led by Europeans, and certainly Picasso more than anyone embodied what modernism meant in the first half of the 20th century as he incorporated any number of different approaches in his always evolving painting. But as with other aspects of society and culture, in the mid 20th century and particularly in the postwar years, the American art scene was, as they say, where it was at. The immigrant Mark Rothko . . . Jasper Johns . . . Andy Warhol. You can say whatever you like about Abstract Expressionism, Pop Art or any other modern movement—and all of it has been said before, in spades—but these artists represented forces to be reckoned with. By the time Haring began his guerrilla art in New York City's public spaces in the late 1970s, no rules remained; the individual, and his or her relationship with the viewer, was all. In a way, the modern American artist was faced with the same parameters as the ancient Paiute forebear had been: a wall, an implement to draw with, whatever talent and imagination the painter possessed, and whatever tale he or she wanted to tell.

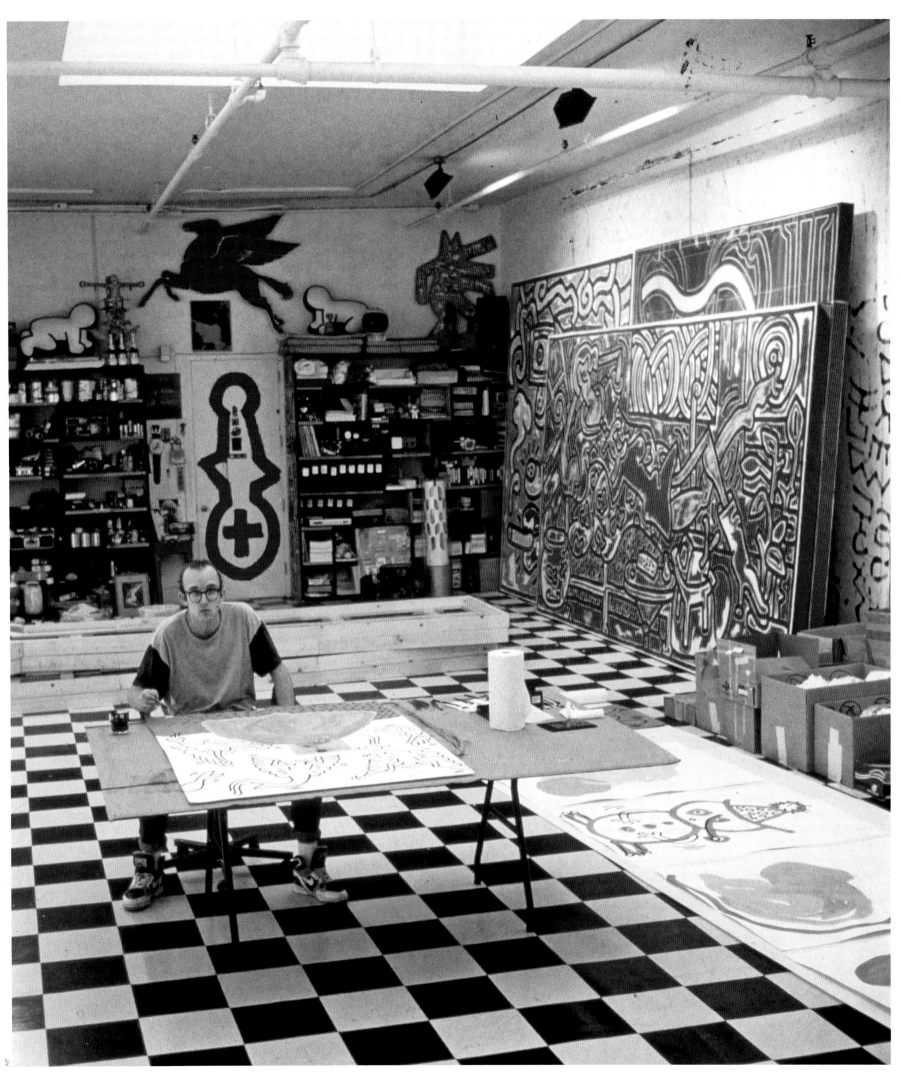

PEOPLE

IN THE TRADITION BUT WITH NEW SUBJECTS

Gilbert Stuart (far right) was a Rhode Islander born in 1755 who first found success as a portraitist in England even as the Revolutionary War was raging back home. We raise this as a point of irony, considering how many famous American patriots Stuart would eventually render on canvas. He was very much of the traditional school, with a talent for naturalness. Upon returning to his homeland and setting up shop first in New York City and later in Boston, he became the artist of choice for what amounted to, in a democratic land, the new nation's aristocracy. He was prolific, making portraits of more than 1,000 individuals, including each of the first six Presidents (and, opposite, the statesman and Revolutionary War hero Aaron Burr). In 1796, he began yet another of his paintings of George Washington, and it was going particularly well when he left it unfinished. He employed this canvas thenceforward as source material for dozens of copies that he and his daughter would craft, each reproduction selling for $100. The painting, known as "The Ath-

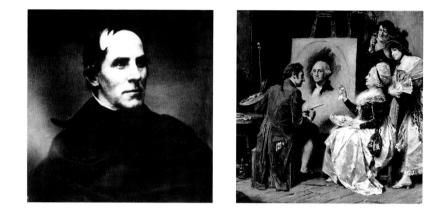

enaeum," was the basis for the image on the one-dollar bill. Roughly speaking, what Stuart was to American portraiture Thomas Cole (above, left) was to American landscape painting. Born in England in 1801, Cole immigrated to the United States with his family when he was still a teen. He took up painting and was focusing on landscapes by the time he landed in New York City in 1825. Finding beauty upstate, he became the founder of what was called the Hudson River School, one of the country's first art "movements." Cole depicted an America full of wonder and hope, ready for discovery and exploration (below, "The Pic-Nic," painted in 1846). His was a romantic view, and if the paintings show the clear influence of such English artists as J.M.W. Turner and John Constable, their message reflects a view of nature shared, back then, with New England's transcendentalist writers. Old-school techniques, new visions.

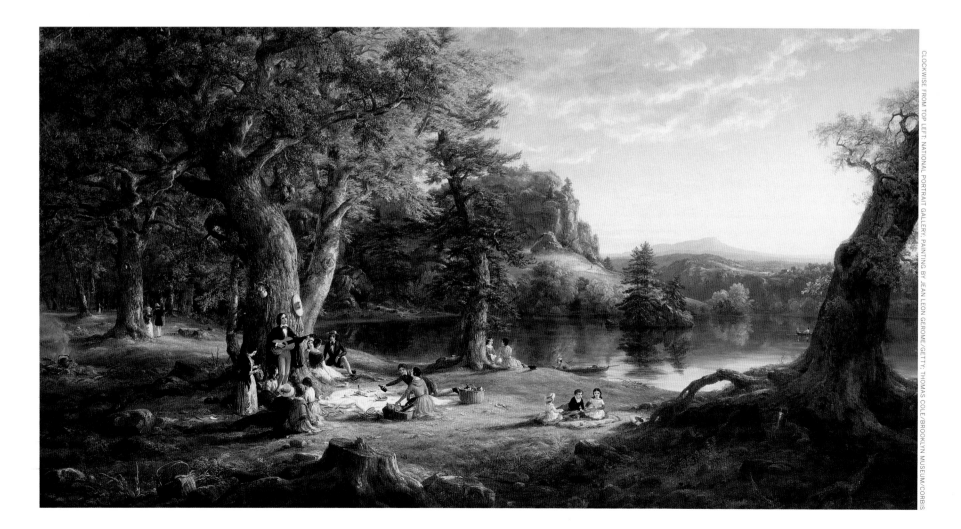

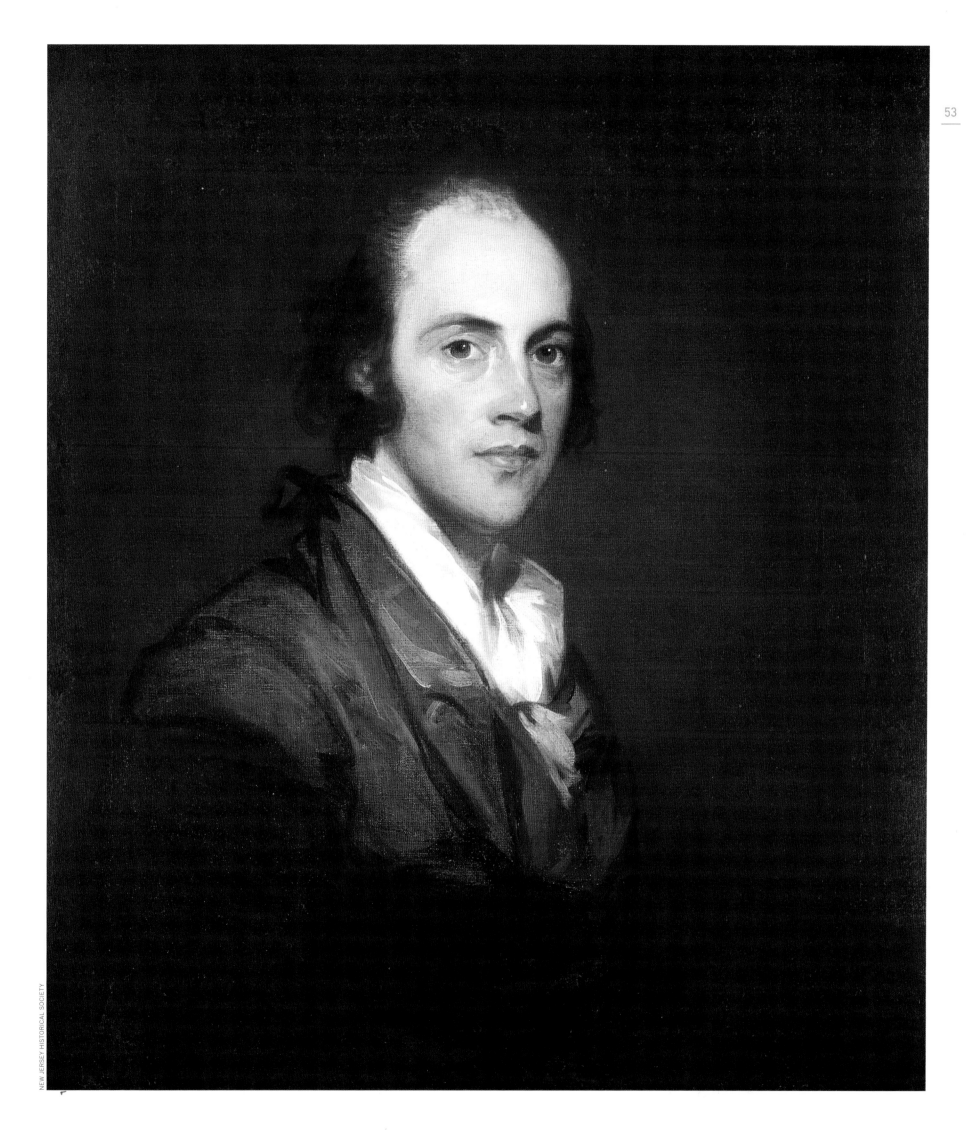

PEOPLE

STANDING ON THEIR OWN

Mary Cassatt was born in Pennsylvania in 1844 and determined early to be an artist; she moved to Paris in 1866 and would spend most of the rest of her life in France. She was, at first, a traditionalist; her paintings were in the Romantic style. But things were about to explode with the Impressionists, and Cassatt was invited into the club by Edgar Degas, whose art, she said, "changed my life." (Below, Cassatt is seen in a portrait by Degas; her own "Young Mother Sewing," from 1902, is at right). In the mature period of her career, she identified herself with no movement and created works hard to categorize beyond an appreciation of their strength and originality. Another of Cassatt's countrymen who had a presence in Paris and an association with the Impressionists, the Bostonian Childe Hassam, made a telling remark after exhibiting at the Exposition Universale of 1889 in Paris:

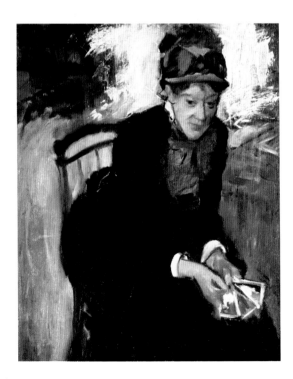

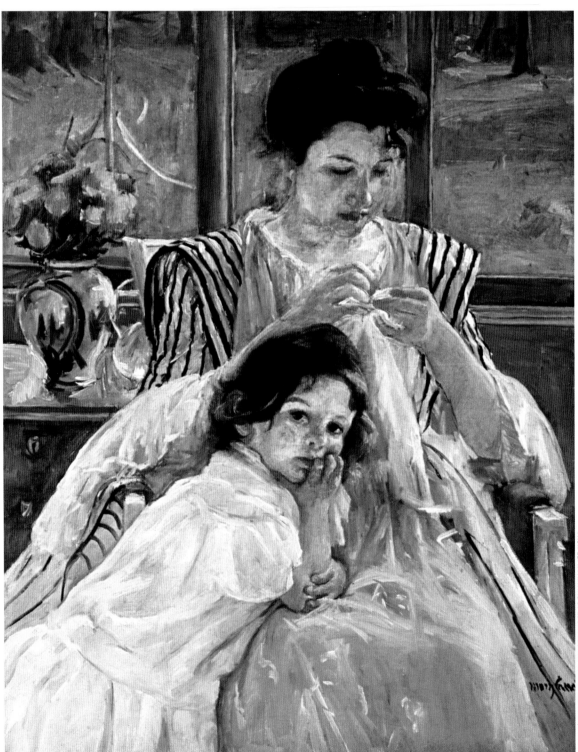

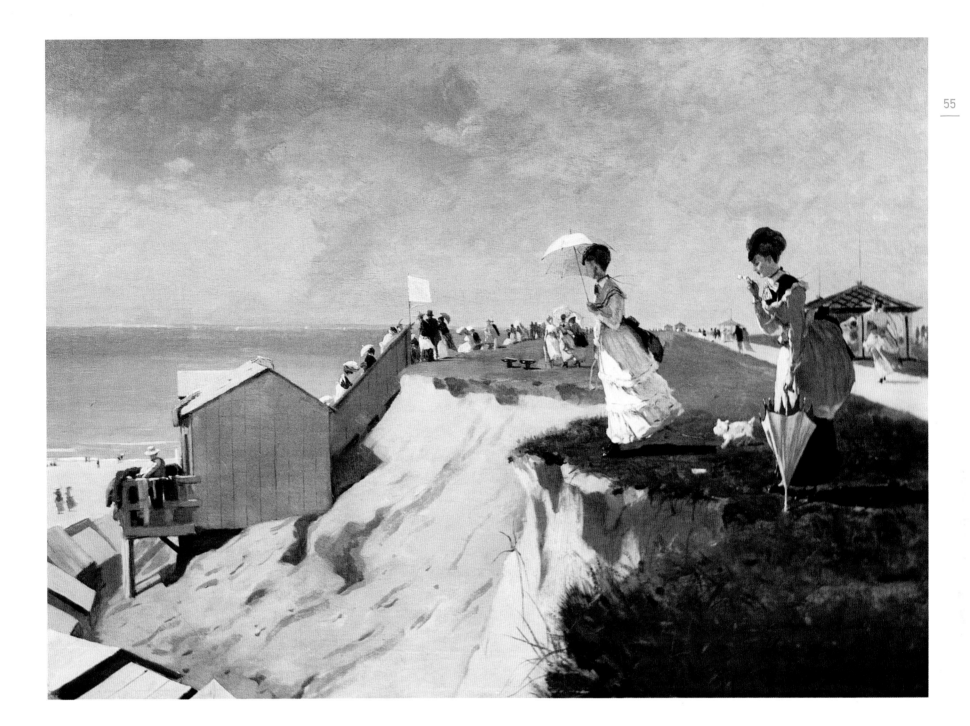

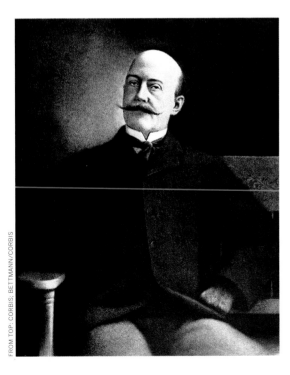

"The American Section . . . has convinced me for ever of the capability of Americans to claim a school. [George] Inness, [James McNeill] Whistler, [John Singer] Sargent and plenty of Americans are just as well able to cope in their own chosen line with anything done over here." This was a new boldness, to be sure, and it led in the 20th century to the Precisionists; the Ashcan School; the stunning imagery from the Southwest of Georgia O'Keeffe; the Harlem Renaissance; the social realism of Thomas Hart Benton's paintings; finally, in the postwar years, to the rise of Abstract Expressionism—a term first floated in Europe well before the war but now ascribed to an American art form that was, at long last, assuming primacy of place in the global art community. It would take some time for critics and, indeed, the artists themselves to be able to claim with confidence that American painting was truly world-class, and this time came in the second half of the 19th century. Winslow Homer (left) was born in Boston in 1836 and became a largely self-taught painter, seeking realism in works done in a variety of media from wood engravings to oils to watercolors. After an early career as an illustrator (he covered the Civil War from the front lines for *Harper's*), he dedicated himself fully to painting and drew immediate praise. His catholic range of subject matter (seen above is "Long Branch, New Jersey," from 1869) and modes of expression seemed to reflect the American art scene generally—always trying things, seeking to find itself, hoping for respect. The portraits that were being produced by Sargent and Whistler were suddenly, as Hassam's report from Paris implies, being spoken of in the same breath as those of European masters, and when new styles and attitudes came to the fore, there were now Americans talented enough to join a movement without looking like mere camp followers.

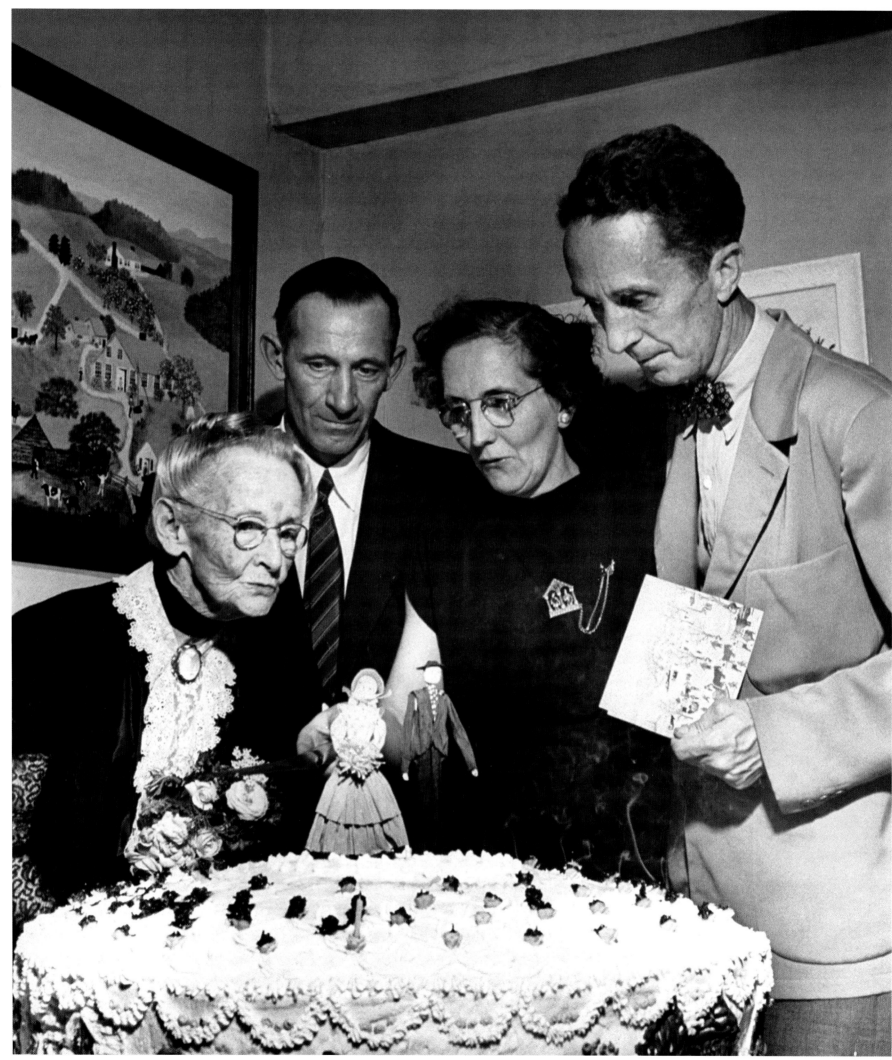

ANY AND EVERYTHING

Descending from Winslow Homer and Philadelphia artist Thomas Eakins were N.C. Wyeth; two subsequent Wyeths, Andrew and Jamie; and, it can be said, Norman Rockwell, who because of his often patriotic subject matter is regarded by some as the quintessential American artist. He was an illustrator—and he never claimed to be anything but. In his day, that's the way critics viewed him, too, and not as a serious painter. They looked down their noses at the sentimental *Saturday Evening Post* and *Boy's Life* cover art so beloved by the public. But there has been reappraisal of Rockwell, best expressed in a comment *New Yorker* art critic Peter Schjeldahl made to *Artnews* in 1999: "Rockwell is terrific. It's become too tedious to pretend he isn't." Terrific, also, in the eyes of many was Grandma Moses, born Anna Mary Robertson in 1860. She only began painting her folk art scenes in her seventies but fortunately lived to be 101 and produced many pictures: 3,600 in three decades. Even critics have puzzled over whether aspects of Moses's art, such as the always skewed perspective, reflect her lack of formal training or an instinctive canniness. Whichever is the case, the overall effect, on many viewers, is mesmerizing. (On the opposite page, Rockwell, at far right, helps his friend Moses celebrate her 88th birthday in 1948, with one of her canvases hanging on the wall behind. Below that, at left, is his "The Problem We All Live With," from 1963, which is a depiction of Ruby Bridges entering elementary school protected by U.S. Marshals. The United States is, of course, a big country, and there was room in it during the 20th century for Rockwell and Moses and also such as Jackson Pollock (right, top, in 1949). Born in Wyoming, he took Abstract Expressionism to unforeseen places with his drip canvases (right, "Number 36, 1948"). It is safe to say that the work of each of these three artists has a legion of supporters and nearly as many detractors. Who's right? That's another way of asking: What is American art? What should it be? And, finally, who is to say?

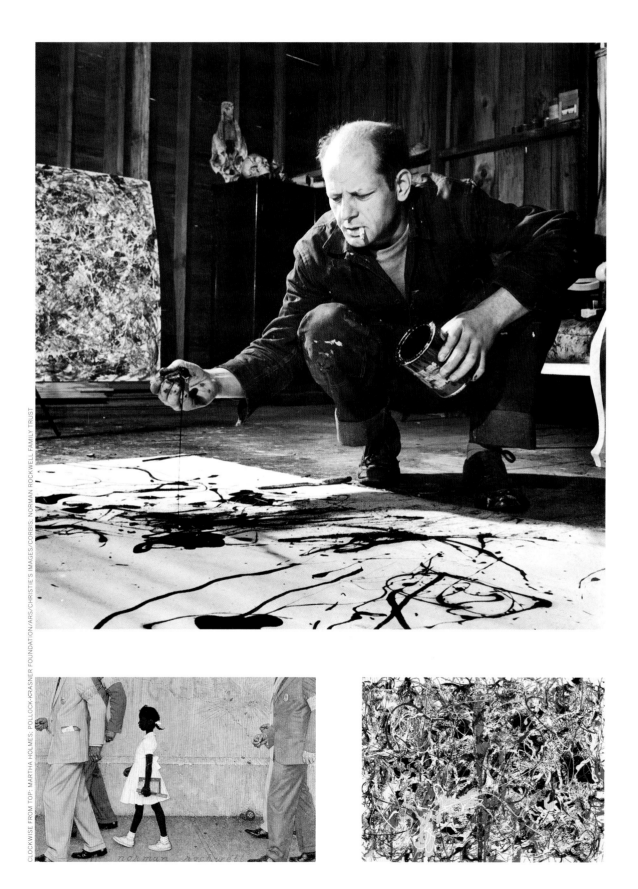

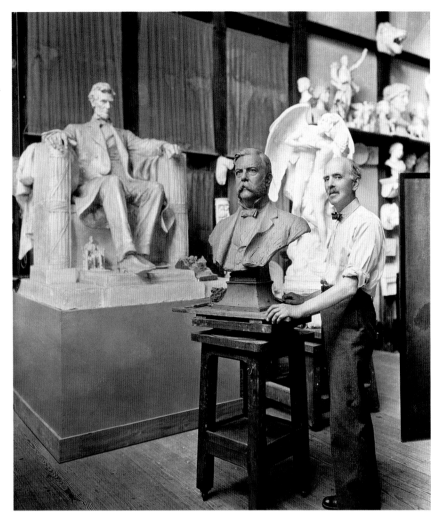

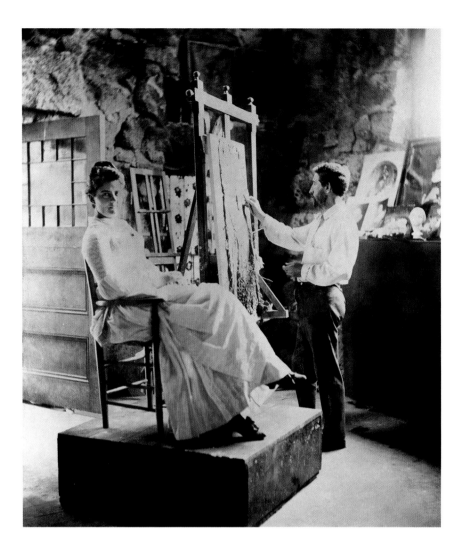

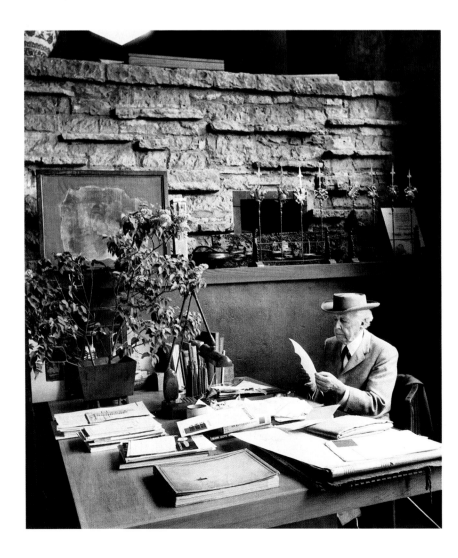

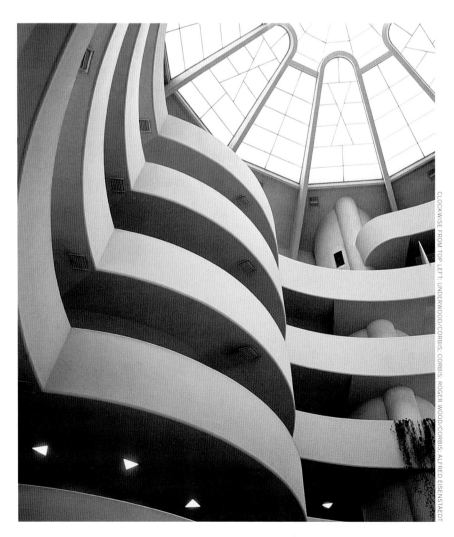

ARTISTS, ALL SORTS

A great nation requires great sculptors to immortalize its great heroes, and in the late 1880s and early 1900s the United States had, among others, New Englander Daniel Chester French (opposite, top left) and Irish-born, New York City–bred Augustus Saint-Gaudens (top right). French was a friend and neighbor of Ralph Waldo Emerson in Concord, Massachusetts, and that town tapped both men for its centennial celebrations of Patriot's Day, April 19, 1875: French crafted for the occasion his famous "Minute Man" statue, and in a plaque on its base is the first stanza of Emerson's "Concord Hymn," which includes the line about the shot heard round the world. French's most famous work is the seated "Abraham Lincoln" in the Lincoln Memorial. Saint-Gaudens's most well-known statuary is probably the "Robert Gould Shaw Memorial" on Boston Common, honoring the African American 54th Massachusetts Volunteer Infantry, which performed with gallantry in the Civil War. As with French, who designed the gold medal given to Pulitzer Prize laureates, Saint-Gaudens moonlighted in coinage, and his double eagle 20-dollar gold piece is widely considered the most beautiful U.S. coin ever made. Among American architects, none is more famous than Frank Lloyd Wright (bottom left, in his home, Taliesin, in 1956), who was born in Wisconsin in 1867 and went on to design some 500 completed buildings, including the revolutionary house Fallingwater in rural Pennsylvania and the Solomon R. Guggenheim Museum on Fifth Avenue in Manhattan (the spiraling interior of which is seen at bottom right). In architecture, the discussion of preeminence in the U.S. usually begins and ends with Wright, and in the culinary arts, the same is true with Julia Child (below, left). Public television's "French Chef" and coauthor of *Mastering the Art of French Cooking*, she changed forever the way Americans think and feel about food. In fashion, two contemporary careers are fun to focus on in any discussion of the Melting Pot: Ralph Lauren (below, top right), born in 1939 in the Bronx as Ralph Lifshitz to Jewish immigrants from Belarus, has built his Polo clothing empire upon a mythical America that exists somewhere between the playing fields of Eton and the wide-open spaces of a Western cattle ranch. Vera Wang (bottom right), born in 1949—also in New York City—to Chinese immigrants from Shanghai, was an elite figure skater, then worked for Lauren as a design director for a couple of years. Today she designs, among other things, wedding dresses for the glitterati.

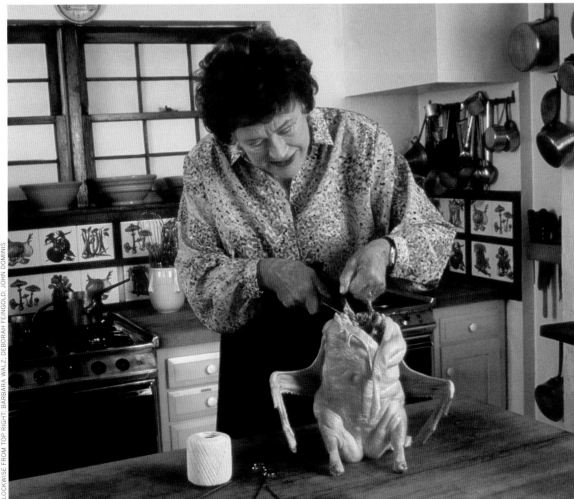

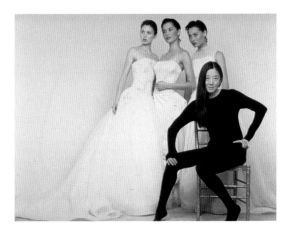

PEOPLE

SHOWBIZ

You are looking, on these pages, at two quintessentially American superstars, separated in time by more than a century. They attained prominence in vastly different ways, and those ways speak volumes about the vastly different things the country cared about near the end of the 19th century, and those we hold dear as we hurtle into the 21st. Annie Oakley (above) was born Phoebe Ann Mosey in 1860 in a cabin in rural western Ohio. She had a difficult, poverty-stricken upbringing and took up hunting before she was 10 to help provide for the family. When the Baughman and Butler fancy-shooting show barnstormed Ohio in 1881, Annie, 21, beat its star marksman, Francis E. Butler, in a contest, and she had found her future. She and Butler wed and then joined Buffalo Bill's Wild West show in 1885 (it's believed that Annie took the stage name "Oakley" from the Cincinnati neighborhood where she and Butler had settled). A colleague performer in the show, Sitting Bull (yes, *that* Sitting Bull), dubbed the five-foot-tall marvel "*Watanya Cicilla*," which translates as "Little Sure Shot." Annie hit the bull's-eye with the public, and fans flocked to Buffalo Bill's tents to watch her perform. Thomas Edison made a Kinetoscope film showcasing her prowess. Oakley never lost her shooting eye; in a 1922 contest in North Carolina, she busted 100 clay targets from a distance of nearly 50 feet—at 62 years old. There are no celebrity shooters in America anymore outside the National Basketball Association; musicians, actors and reality TV performers grab the spotlight these days. Among the biggest of the big at the moment is Beyoncé (opposite), the R&B singer, dancer and actress who is in her way every bit as gifted as Oakley was. In the olden days, a girl from Houston like Beyoncé Knowles might have learned to aim a rifle. These days, she learns to shoot for the stars in other ways.

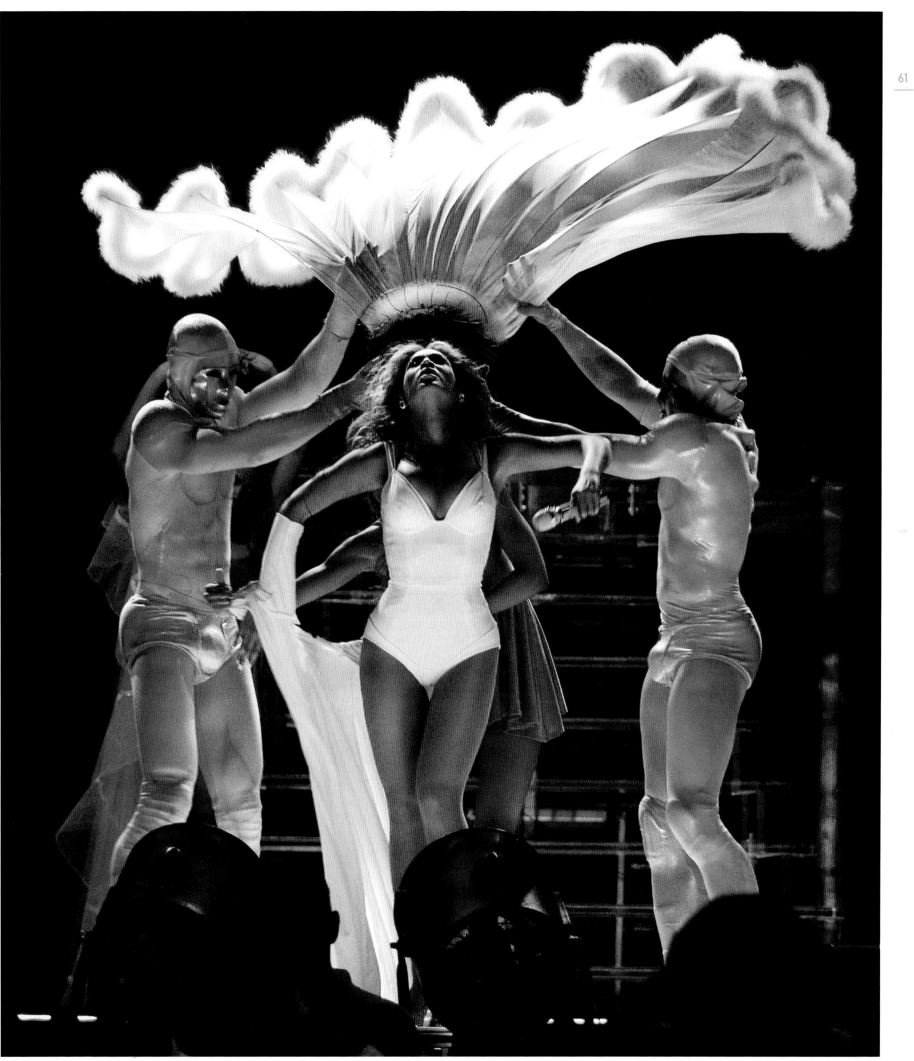

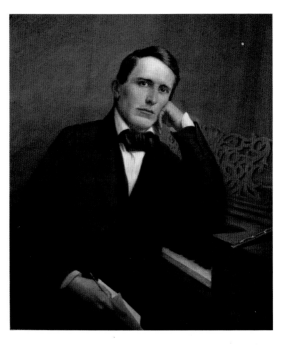

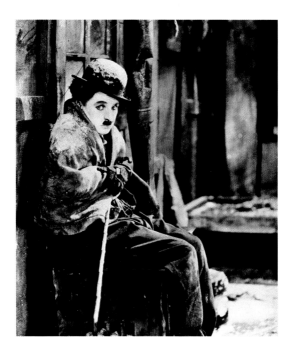

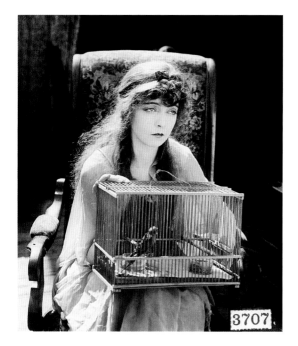

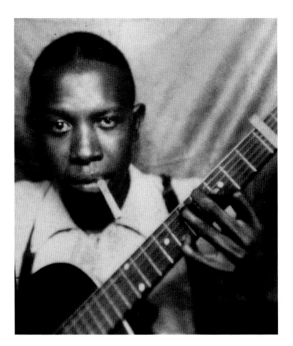

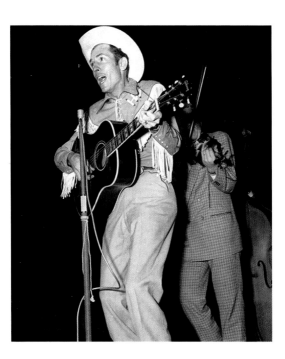

A CULTURAL GRAB BAG

Today, we have country and western stars, hip-hop stars, pop stars, great symphony orchestras, teen-idol heartthrobs of the silver screen and serious actors who don't shrink from Shakespeare. Interestingly, it has been that way in America for a long time, what with so many cultures bringing their own sounds and preferences to the mix. Opposite, top row, left: The Pennsylvanian Stephen Foster (1826–1864), writer of classic songs including "Oh! Susanna," "My Old Kentucky Home" and "Beautiful Dreamer," is known as the Father of American Music, while Mississippian Robert Johnson (1911–1938; seen just below Foster) has been called everything from King of the Delta Blues Singers to the Grandfather of Rock. Louis Armstrong (1901–1971) was essential to the development of jazz, and the composer, pianist and bandleader Duke Ellington (1899–1974) pushed the envelope, insisting on calling what he wrote and played "American music" rather than jazz (Armstrong is on trumpet with Ellington at the piano, at right). Cole Porter (1891–1964) and George Gershwin (1898–1937; seen opposite, middle row, center and right respectively) helped build an American Songbook of standards that combines elements of jazz, classical, folk and pop. Bottom row, left to right: Aaron Copland (1900–1990) composed for the concert hall but sought out Ellington's band at the Cotton Club and happily allowed jazz to flavor his own music; Hank Williams (1923–1953) brought country music to the masses in compositions that are as much standards today as Porter's or Gershwin's; and Woody Guthrie (1912–1967) did the same with folk music, writing songs, such as the classic "This Land Is Your Land," that seemed somehow, in their hallowed sound, to predate Foster. Meantime, there were the movie stars: Lillian Gish (1893–1993; seen in the top row, right) of the silent-film era handing off to Bette Davis (1908–1989; this page, near right), and Charlie Chaplin (1889–1977; opposite, top row, center) to Clark Gable (1901–1960). And then there was Walt Disney (1901–1966; this page, far right, bedecked with Mickeys), who changed the way we grew up. It is impossible to make a cogent point of all this beyond saying, yet once more, "Only in America."

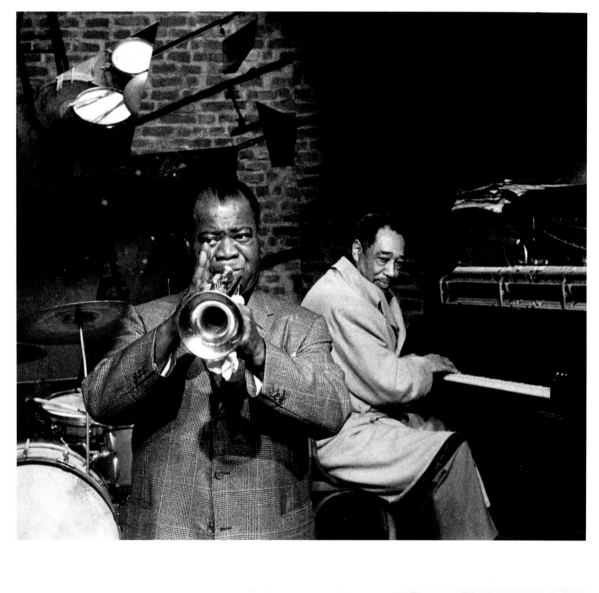

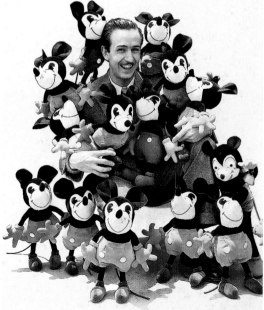

PEOPLE

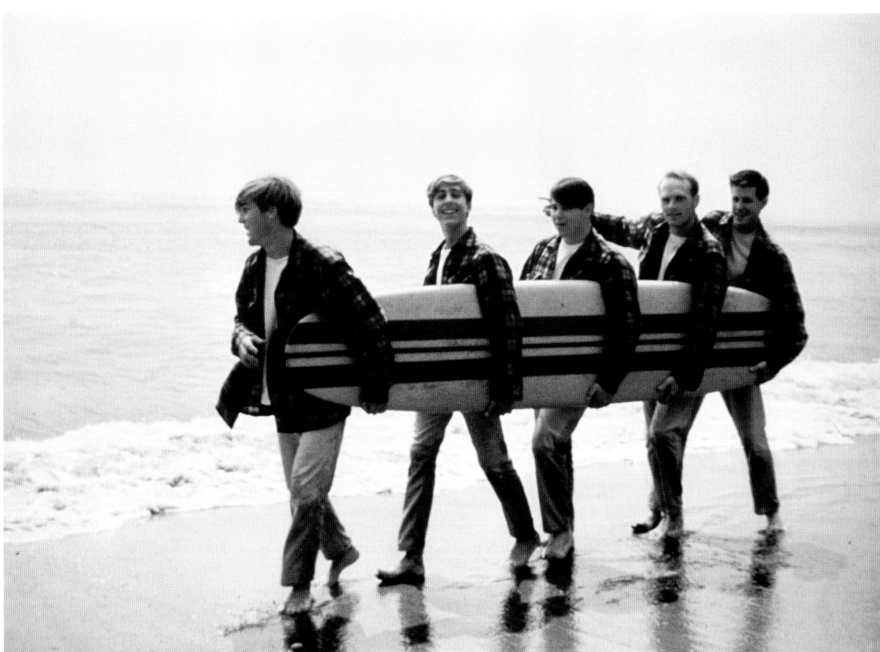

SOMETHING FOR EVERYONE

These pictures, taken together, send their own message. Opposite page, top row, from left: Elvis Presley (1935–1977) changed everything in the 1950s when he mixed black and white music, country and rhythm and blues, and brought rock 'n' roll to the Western world's young. Marlon Brando (1924–2004), meanwhile, changed what a movie star could do and what he represented. Marilyn Monroe (1926–1962) will never be equaled as a sex symbol and an icon, and the story of this talented woman will always rank as one of the country's most tender tragedies. In the 1960s, the times changed again, as the Beach Boys (above) and their increasingly sophisticated pop symphonies came out of California; as (middle row, from left) Bob Dylan (born 1941) emerged from the folk clubs of Greenwich Village in New York City (and from the tradition of Woody Guthrie) to create anthems for his generation and then a ruckus by plugging in; as Aretha Franklin (born 1942) stepped forth from her church choir in Memphis to become the Queen of Soul; as Johnny Cash (1932–2003) brought country music to the whole nation when he developed into a TV star as well as a recordmaker. Legacies now firmly established would extend—Bruce Springsteen (bottom left) would follow on, Michael Jackson (bottom right) would follow on, Paul Newman and Meryl Streep (bottom center) and Johnny Depp would follow on—and others will continue to. A diverse audience sits and waits, eagerly and in wonderment, for the next big thing.

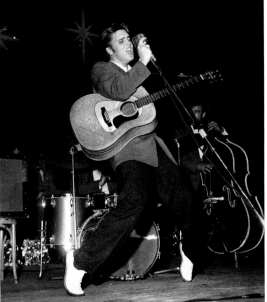
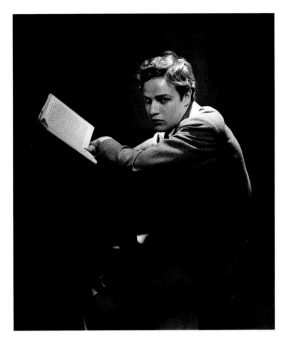
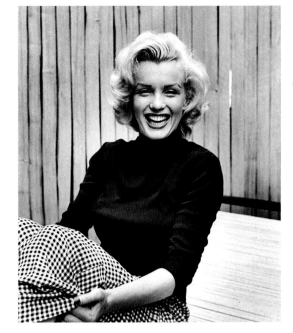
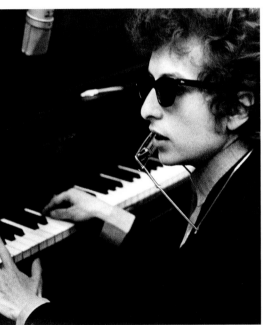
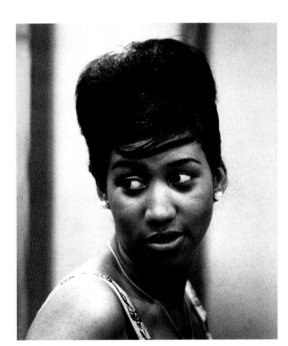
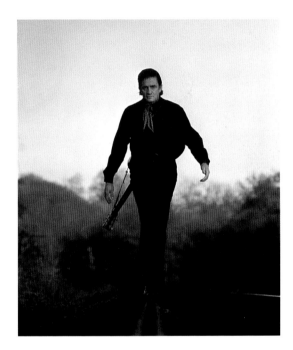
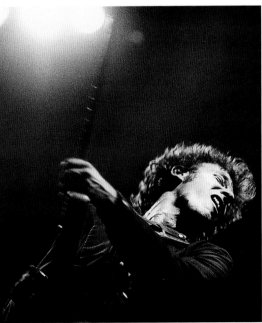
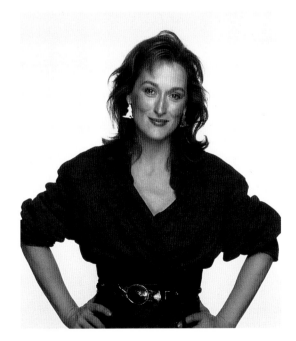
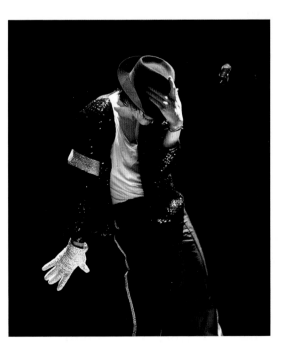

PEOPLE

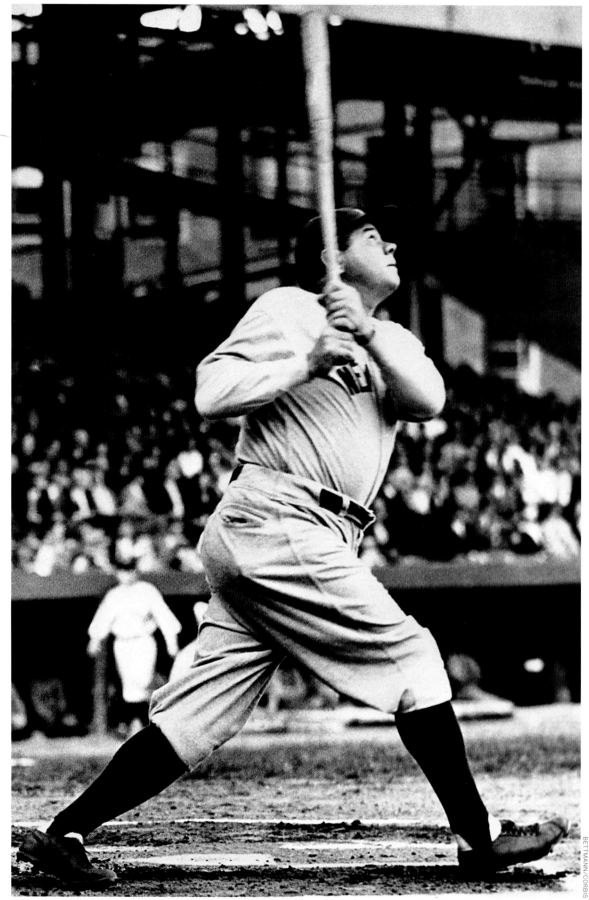

BETTMANN/CORBIS

ON DIFFERENT PLAYING FIELDS

The Bambino, the Sultan of Swat, *the Babe*—George Herman Ruth (left)—may well have been the best baseball player of his era, perhaps even the best ever, but we can never know for sure. Back when he was building his legend during the two decades beginning in 1914—at first with the Boston Red Sox and later, most famously, with the New York Yankees—professional sports in America were largely a white man's club. Whether the pitcher Satchel Paige could have mastered Ruth, or whether the great catcher Josh Gibson might have challenged his slugging feats, will never be known, for in the 1920s, '30s and '40s, they could play ball only in the Negro Leagues. In 1947, Jackie Robinson debuted with the Brooklyn Dodgers, and baseball's color barrier fell—not, it should be noted, without considerable controversy and much vile behavior by fans and even by other players. Needless to say, when the Sultan was swatting back in the day, not just major league baseball diamonds but many—make that most—golf courses were off-limits to blacks. Charlie Sifford and Lee Elder were late-to-the-game pioneers in that sport in the 1960s, and today Tiger Woods (opposite), of a mixed-race parentage that includes African American, white and even Thai elements, is in a place where he can be the world's most famous—and highest-earning—athlete. Of course, not all changes in America's sporting culture have benefitted Tiger. In Babe's day, a sports writer's job was to create heroes, and the press was complicit in hiding from the public the Bambino's philandering and carousing. Today, as Tiger found out in late 2009 when news of his extramarital affairs made headlines, misdeeds by celebrity athletes set off a media feeding frenzy.

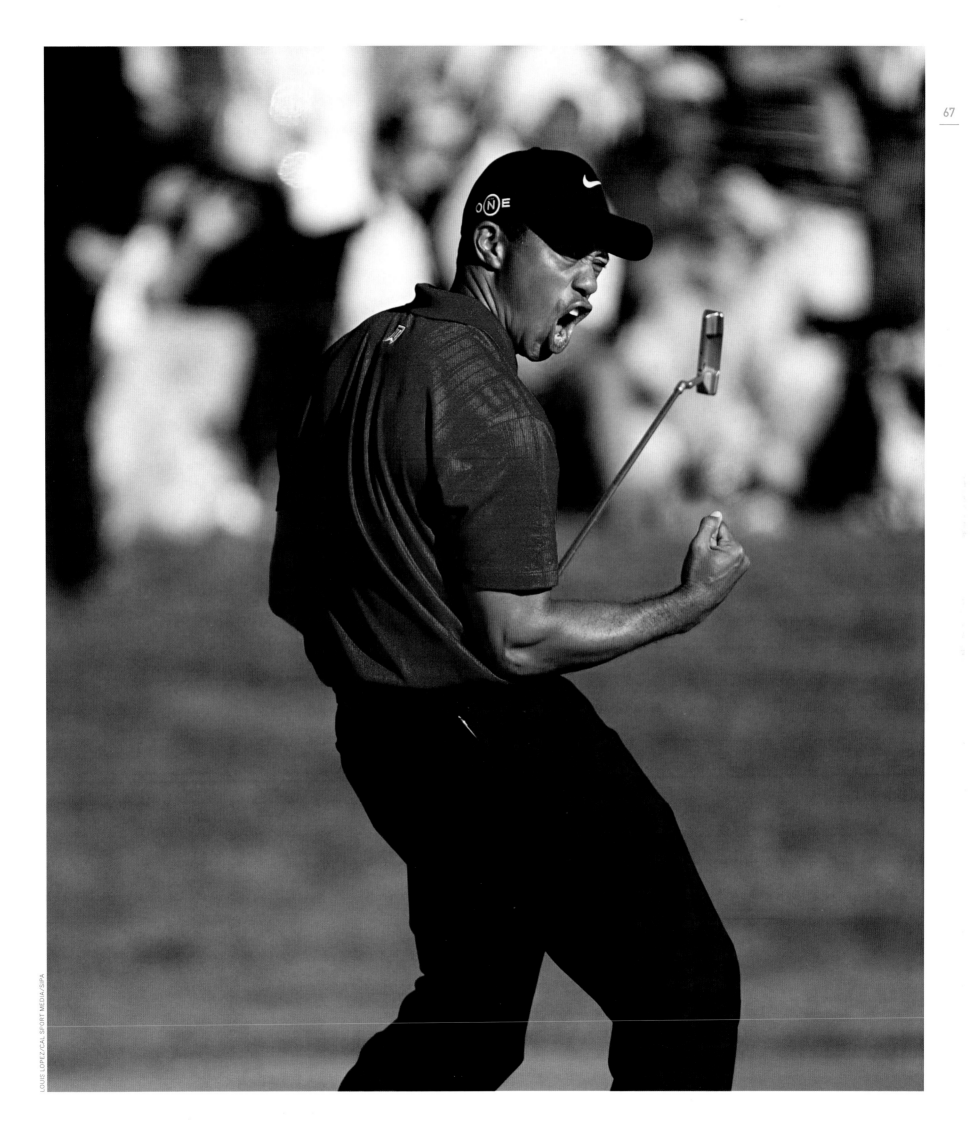

PEOPLE

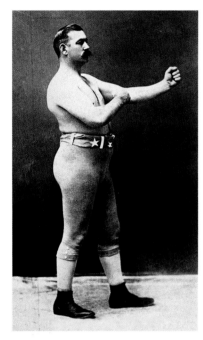

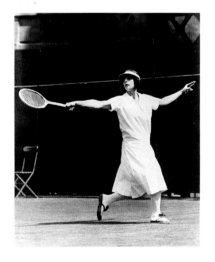

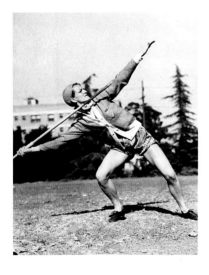

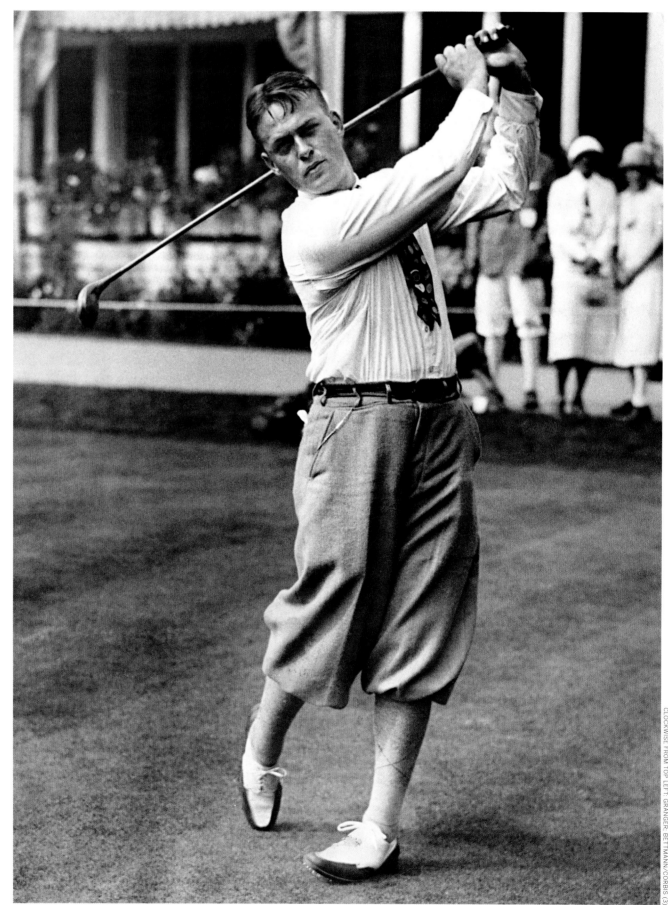

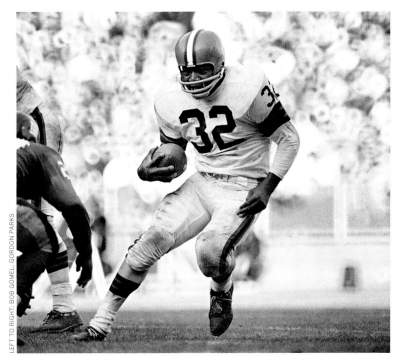

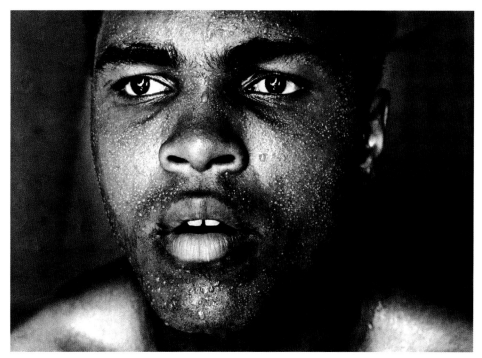

STARS OF THE STADIUMS

Opposite, top left: The brutal, boisterous, racist alcoholic John L. Sullivan (1858–1918) of Massachusetts rose out of the illegal but immensely popular bare-knuckle boxing tradition to become a legitimate champion, earning, by his own assertion, more than a million dollars in his career and becoming, it can be claimed, America's first sports superstar. Below him, Helen Wills Moody (1905–1998) was among the greatest-ever tennis players and the country's first female sports icon, winning 19 major tournaments in the 1920s and '30s. Opposite, right: Bobby Jones (1902–1971) was, in 1930, the first to win golf's Grand Slam (taking all four titles considered "the majors" in a single calendar year) and remains the only one to have turned the trick; he was also, along with Moody, Babe Ruth, tennis champ Big Bill Tilden and footballer Red Grange, among a group of immensely charismatic and talented sports figures who are credited with making the Roaring '20s a golden age of American athletics. Bottom left: The extraordinary athlete Babe Didrikson Zaharias (1911–1956) won two gold medals and a silver in track and field at the 1932 Olympics under her maiden name, then under her husband's surname became a champion golfer, winning her third and last Women's Open in 1954, a year after being diagnosed with colon cancer, which would take her life. Jim Brown (born 1936; above, left) set football running records that have since been broken, but is still considered by many the best ever; he was also perhaps the country's finest collegiate lacrosse player during his days at Syracuse University. Boxer Muhammad Ali (born 1942; above, right) was, in the 1960s and '70s, a sports, political and cultural figure of such scope, it was said of him that he was probably the most famous man in the world. The Williams sisters (below, left), Venus (in yellow; born 1980) and Serena (born 1981), following in the footsteps of trailblazing African American champions Althea Gibson and Arthur Ashe, came from the public courts of Compton, California, to conquer the tennis world—atop which they remain today. In 2008 in Beijing, swimmer Michael Phelps (below, right) had an Olympics unlike any, ever, winning eight gold medals in eight races and relays.

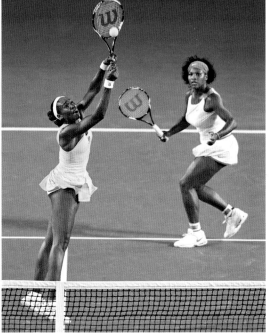

PEOPLE

THE CRIMINAL ELEMENT

Every day in the United States, millions of laws are broken. They range from the relatively innocuous—driving a few miles an hour over the speed limit—to the egregious. The vast majority of lawbreakers escape any degree of public notoriety, but there are exceptions big and small. Some criminals, for reasons that are uneven, become truly famous; some become almost mythic. We present on these pages crimes committed by two men who couldn't be more different, excepting their shared criminality and the fact that they are both destined to live forevermore in American history. The contrast in their cases illustrates how variable are the forces that lead to a kind of celebrity venality. Billy the Kid is as accurate a name as one can ascribe to the legendary Wild West outlaw. He was born around 1860, probably in New York City, and was christened Henry; for a surname he sometimes went by McCarty, sometimes Bonney, and sometimes Antrim, the former two being the names of the men who may have been his dad, and the last being his stepfather William Antrim's name (from Antrim, it is believed, he took the name Billy). His mother moved with him to the Southwest, and when she died in 1874, he became an orphan. Everyone liked Billy, except for those who scrapped with him. His career as a killer began in 1877, but how extensive it was remains in doubt. Billy claimed 21 notches on his belt, "one for every year of my life," but contemporary historians put the number at nine or 10. Within months after Billy was killed by Sheriff Pat Garrett in July 1881, there were no fewer than eight romantic novelizations of his deeds already in print, with more than a million copies sold nationwide, among them Garrett's own *An Authentic Life of Billy the Kid:* outsize attention for a small, crummy career. By contrast, nearly three thousand people were killed on September 11, 2001, when hijacked airplanes crashed into the Twin Towers of the World Trade Center in New York City (opposite), the Pentagon in Washington, D.C., and a rural field in Pennsylvania. If we consider this a crime rather than an act of war, it represents the largest mass murder in U.S. history. Osama bin Laden's place on the FBI's Ten Most Wanted list was deserved, as is his status as the most reviled criminal in U.S. history.

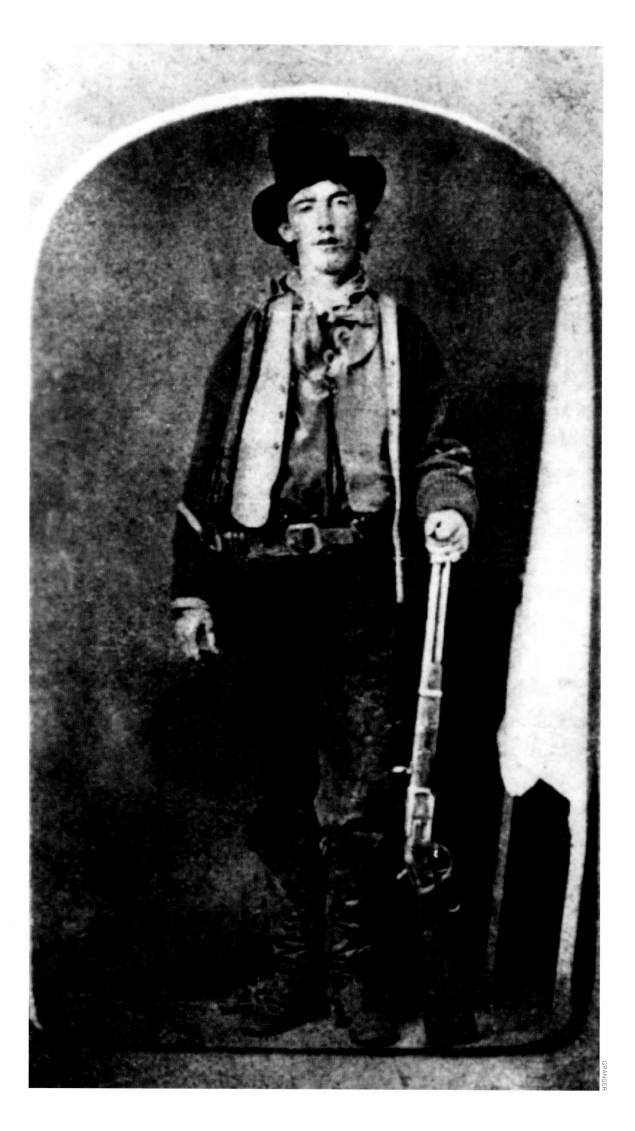

GRANGER

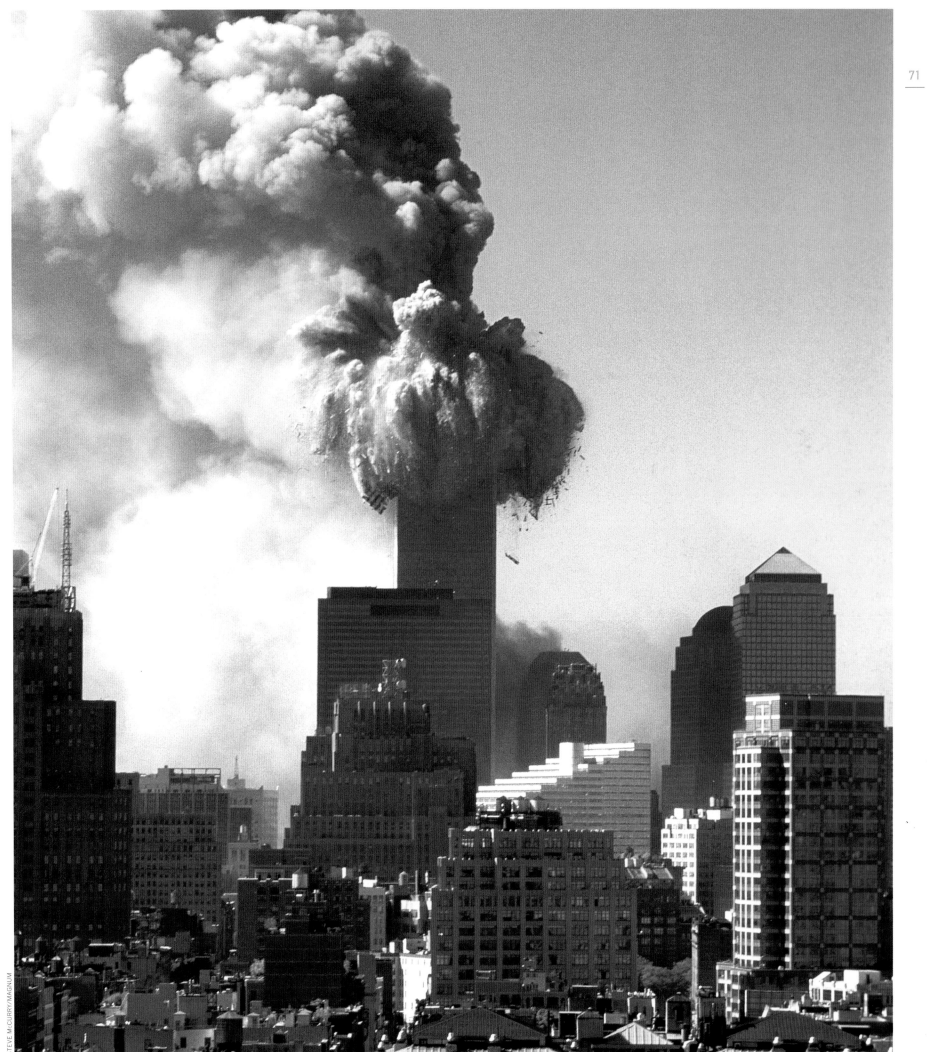

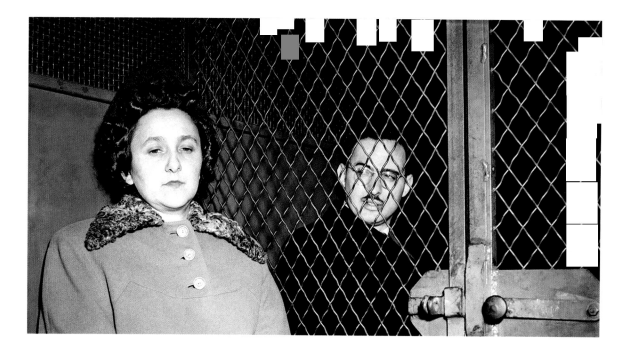

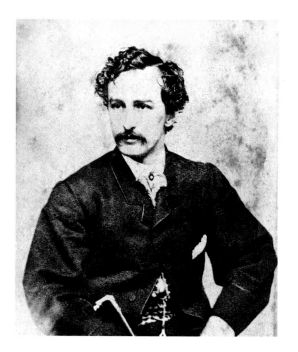

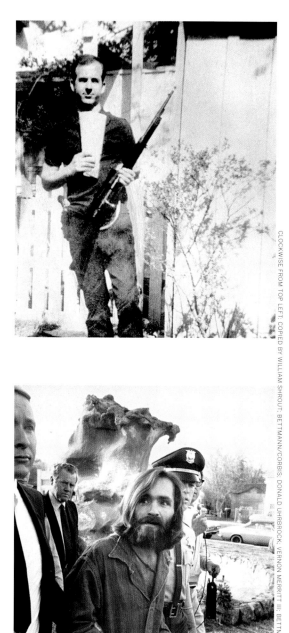

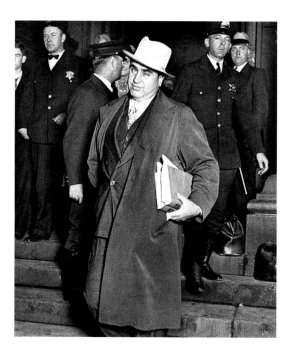

A ROGUES' GALLERY

On these pages we have categories of American criminals—traitors, assassins, mobsters, gangsters, murderers, plain old scoundrels. This page, from top, and left to right: Benedict Arnold was an American general during the Revolutionary War who, upset at the progress of his career, plotted to turn over the fort at West Point, New York, to the British; his plans were found out, and he later escaped to England. Ethel and Julius Rosenberg were an American couple who, in 1953, were executed as spies for the Soviet Union; revisionist historians imply he was more culpable than she. John Wilkes Booth, an actor fiercely devoted to the recently defeated Confederate cause, killed President Abraham Lincoln as he sat in his box at Ford's Theatre in Washington, D.C. According to the official investigation, Lee Harvey Oswald, a man with Communist sympathies, assassinated President John F. Kennedy with two shots from his rifle on November 22, 1963, in Dallas. Al Capone was a leader of organized crime in Chicago in the late 1920s and is believed to have ordered the infamous Saint Valentine's Day Massacre of rival mobsters. Charles Manson, seen by his followers as something of a guru, ran a quite different kind of mob—his so-called Family—and ordered very different kinds of rubouts in 1969 in Los Angeles. Opposite, from top, and left to right: Bonnie and Clyde—Bonnie Parker and Clyde Barrow—were outlaws who went on a two-year killing and bank robbery spree in the Southwest in the 1930s; they were killed by police in an ambush. Patty Hearst was a California heiress who, having been kidnapped by the radical Symbionese Liberation Army in 1974, was present at some of that

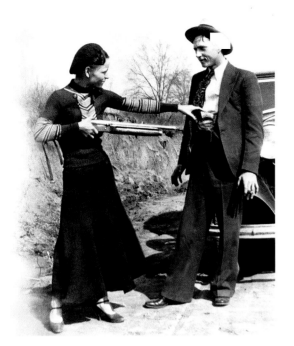

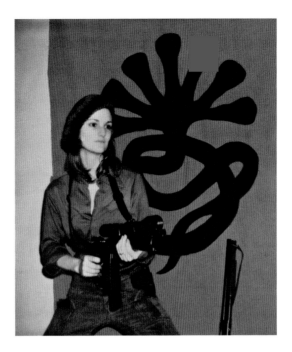

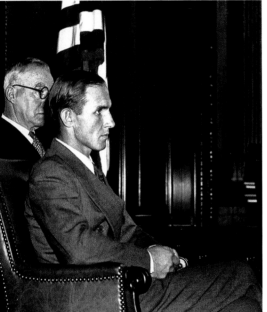

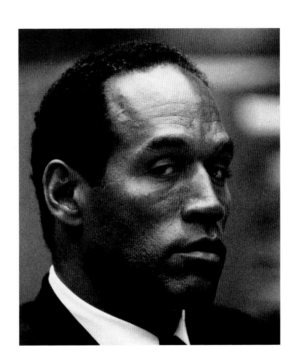

group's operations, which included a killing and a number of bank robberies; today, exonerated, she lives quietly in Connecticut. Bruno Richard Hauptmann was convicted and put to death for the 1932 kidnapping and murder of the baby of Charles and Ann Morrow Lindbergh; his deed was said at the time to be the Crime of the Century. The 1994 murder of former football star O.J. Simpson's wife and her friend in Los Angeles was later given that appellation; Simpson was acquitted at the criminal trial but lost a civil suit involving the same deaths. The Italian native Charles Ponzi was convicted in Massachusetts of engineering a pyramid scheme that, in 1920, bilked investors out of millions. In 2009, Bernard Madoff was convicted in New York City of running a similar swindle, long since rechristened a Ponzi scheme.

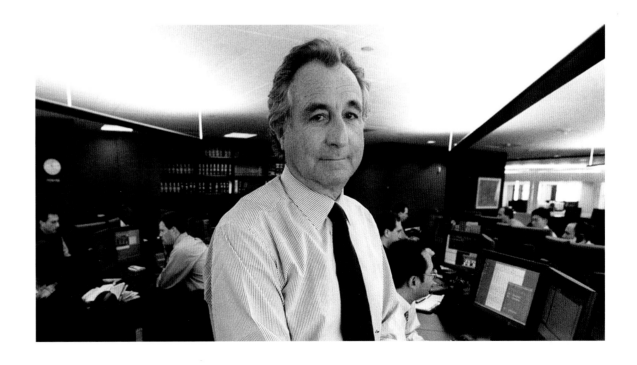

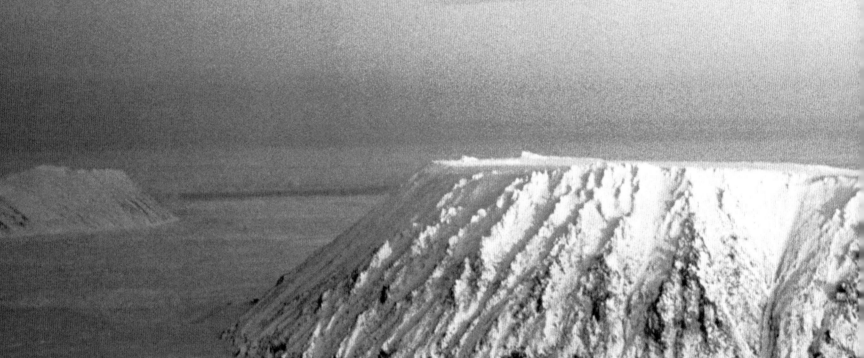

PLACES

To return to the beginning, this is where the so-called Bering Land Bridge—actually, an immense plain of tundra 1,000 miles wide—existed a dozen millennia ago. Today, the small Diomede Islands are all that remain above sea level, but once upon a time, this was Beringia, and where there is now frigid seawater was land: mankind's gateway to America.

PLACES

AIN'T IT GRAND!

In a land so blessed with natural wonders as the United States, it is hard to choose a signature site. If forced—absolutely forced—to do so, we would probably nominate the Grand Canyon. Here is how Donald Culross Peattie poetically described the (constantly evolving) formation of this cleft in the earth: "The Grand Canyon is carven deep by the master hand . . . It is all time inscribing the naked rock; it is the book of earth." When we consider the natural history of this place, we see that these words hardly constitute hyperbole. Two billion years ago, events began to conspire to create the world's most awesome notch. Tectonic mayhem, water, erosion and "deposition" (the formation of rock from sundry materials) began to converge in a mysterious, endless arabesque. Then 60 million years ago, two geological plates collided. A huge plateau was upthrust, and much later, the Colorado River—the tool in Peattie's "master hand"— began its exquisite sculpture, digging into the soil with its flow, creating the canyon. The result, after six million years, stretches 277 miles and is a mile deep. Nowhere else exists such a moving record of time's passage, indelibly etched in the exposed rock of the canyon walls. Native Americans, including the "Ancient Ones," or Anasazi, knew this place as home turf. The Spanish were the first Europeans to gaze upon the gorge in the 1500s. In 1776, Francisco Atanasio Dominguez and Silvestre Vélez de Escalante, two priests, peered in from the North Rim at Glen and Marble canyons. The same year, the missionary Fray Francisco Garces pronounced the canyon "profound." In the early decades of the United States, pioneers and geologists made their way to this place, but the great exploration occurred in 1869 when Civil War veteran Major John Wesley Powell did the previously unthinkable and led a wild-and-woolly boat expedition down the Colorado. Reports of Powell's success amazed folks back East, and the Grand Canyon became the tourism lure it still is today. At right, a member of the Powell Survey team peers into the canyon from Toroweap Point. Opposite: By 1946 visitors and amenities are plentiful.

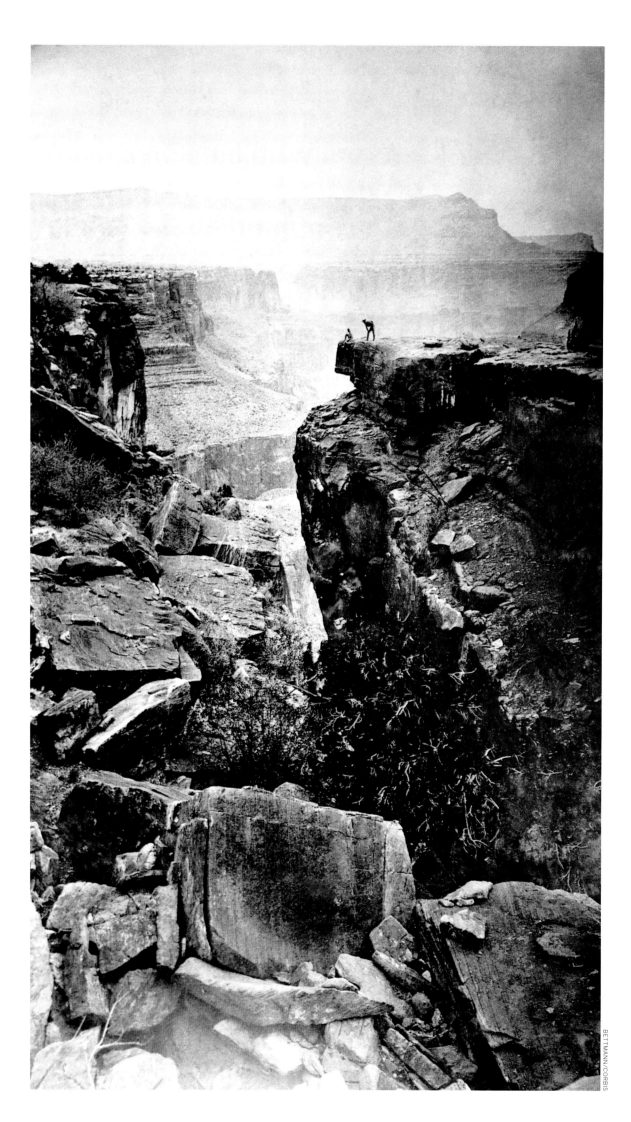

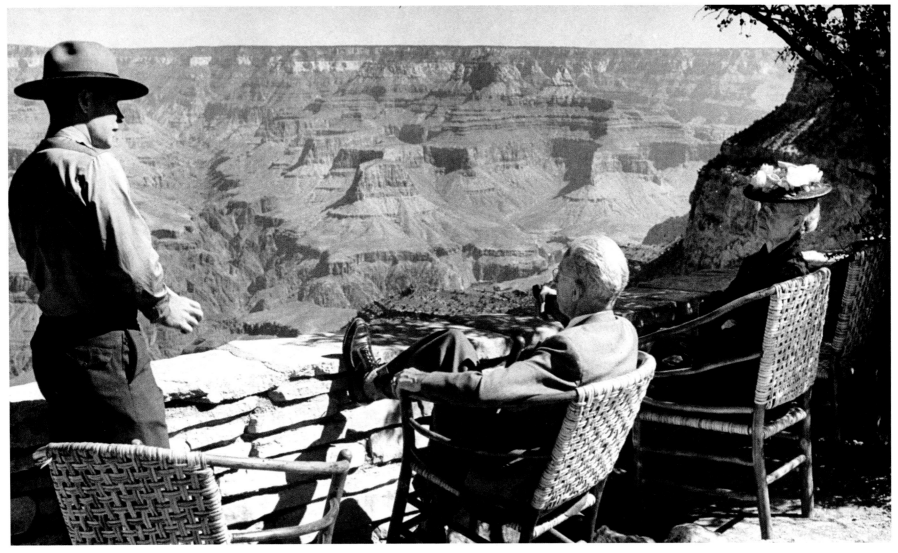

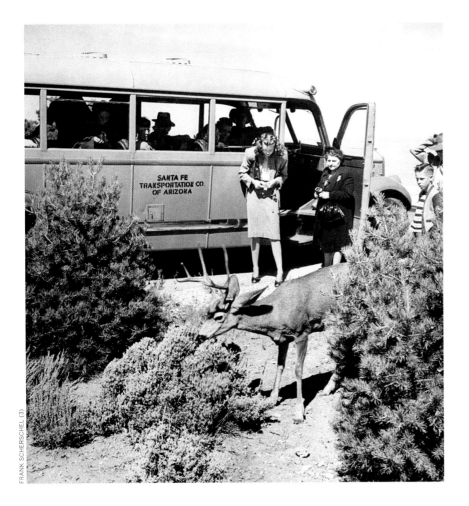

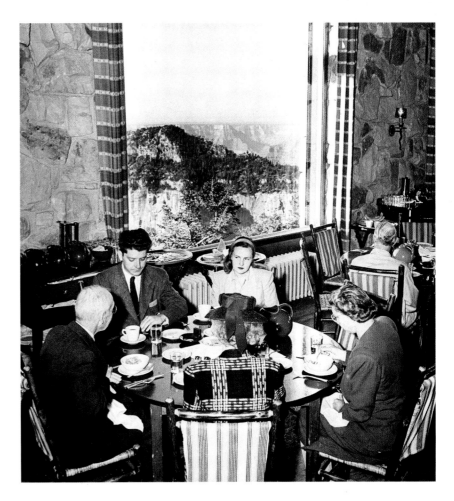

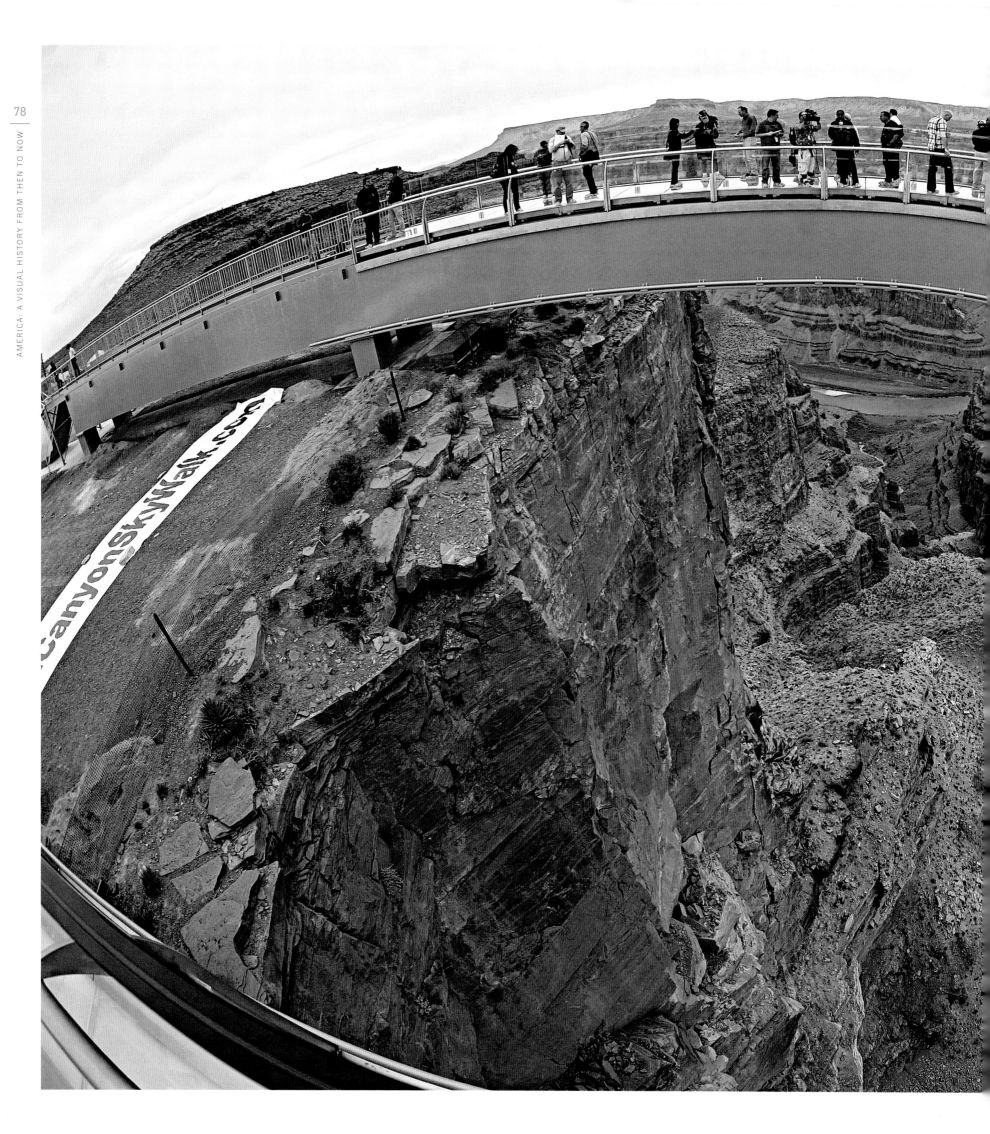

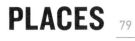

ON EVERYONE'S BUCKET LIST

The Grand Canyon ranks today as one of the world's premier attractions, right up there with the Great Wall of China, Stonehenge and the Great Pyramid of Khufu. Among natural wonders (as opposed to man-made), it has few peers. Perhaps Australia's Great Barrier Reef. Maybe the Serengeti. Angel or Victoria falls? Mounts Everest or Kilimanjaro? Protected as a national park since 1919—a designation that came late in the game, due to opposition by mining and other development interests—the Grand Canyon annually attracts some five million visitors from all over the globe. They come to gape, to raft, to hike, to camp (nearly 40,000 nature lovers sleep in and around the canyon overnight each year), perhaps to ride a mule down a switchback trail to the valley floor. There are surprises in store for the recreationists in the canyon environment. Hikers trying an ill-advised one-day round-trip from the rim to the river and back are sometimes overwhelmed to find how much hotter it is at the bottom. More sedentary vacationers board the vintage Coconino Canyon Train for a 24-mile tour of the region featuring many spectacular vistas or charter small planes or helicopters for an aerial view. The local Hualapai tribe recently commissioned the Grand Canyon Skywalk on their property (left); for a steep fee, a visitor can walk out upon it and look down through the glass floor at the steep canyon walls immediately below. What the Anasazi might have made of the skywalk is anyone's guess. Just north of the canyon is Lake Powell (below), a major recreation destination that was created by the Glen Canyon Dam in the 1960s. Environmentalists continue to lament the loss of Glen Canyon.

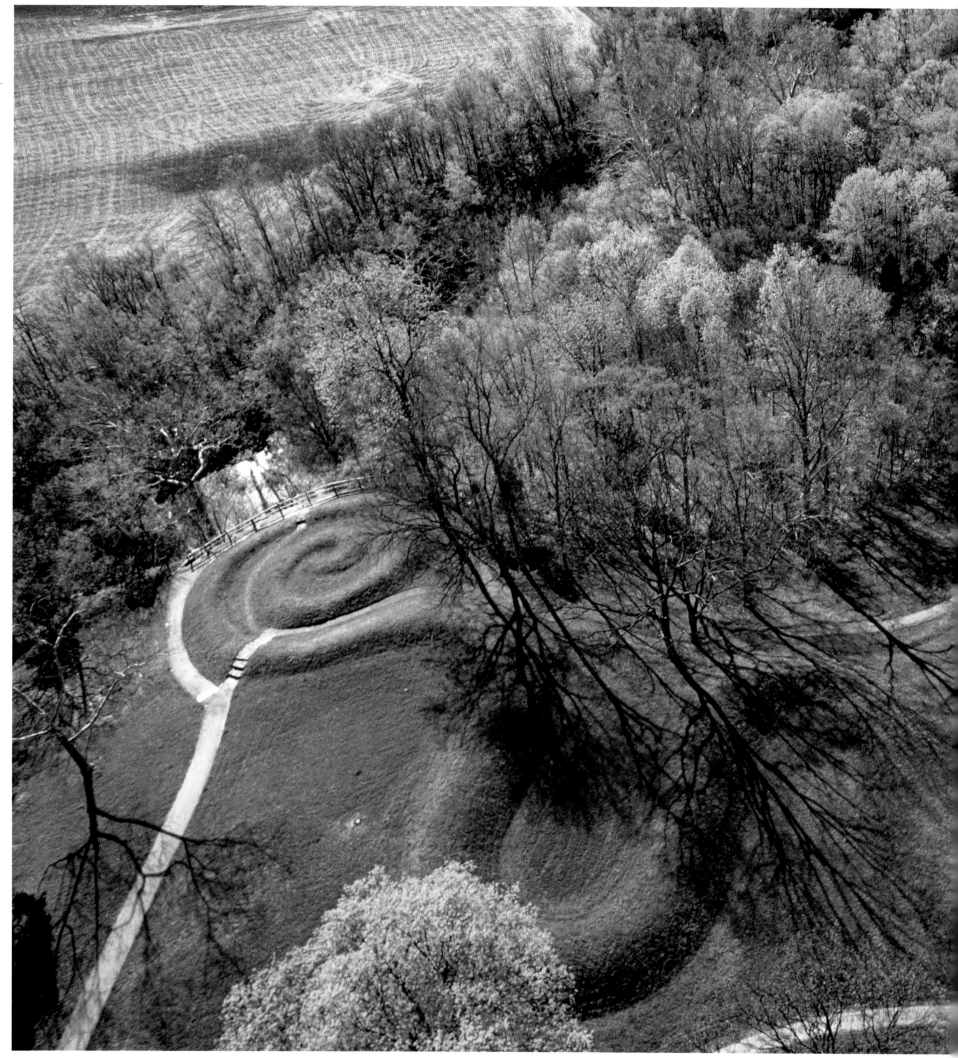

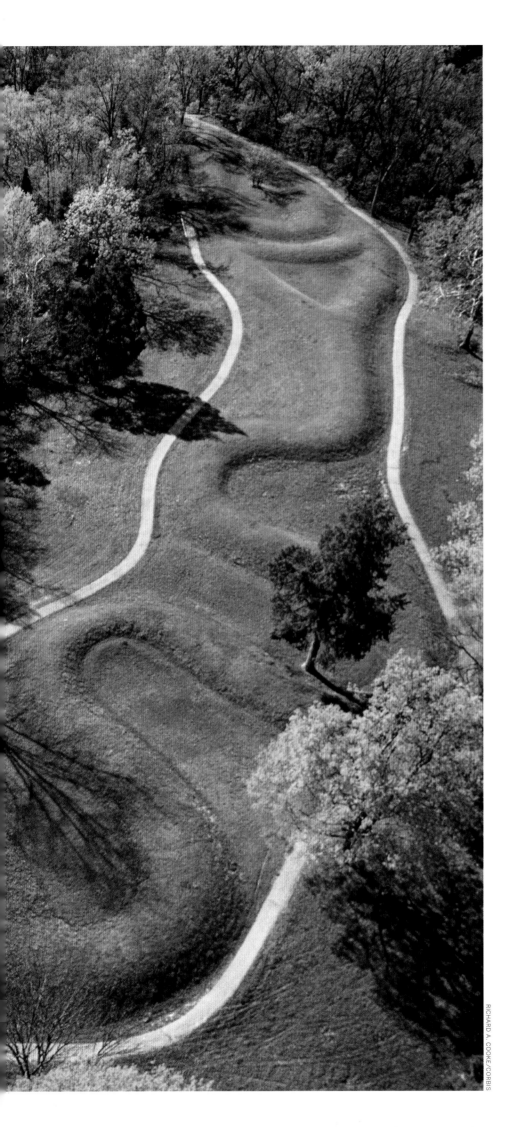

RICHARD A. COOKE/CORBIS

TEBO PHOTOGRAPHY

SYMBOLIC STRUCTURES?

While American history is well documented, America's prehistory—the history belonging to the many, many people who were here before the Europeans—is too often ignored. As we have emphasized earlier in our book, humans were firmly established in the New World long before this comparatively recent migration. The earliest peoples' hunter-gatherer lifestyle grew over time in sophistication, as evidenced by found tools, artifacts and earthworks. Most spectacular among the legacies are thousands of mounds scattered throughout the United States. Some were burial places, some marked sacred sites. The Great Serpent Mound near Hillsboro, Ohio (left), is the largest effigy mound in the U.S., averaging 20 feet wide by five feet high and running a quarter mile from tip to tail. It is not certain beyond a doubt who built it or when, but the local Adena culture began making mounds around 700 B.C. What does the cryptic structure suggest about who its creators were? In the present day, the myriad, sometimes gargantuan edifices that house Indian-owned casinos similarly say something unclear about the Native Americans behind them. This gaming phenomenon dates to the 1970s, when a property tax case that was appealed all the way to the U.S. Supreme Court resulted in a unanimous decision decreeing that Indians could not be taxed for holdings on their reservations and in fact that activities on their lands could not be regulated by local authorities. Bingo parlors began sprouting in states where there were strict gambling regulations, and then investors from outside with bundles of money started talking to tribes. Today, Foxwoods in Connecticut (above), owned by the Mashantucket Pequot Tribal Nation but originally financed for them by a Chinese Malaysian gaming tycoon, is the largest casino in North America and has more slot machines—7,200— than any casino in the world. The Pequots and other tribes profit mightily by such ventures, and improvements in education, housing and general quality of life have resulted in several cases. But the irony has been raised by others that the economic salvation for the native citizens of our land has rested, in these instances, on the back of an industry that most states feel compelled to prohibit, aside from their own lotteries. In one way, certainly, this is the Native Americans' latest treaty with those who pushed them off their land.

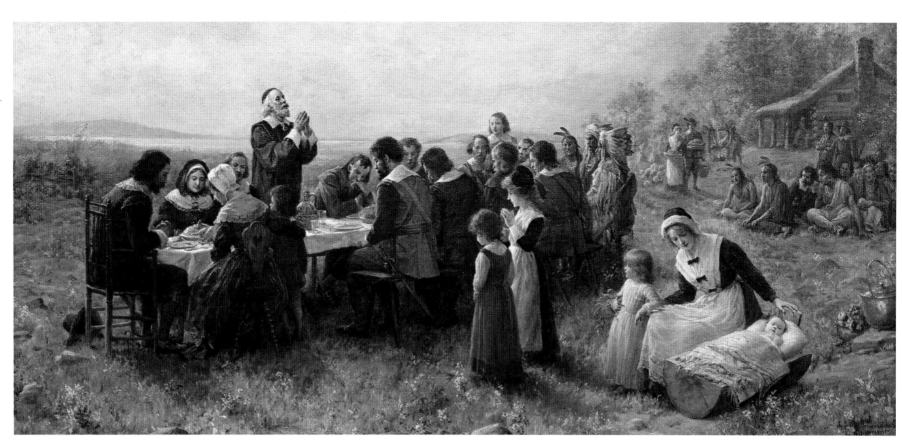

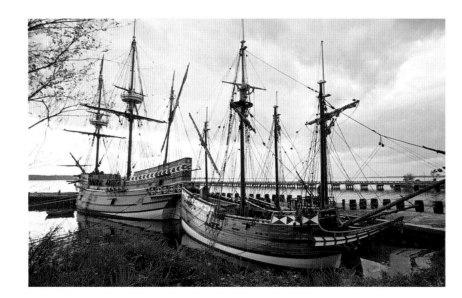

CLOCKWISE FROM LEFT: CHRISTIAN HEEB/AURORA; MICHAEL FREEMAN/AURORA; LONDIE G. PADELSKY/LARRY ULRICH PHOTOGRAPHY

HALLOWED SITES

A nation as great and now as long-standing as ours develops a mythology with a basis in facts that have been embellished by the kind of romantic add-ons that make for a fine grammar-school skit. What we know for sure: We know that in 1565, Spanish explorer Pedro Menéndez de Avilés founded a settlement on the Atlantic coast of what is now northeastern Florida and named it for Saint Augustine (opposite, bottom left); the town stands today as the oldest permanent white settlement in the country. We know that British colonists tried and failed to establish a community in present-day North Carolina in the late 16th century, before finally succeeding in Virginia in 1607 with Jamestown, named for their reigning king (left center, replicas of the ships that carried the settlers). We know that, not long after, in 1620, the ship *Mayflower* transported religious refugees to what would become Plimouth Colony in Massachusetts—and we do know that the Patuxet Squanto, whom we met on page 13 of our book, helped the refugees survive and that he and his fellow Indians broke bread with the settlers (top). We know that, on the other coast when the Spanish crown decided to colonize California in the 1700s, Fray Junipero Serra was chosen to lead missionary efforts with the Native Americans there, and that among the nine missions he established was the one at San Juan Capistrano; the Father Serra Church, as it is now called, is where the good friar himself said Mass, and it is believed to be the oldest church still standing in California (above and opposite, both bottom right, are exterior and interior views). Today, of course, these stories have accoutrements: the mysteries of North Carolina's Lost Colony, all the trappings of the First Thanksgiving at Plymouth (as it's now spelled, and as the replicated plantation now exists, top right and above, left, on this page), and the faithful migrating swallows of San Juan Capistrano. We have our history, and then we have an even better tale to tell.

PLACES

YELLOWSTONE, FIRST AND FOREMOST

In the present day, more than 100 countries throughout the world have national parks or reserves, but when President Ulysses S. Grant signed a bill in 1872 creating a park at the headwaters of the Yellowstone River, this was the only one. The backers of the law had two expectations: that wondrous natural phenomena might be protected, certainly, but also that news of the designation would put Yellowstone on the map, that people would want to come see the attractions, and that money could be made by innkeepers and other concessionaires, who would flock to the region just as surely as the tourists would. But no one was certain what a national park was; Yellowstone would be an experiment. Few legislative initiatives have proved, over the long haul, so successful, as we have indeed become a society dedicated to preserving our natural wonders, and to witnessing them firsthand. The wonder of Yellowstone has to do certainly with the bison and wolves and all that, but the aspect that fascinates is the thermal activity: the geysers and pools and resultant mists. The park sits atop a 2,000-degree lake of molten rock, an underground pressure cooker 50 miles long and 30 wide. For at least a few million years, since magma burned a hole under ancient Wyoming's bedrock, Yellowstone periodically disgorged a small ocean of lava in episodes hundreds of times greater than any recent volcanic eruptions on earth. Today, volcanic action heats rock below the surface, and this in turn creates all manner of spectacle in thousands of steaming hot springs and hundreds of geysers, including Old Faithful, plus bubbling mud pots and fumaroles. At Yellowstone, the earth is cooking—and today, with more than 3 million annual visitors, so is the scene itself. In these scenes: A hunting party poses amid trophies in the Yellowstone region in 1896 (top) and ladies shade themselves from the sun circa 1880 (bottom); an elk looks upstream in the present day (opposite, top); and snowmobilers travel among bison (bottom).

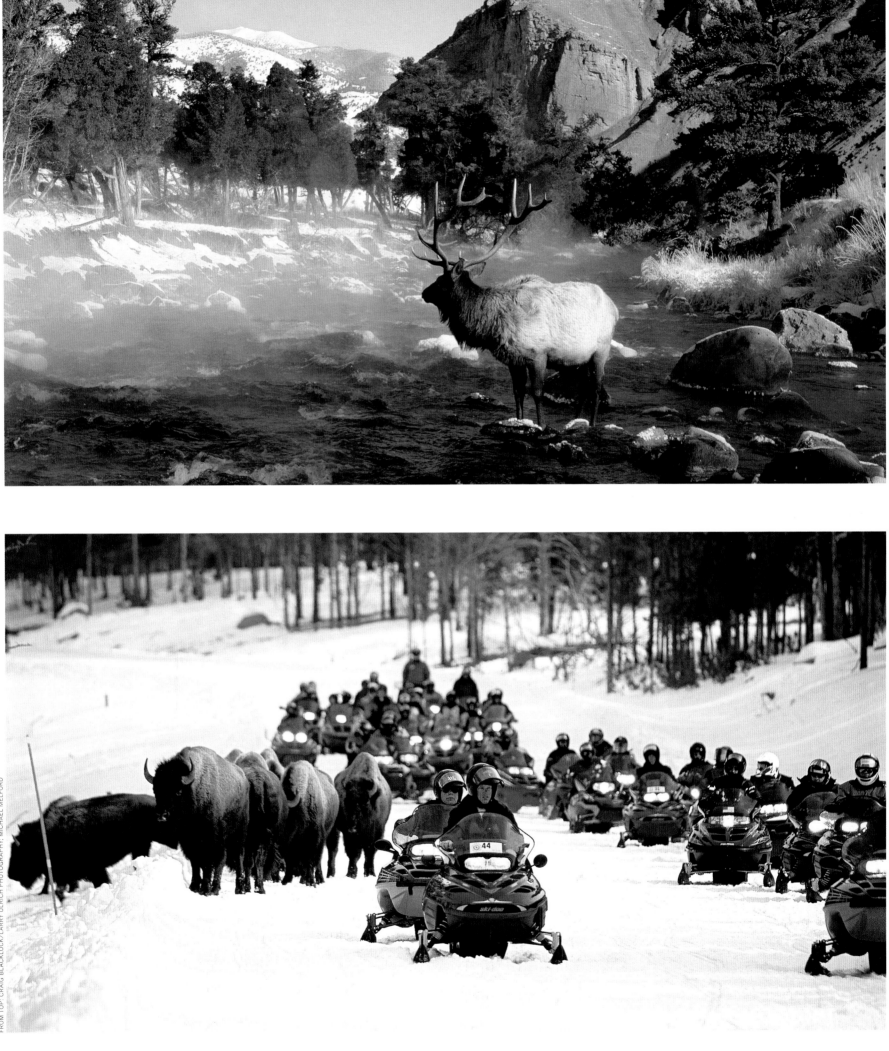

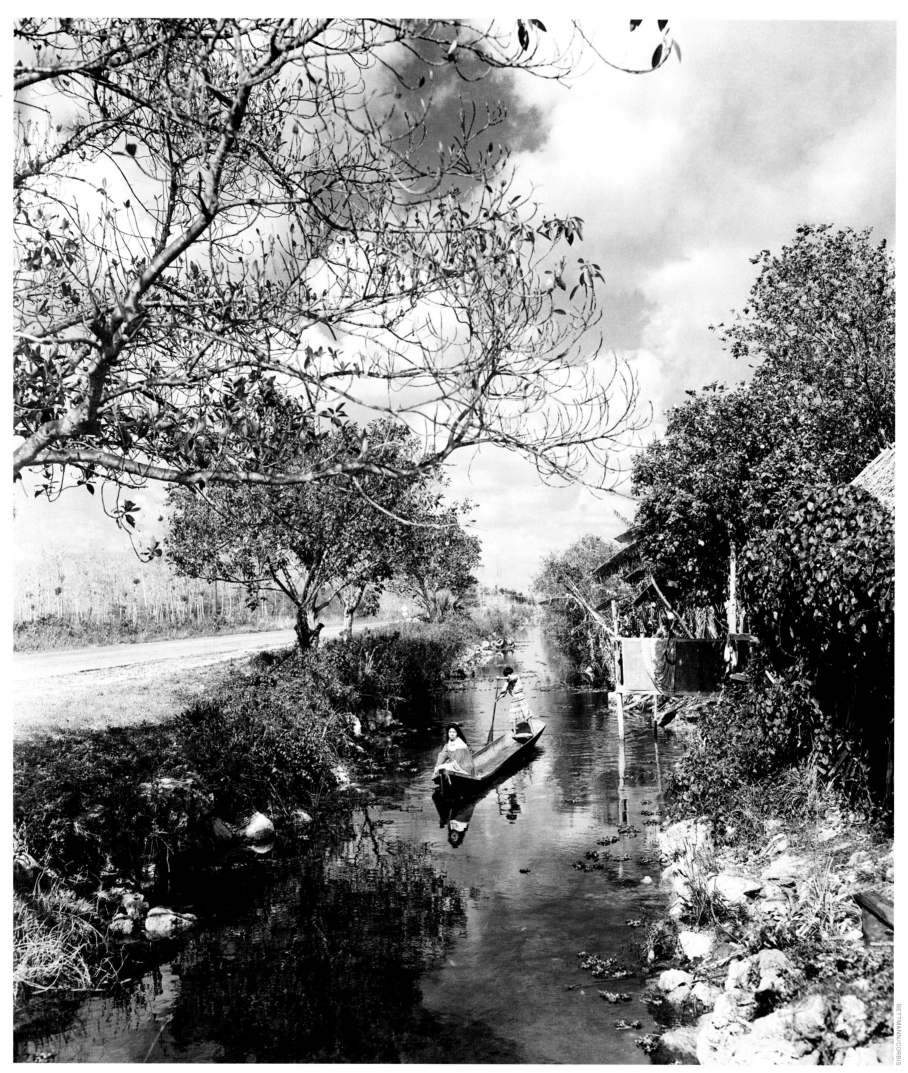

ALEX QUESADA/POLARIS

THE RIVER OF GRASS

There's nowhere in America remotely like Florida's Everglades. It's even difficult to get your mind around just what this place—this realm—*is*. By definition, Florida's Everglades National Park is the largest subtropical wilderness in the United States. More descriptive of what's at the heart of the unique Everglades ecosystem is the often applied term *river of grass*. Yes, it is that, a slow-flowing river some 50 miles long and not more than knee-deep, winding through 1.5 million water-soaked acres of shimmering saw grass, mangrove swamps, pinelands and hardwood stands. The river is the lifeblood of the Everglades, creating a teeming paradise for wading birds such as the roseate spoonbill, the reddish egret, the tricolored heron and flamingos, as well as fish, alligators and hundreds of lesser-known animals and plants that have adapted to this special environment. Among 12 endangered species clinging to life here are the Florida panther and the West Indian manatee. The Everglades seems a primordial place, and it is that, and therefore few other entries in this book provide a more poignant contrast between the very distant past and the very different present day. Do we as a race have the time or inclination, in the modern age, for the primordial? It is to be supposed that the Everglades is involved in what is likely a never-ending battle for survival. As the needs of the Sunshine State's human population continue to grow, the place is under constant siege by development, and the Everglades have already been severely encroached upon in the past century. For now, at least, the river of grass remains a wonder of the natural world. What about tomorrow? Opposite: Seminole Indians, native to the area, canoe to their village in 1945. Above: Recreationists kayak in the park in the present day.

PLACES

MAJESTIC RAINIER

It looms over the Pacific Northwest, it positively looms. The undisputed focal point of the country's fifth-oldest national park is also the fifth-tallest peak in the Lower 48: majestic Mount Rainier, a classic stand-alone pinnacle, whose ice cap on a clear day dominates the Seattle skies. Its name was born in 1792 when British explorer Captain George Vancouver, in the fashion of the time, named it after his friend Rear Admiral Peter Rainier. Despite being so close to the sea, the massive mountain reaches a height of 14,410 feet and accounts for more than a quarter of the national park's 378 square miles; it is a truly huge hunk of rock. And ice: Mount Rainier has the most heavily glaciated peak in the contiguous states, with 35 square miles of snow and ice. Of its 25 active ice sheets, the largest one is Emmons Glacier, which alone has a surface area of 4.3 square miles. The lower areas of the park are famous for radiant wildflower displays, and in the surrounding foothills are lush old-growth forests. As you might surmise from the look of this mountain, ages ago, when it loomed over nothing but trees and fields, it was an active volcano. It is still, and that old cone could once again breathe fire. Below: A motor campground in 1926. Opposite: As seen from Seattle's Lake Union.

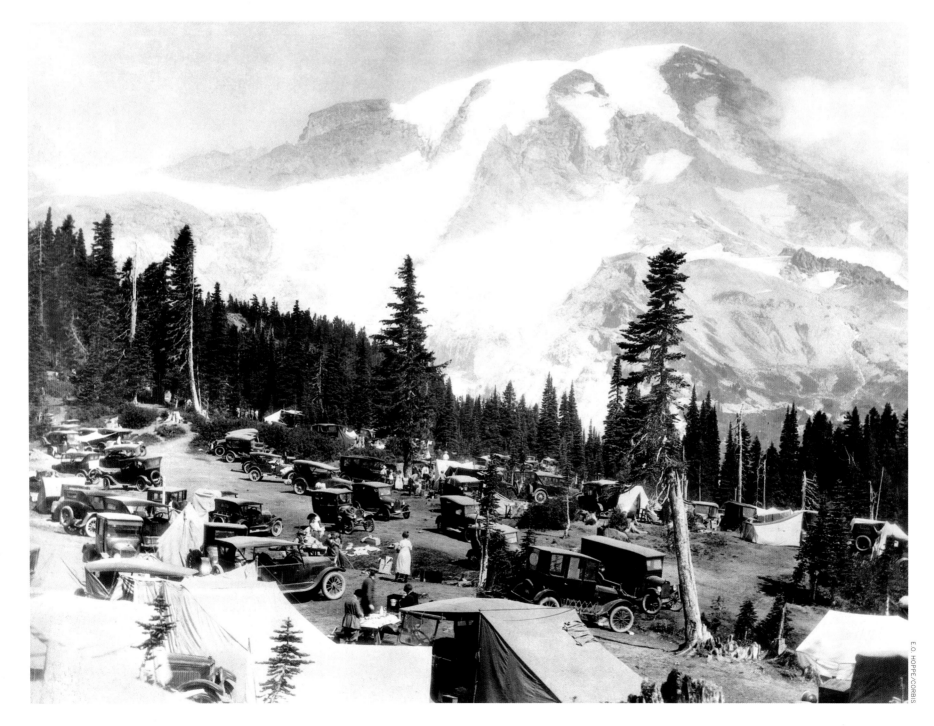

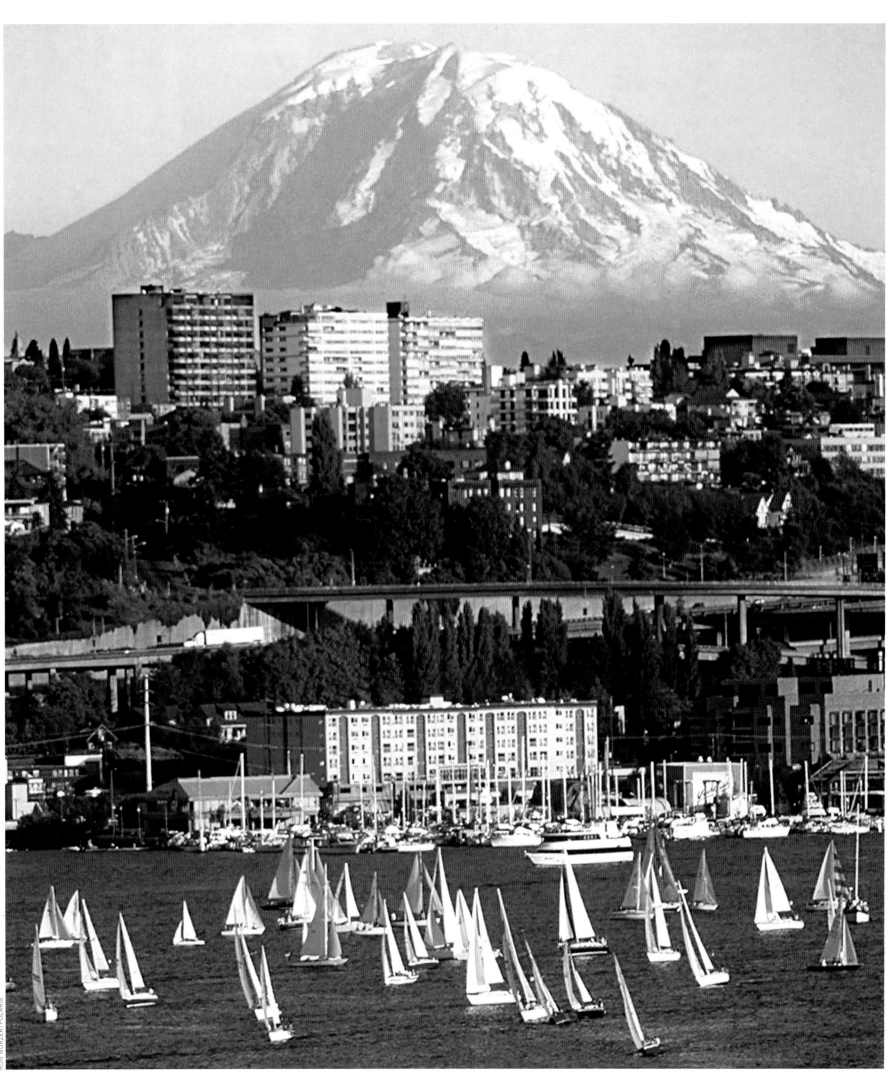

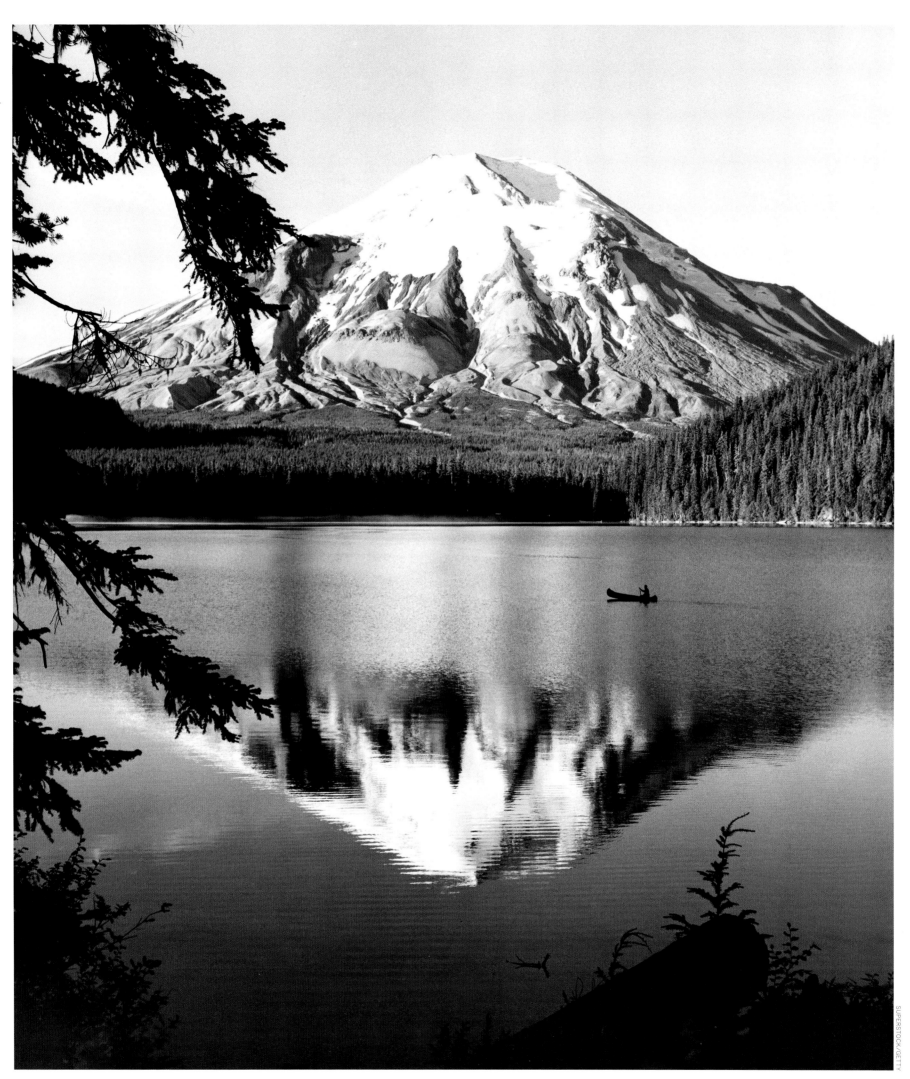

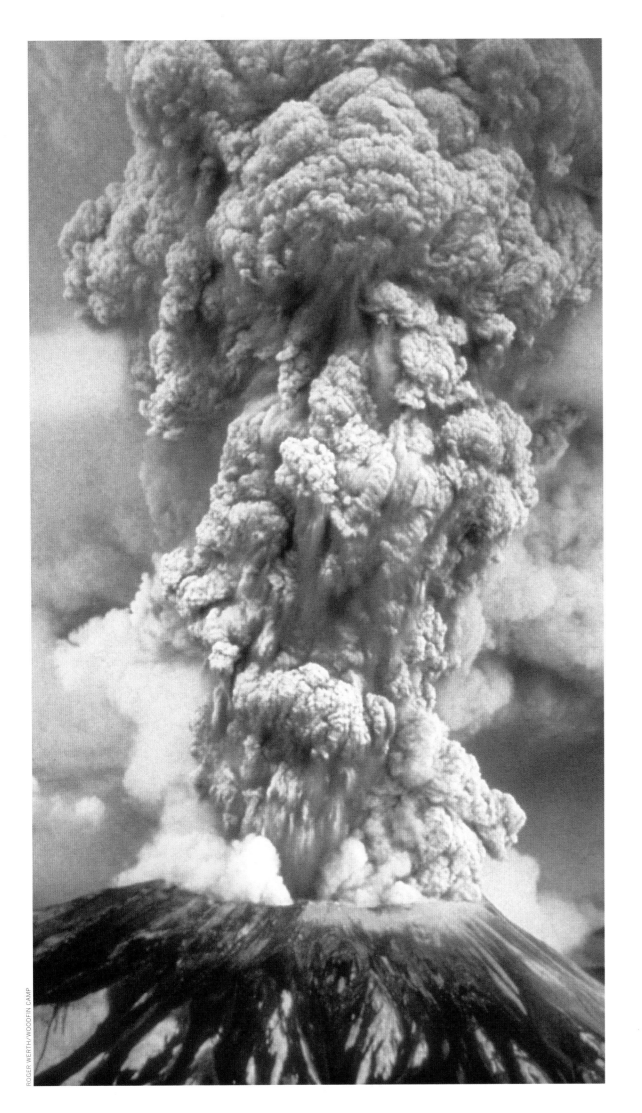

ROGER WERTH/WOODFIN CAMP

TUMULTUOUS ST. HELENS

Not far from Rainier, geologically speaking, in Washington State, is another volcanic mountain that, in our day, has provided a stark contrast of Then and Now—a living lesson in how so much of our topography was arrived at over eons. Washington's Mount St. Helens used to be known as the Fuji of America because of its dazzling symmetrical beauty (opposite). That all changed on May 18, 1980, with one of the greatest eruptions in our present era in North America (left). For two months, scientists had monitored activity in the volcano, dormant since 1857. Rising magma was causing its north flank to swell a shocking five feet a day. The bulge was more than 450 feet on May 18 when a magnitude-5.1 earthquake launched the biggest recorded landslide in history, followed by a lateral blast of superheated stone, ash and poisonous gas that extended nearly 20 miles. At the same time, a vertical eruption 15 miles high blew volcanic ash eastward around the globe. The area around Mount St. Helens was forever altered. The volcanic cone was blown away, leaving a horseshoe-shaped crater and a peak that was a seventh shorter at 8,363 feet. About one cubic mile of Mount St. Helens had been hurled into the air. Fifty-seven people and thousands of animals had been killed. Ten million trees had been felled. Avalanche debris, mudslides and ash had wreaked havoc on houses, roads and railways. And then . . . the comeback began . . . the next chapter. The pre-eruption landscape of Mount St. Helens had been one of dense coniferous forests and clear streams and lakes. It would be a long road back to that state, but the road is being traveled. Just for the record, however: Mount St. Helens remains a potentially active and dangerous volcano today.

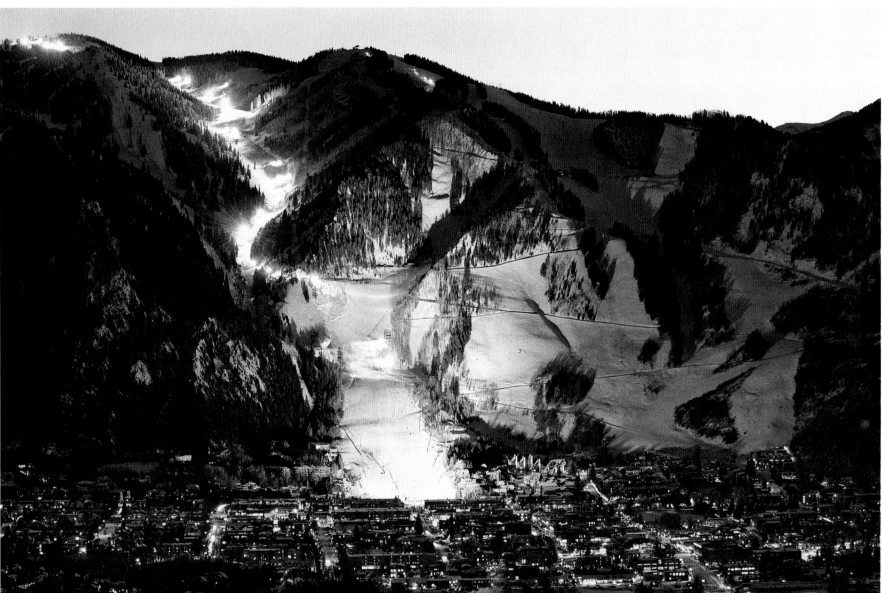

ALWAYS AWESOME ASPEN

The Rocky Mountains are nothing if not awe-inspiring, and of the enclaves deep within the Rockies of Colorado, few are as constantly inspiring as the ski town of Aspen. As the description indicates, Aspen today is defined by a sport, a recreation. Obviously, it was not always thus. In the late 19th century, this, like so many other high-country outposts in the Rockies, was a mining town. That industry ebbed and flowed, and Aspen's fortunes rose and sank, until, at the advent of the Great Depression in 1929, there were only about 700 citizens dwelling amid all that serene beauty. By this time, the Scandinavian import of skiing had taken hold in New England and various hilly parts of the West, but to foresee skiing as the boisterous future of the slumbering town Aspen had become would have taken a visionary. Some businessmen tried to jump-start a resort, but when World War II interrupted, plans were put on hold. An American serviceman who trained in the Rockies with the 10th Mountain Division for duty in that war was Austrian-born Friedl Pfeifer, and he filed away his vivid impressions of Aspen. He returned there after the war and teamed up with industrialist Walter Paepcke to found, in 1946, the Aspen Skiing Corporation. That sport in this setting was a match made in heaven, and quite quickly Aspen became a resort town. Its reputation as a cultural center followed, with its renowned music festival drawing thousands in the summertime. (Two mellifluous warm-weather scenes are opposite: musicians playing in the open air in 1947 and famed pianist Arthur Rubenstein riding an early chairlift in 1955. Above is glittering Aspen today.) More ski areas were developed—Buttermilk and Aspen Highlands in 1958, Snowmass in 1969. But the question needs to be asked: Are these resorts as beautiful as they once were, when pristine? That word *awesome*—forever applied to Aspen—was once issued with a deeply drawn breath by anyone with an appreciation for nature. Today it is often heard in exclamation by a high-flying snowboarder, coupled with the word *dude*. Same adjective; wholly different meaning.

PLACES

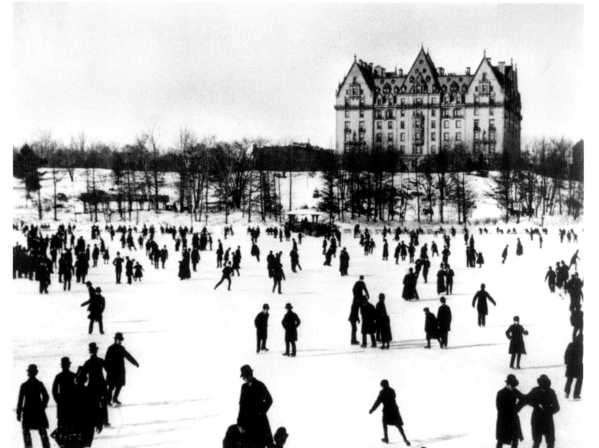

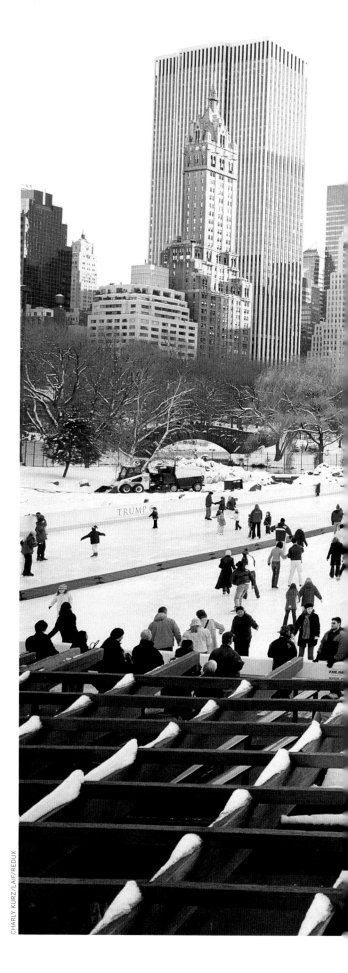

THE GROWING OF GOTHAM

In 1625, Dutch colonists founded their settlement New Amsterdam upon the island of Manhattan, having purchased—some say, swindled—the land from local Native Americans. The colonists started at the southern tip and built slowly northward. The British seized control in 1664 and continued to expand the city. Just over a century later, the American Revolution was launched to the northeast in Massachusetts. New York's loyalties were divided between Crown and colony, but the crucial port city was nobly defended by General George Washington until after the battle of Long Island. Later, under the Constitution, New York became the new nation's first capital, and Washington was inaugurated as President there. In 1874, the city grew beyond Manhattan, when portions of Westchester County were annexed, and under the Charter of 1898, the five boroughs of Greater New York—Staten Island, Brooklyn, Queens, Manhattan and the Bronx—were established. From that day to this, the sky was literally the limit. The Big Apple has sprouted a succession of the world's tallest buildings: the Singer, the Metropolitan Life, the Woolworth, 40 Wall Street, the Chrysler, the Empire State, the World Trade Center. The tragic end of the Twin Towers on September 11, 2001, only confirmed the New York City skyline as the world's most famous, most symbolic and somehow most significant. With a magnificent natural harbor and more than 500 miles of waterfront, New York is a major world port. It was long the world's financial center and continues to rival any of the world's major cities as the nexus of culture. It is the urban equivalent of the Grand Canyon or Mount Everest. It is New York City, the one and only. And it is true: The city never sleeps. Pictures of the growing of Gotham were seen in our book's introduction, and here we see two views of Central Park. Above, circa 1890: The Dakota apartment building was once a lonely sentinel on Manhattan's Upper West Side. Right: Today, the park is an oasis amid tall towers.

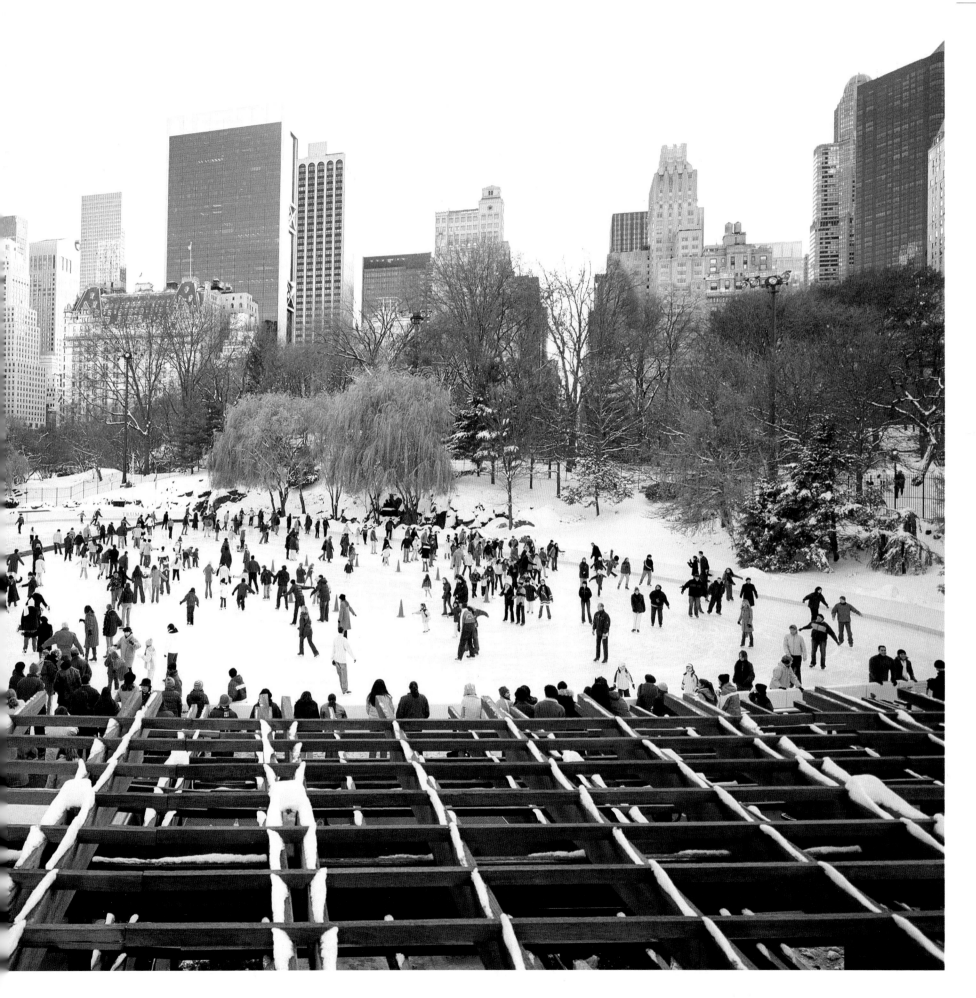

PLACES

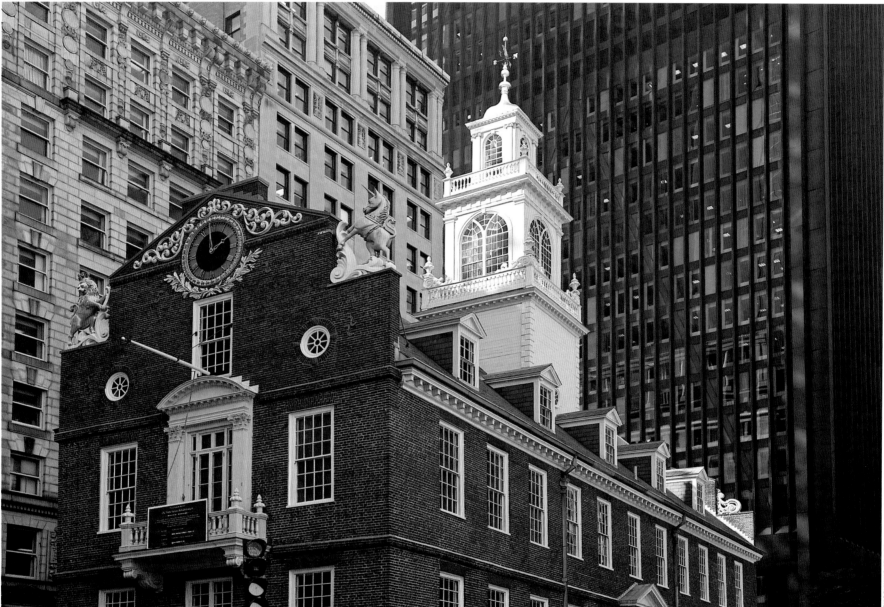

GERALD BRIMACOMBE

AMERICA RISING, PART I

Other great urban centers besides New York burgeoned in the 19th and 20th centuries, and watching the skylines of America change was one way to measure what was happening in the United States. The country was growing, certainly, but also growing bolder. On the East Coast, the cities where colonists had plotted became ever greater hubs of commerce and culture—and a brand-new city was built on swampland between Maryland and Virginia to be the seat of the federal government. On these pages, Boston's Old State House, where the revolutionaries gathered, stands today in charming relief against skyscrapers (above). Philadelphia's City Hall (opposite, left, top and bottom) is seen circa 1930 and today. And Washington, D.C., emerges. The birth of the nation's capital was not an easy one. In 1790 a new law provided for a city to be erected by the Potomac River on a site selected by George Washington himself. This new "federal city," 100 square miles in size, was built adjacent to the settlement of Georgetown. It was named in honor of our first President in 1791. Since the land wasn't the most salubrious, difficulties were many. And then, in August of 1814, the Burning of Washington occurred during the War of 1812, when the British invaded and set torch to several buildings, including the Capitol (then under construction), the White House and the Treasury. The invaders were expelled and most structures were repaired, although the Capitol would not be completed until after the finish of the Civil War, in 1868. It is seen distantly in the photograph on the opposite page, top right, circa 1888; the marshland surrounding the Anacostia River suggests the swamp that was general here. Bottom: The Washington Monument between the Lincoln Memorial and, again, the Capitol, today.

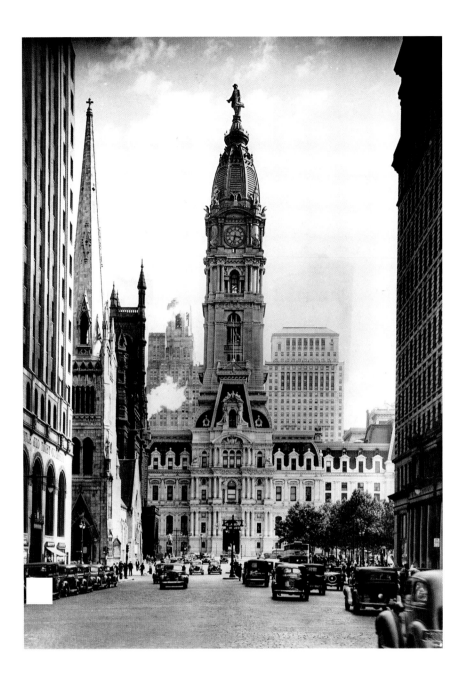

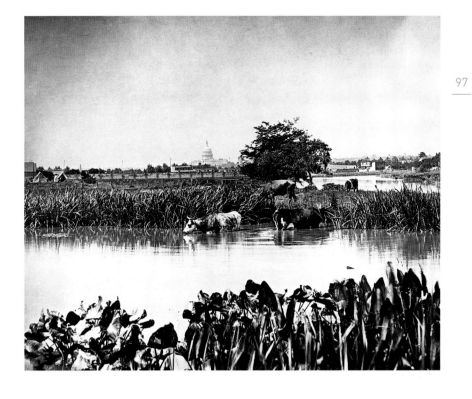

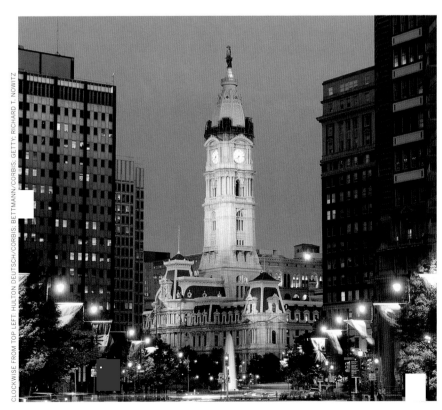

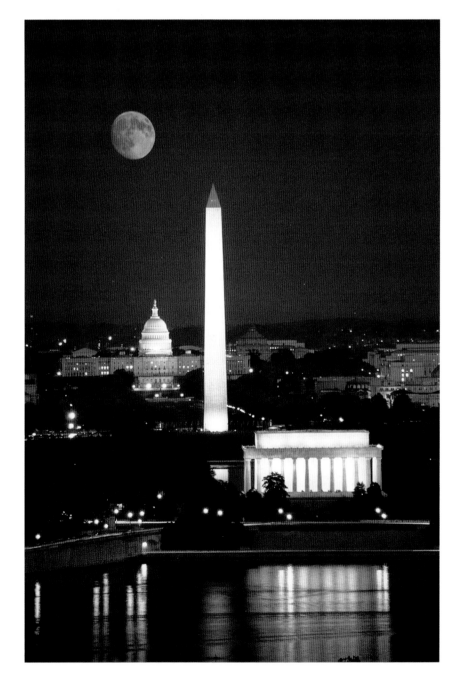

PLACES

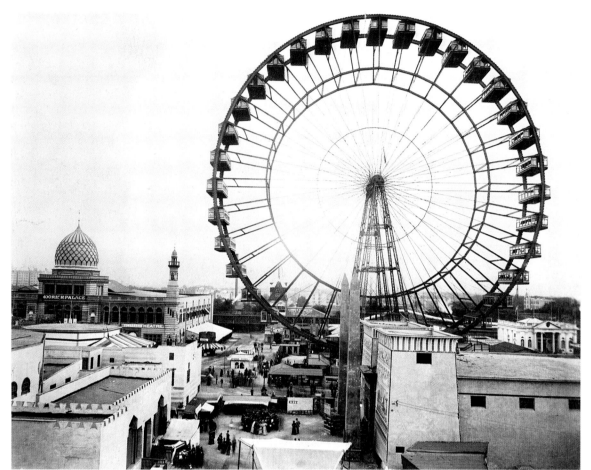

AMERICA RISING, PART II

The second and third largest metropolitan population centers, after New York City, now lie to the west of the great port and reflect the narrative of the country. In Illinois is Chicago, a city that came into being in the 19th century and quickly grew to be a bustling enterprise; it is now in third place nationally. In Southern California is Los Angeles, the gleaming, glitzy 20th century enterprise that is home to Hollywood, surfer dudes and year-round barbecues; it stands second in population. In the Midwest, Chicago rose where once the Illinois Indians, who had been removed with violence, had lived for generations. The Windy City grew to be a gritty center of commerce and trade; it became the northern home of the blues and of jazz, and today has a theater scene second only to—and perhaps more inventive than—New York's. (Left, Chicago attractions Then and Now: the Ferris Wheel at the World's Columbian Exposition of 1893, and—on July 14, 2009—the observation deck on the 103rd floor of the Sears Tower, once the world's tallest building and still the tallest in the U.S. Two days after this picture was taken, it was renamed the Willis Tower, having been bought by a London-based insurance firm of that name.) Chicago likes to think of itself as a place with big shoulders, and an intelligent head resting atop them; Los Angeles is often characterized, usually unfairly, as flighty, as "La La Land." L.A. was a relatively small oasis in the desert until water was found (see the film *Chinatown*). Its precipitous rise in the 1900s reflected the American mind-set: larger, faster, sunnier, more glamorous. Opposite, top: an orange orchard in 1903 located where, later, Hollywood Boulevard will intersect with Western Avenue. Bottom: the Oscars red carpet outside the Kodak Theatre on Hollywood Boulevard today.

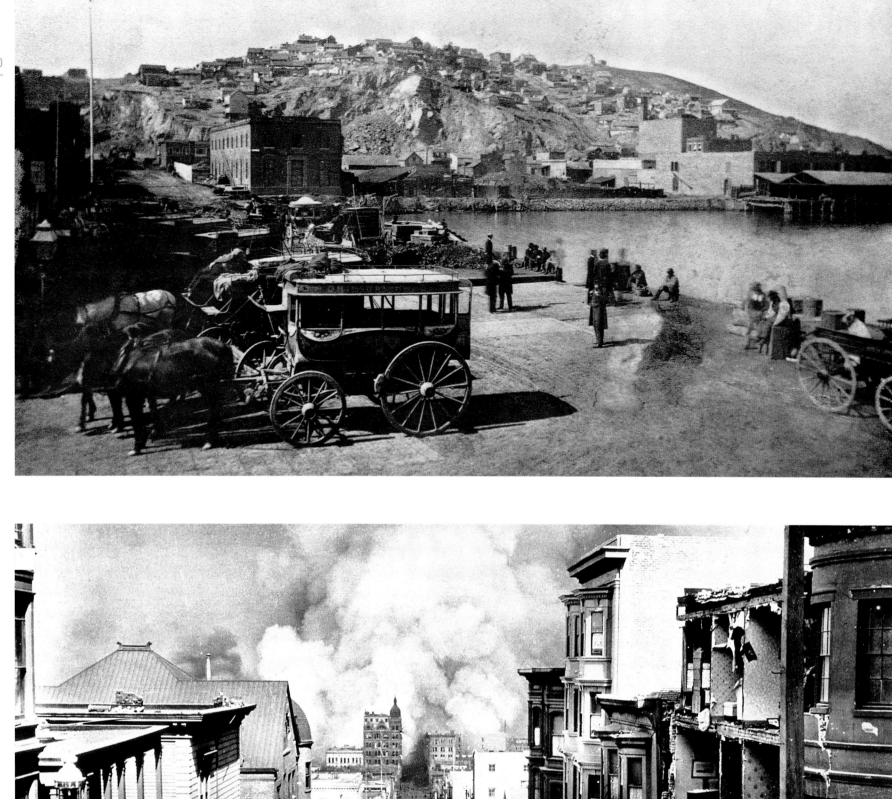

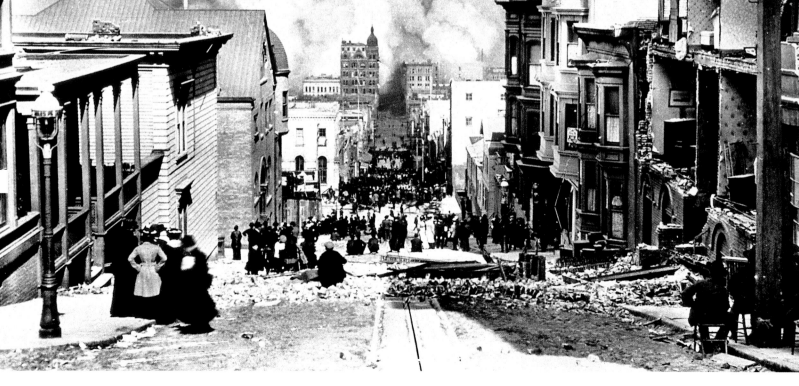

REBIRTH BY THE BAY

At 5:12 a.m. on April 18, 1906, a foreshock was felt throughout the Bay Area of San Francisco on the coast of north central California. Within a half minute a giant earthquake rent the city. Felt from the south of Oregon to Southern California, the quake ruptured some 270 miles of the San Andreas Fault. The epicenter was near San Francisco, where shocks severed gas mains and snapped electrical wires, starting fires throughout the city. The writer Jack London, living 40 miles away, saw a "lurid tower" of fire that "swayed in the sky, reddening the sun, darkening the day, and filling the land with smoke." By the time London reached the city, the devastation was so thorough that he was moved to declare San Francisco "gone." It wasn't, of course, though as many as 3,000 people were killed and 200,000 left homeless. Tent cities for earthquake refugees were established in the city's parks and they lingered for months, even years. Slowly at first—very slowly—the city rebuilt itself and was eventually reborn as one of the nation's glittering prizes, a true jewel of an urban center, a destination for the world's citizens as well as America's. Unseen in much new construction are stabilizing systems to withstand the inevitable future earthquakes. And those quakes *are* inevitable. The San Andreas Fault has gone nowhere since 1906, and the science of plate tectonics has not appreciably changed. Buildings in Los Angeles have been damaged in the last century, and highways in Oakland wrecked. Today, San Francisco is its best self: the gleaming, vibrant, exciting City by the Bay. Tomorrow is, as it will always be in this place, anyone's guess. On these pages are seen chapters in San Francisco's history. Opposite, top: circa 1850, when the city, begun as a fort and mission, is being transformed from a small settlement of 1,000 into a California Gold Rush boomtown of 25,000 overnight. Bottom: The earthquake has struck. Above, right: The Golden Gate Bridge opens in 1937. Below: Some of the famous "Painted Ladies" Victorian houses succumbed to the quake and some survived.

CLOCKWISE FROM TOP: AP; FERDINANDO SCIANNA/MAGNUM; BUYENLARGE/GETTY

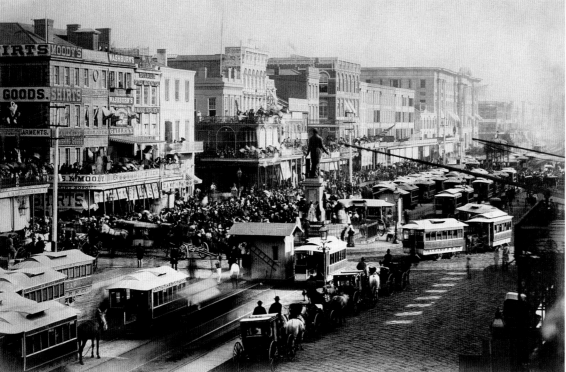

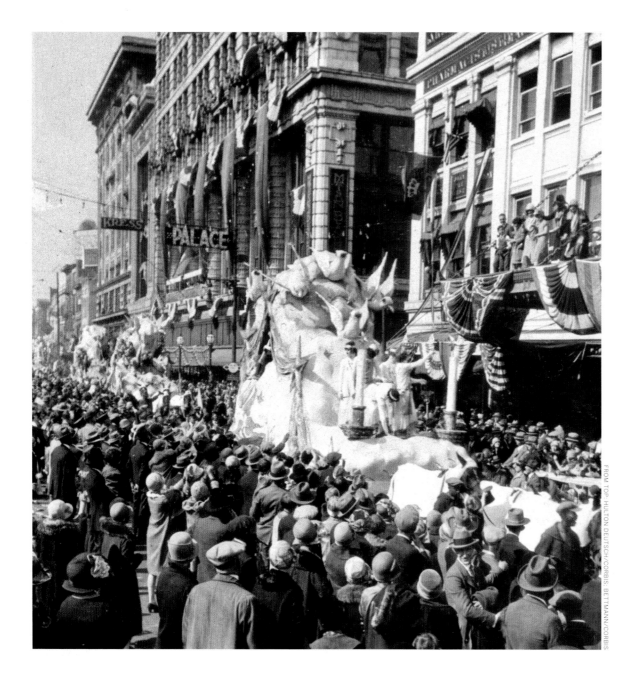

HARD TIMES IN THE BIG EASY

New Orleans has long been one of the nation's most beloved cities, cherished for its vibrancy, its romance, its parades and parties, its food and architecture and sound track—jazz. This Louisiana city, which sits near the Gulf of Mexico on both sides of the mighty Mississippi, was founded in 1718 by the French Canadian Jean-Baptiste Le Moyne, ceded to the Spanish in 1763, and given back to the French in 1801; ironically, much of the distinctive architecture that characterizes the famous French Quarter is attributable to the Spanish. Denizens of New Orleans find such quirky facts appealing, and they have long relished their multiculturalism. However, they did not, in the 1800s, embrace racial equality, despite their substantial population of free people of color: The port city was central to the slave trade in the Deep South (slaves coming through New Orleans represented half a billion dollars worth of humanity—which is to say, property). After Reconstruction, a Jim Crow government took hold, and the city boomed along (left, top: Canal Street circa 1870). In the 20th century, life went on gaily enough (bottom: a Mardi Gras parade in the 1920s), although New Orleans was shrinking in stature. What was, in the mid 19th century, one of the country's largest and most affluent cities, slid in both categories. Still, the Big Easy remained a must-visit place. And then came Katrina. In late August 2005, the huge hurricane rounded Florida, settled into the Gulf, grew to a category 5 storm—one of the largest ever measured—and stared menacingly at New Orleans. When it finally made landfall, it dealt the city a glancing blow, and there was hope. But then the floodwalls and levees began to fail under the assault of the storm surge, and 80 percent of the city went under. More than 1,500 people were killed and others are yet to be found; they may be dead, or they may have drifted into the New Orleans diaspora that spread throughout the land. Today, the city is still getting back on its feet. People are visiting again. There is gaiety in the air once more. But it will be long before things are as they were. On the opposite page, images from the aftermath, clockwise from top: On August 20, 2007, kindergartners smile as their school—the Dr. Martin Luther King Jr. Charter School for Science and Technology in the 9th Ward—finally reopens; on August 28, 2006, Mervin Campbell, a trumpeter with the Treme Brass Band, helps his son, Hector, who was born a day before Katrina hit, celebrate his first birthday; and Mennonite volunteers from Pennsylvania and New York represent only one group of humanitarians that helped to rebuild—and are helping still.

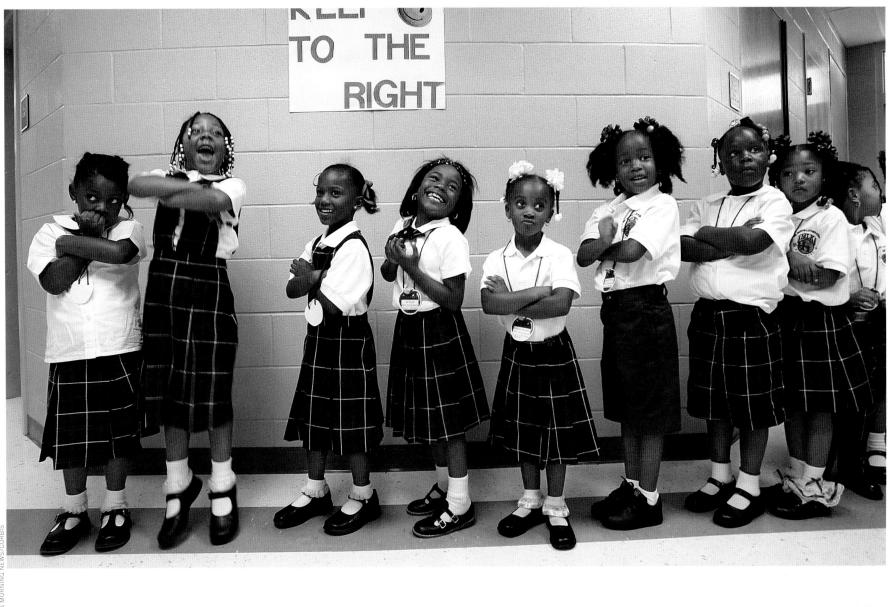

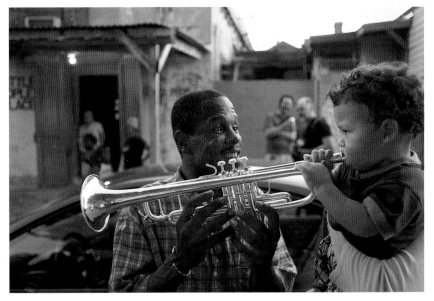

PLACES

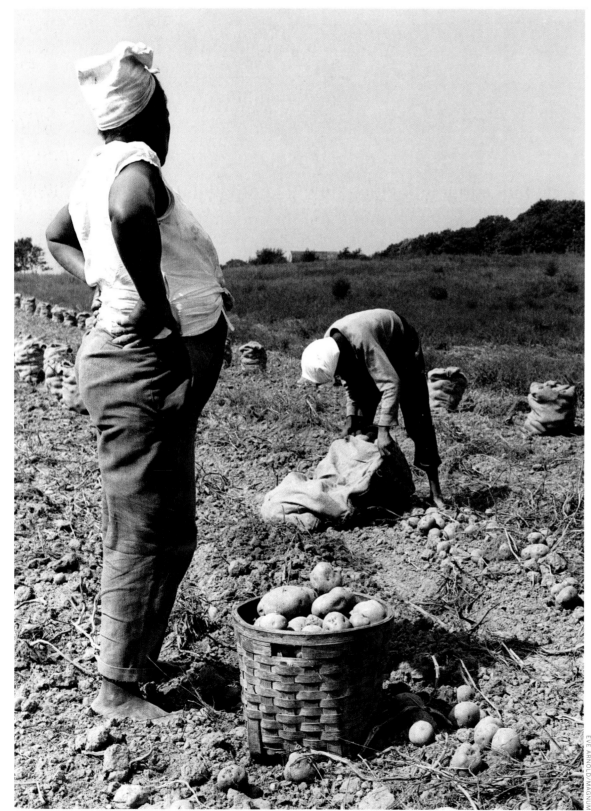

EVE ARNOLD/MAGNUM

PLOWING THE FIELDS UNDER

A brief look at New York's Long Island, an aptly named sliver of land extending eastward into the Atlantic from New York Harbor for a good many miles (118 of them), provides a stark if admittedly extreme example of the two centuries of development that occurred in many parts of the country as the United States found its way in the world. First, when the white man came, he met the natives—in this case, primarily members of one of the Lenape tribes at the western end of the island, relatives of southern New England's Mohegan-Montauk-Narragansett group. The Dutch gradually settled in the west, closer to New Amsterdam, while English Puritans colonized the east; in 1664, when the English took over New Amsterdam and renamed it New York, they also took control of Long Island. In the 19th century, Long Island was an exemplar of America's agrarian side: Corn and potato fields stretched to the horizon, and they would continue to dominate the eastern reaches for decades to come (left: migrant potato pickers in 1951). In 1883, the Brooklyn Bridge was completed, and Long Island was now connected to the city other than by boat; the western towns grew exponentially and took on the character of suburbs. Then came the postwar boom of the 1940s and '50s, as GIs returned home and set about building families. Between 1947 and 1951, the home builders Levitt & Sons established the first of their four Levittowns (opposite, top; the other three sprouted in New Jersey, Pennsylvania and Puerto Rico)—planned communities of look-alike ranch-style houses, paradigms of the modern suburbs. More than 50,000 people live in Levittown today, and some 7.7 million on Long Island, making it one of the most densely populated places in America. Opposite, bottom, left to right: a Levittown traditionalist, Polly Dwyer, president of the historical society, in front of a basically unaltered house in 2007, and Maureen Hare, standing in front of her renovated Levittown Victorian, now twice its original size, in 1996.

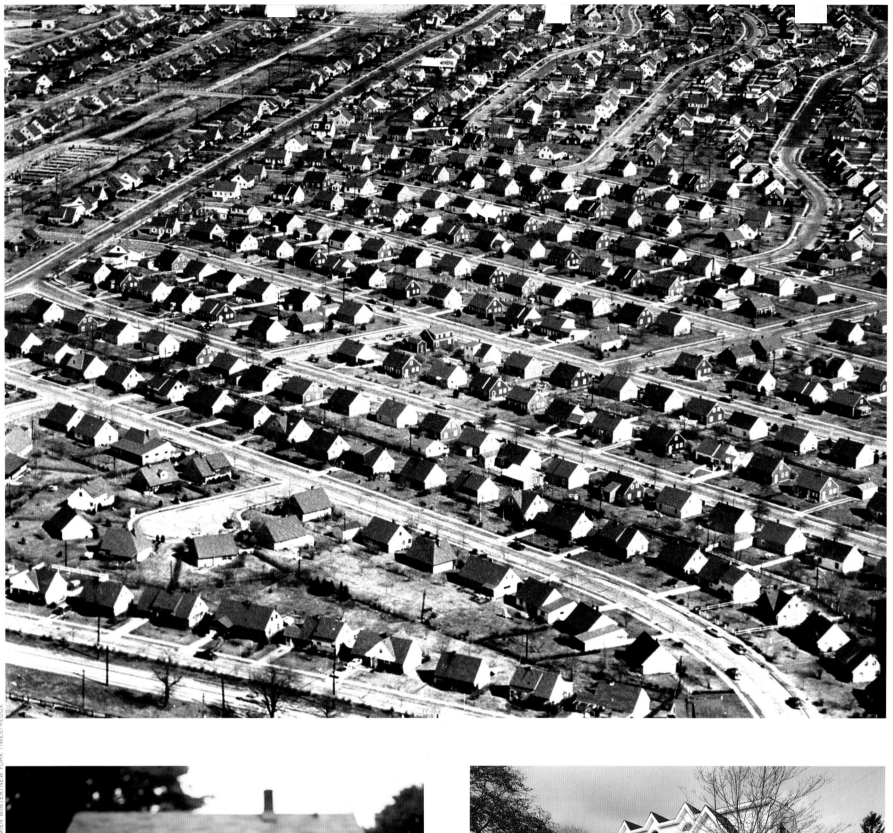

FROM LEFT: JERRY COOKE; OFER WOLBERGER

THAT OLD-TIME RELIGION

While there may be older edifices in the United States that once were places of worship—just consider all the sacred sites of the Native American that today attract tourists—the claim can be made that the First Parish in Plymouth, Massachusetts (its current building, above, left), is the oldest continuously active Christian congregation in the country. A brief look at its history is fascinating in how it comments on our Americanism. In 1608, a group of dissenters from the Church of England fled to the Netherlands from their home in Scrooby, Nottinghamshire, and established themselves in Leyden. A dozen years later, members of this church were aboard the famous *Mayflower* on its voyage to the New World. These were the Pilgrims. Now for the fun twist: The Founding Fathers, in their wisdom, protected freedom of religion, which is exactly what the Puritans had originally been seeking. In 1800, the First Parish elected to become Unitarian; as it happened this was the religion of John Adams, one of our founders, and the church is now a member of the Unitarian Universalist Association—a living symbol of America's open-minded approach to religion. At right: The Old Ship Church, also in eastern Massachusetts—in Hingham—was built in 1681 and is the oldest structure in continuous ecclesiastical use in the country. Religious trends or charismatic leaders have caught fire at regular intervals in U.S. history; some great worldwide movements, such as Pentecostalism with its 100-million-plus adherents, essentially got their start here. Among many well-known preachers through the years, charlatans and truly holy ministers in their ranks, perhaps none has touched as many Americans—and, indeed, citizens of the wider world—as evangelist Reverend Billy Graham, seen opposite, top left, at a 1949 revival meeting in Los Angeles, and at right in Daytona Beach, Florida, in 1961. Today, Rick Warren's evangelical Saddleback Church in California is where millions nationwide find solace, staying in touch through television and books if they cannot make it to the megachurch itself for services.

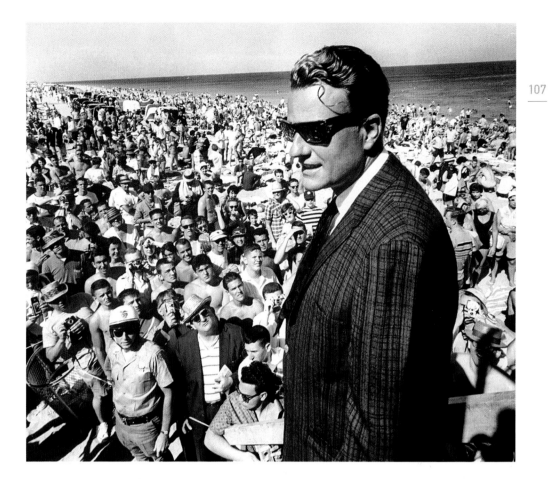

PUTTING ON A SHOW

In early America, all the world was a stage, and impromptu performances might be part of any camp meeting or Fourth of July ceremony. Itinerant troubadours and town marching bands were part of the fabric of society; barnstorming shows, like Buffalo Bill's Wild West extravaganza (page 60) and P.T. Barnum's circus, traversed the nation and brought out the crowds. Local orchestras, including the Minnesota Ladies Symphony Orchestra (opposite, top, circa 1895) became sources of civic pride. As the nation felt its growing strength, it of course wanted to measure up culturally to the Old World, whence it came. On May 5, 1891, the philanthropist Andrew Carnegie's Music Hall celebrated its opening night with a concert featuring Pyotr Ilich Tchaikovsky himself presiding—triumphantly—over a performance of his "Coronation March." In 1893, board members persuaded Carnegie to allow the hall to be named in his honor, and sometime thereafter, as the venue took its place among the world's august theaters, the famous joke was crafted: Tourist asks New Yorker on a Manhattan street corner, "How do you get to Carnegie Hall?" New Yorker answers, "Practice, practice, practice." Carnegie Hall was intended as a home for the Oratorio Society of New York and the New York Symphony Society, but it proved incapable of restricting its stage to the highbrow arts. Performers from Benny Goodman to the Beatles played there; in the present day, the YouTube Symphony Orchestra, which was assembled entirely through online tryouts, chose Carnegie Hall as the one and only place for its first nonvirtual show (right). Meantime, the American musical became a national treasure (opposite, bottom left: *No, No, Nanette* on Broadway, circa 1925), and the old camp meeting evolved into the outdoor music festival, epitomized by events at Newport, Rhode Island, where Duke Ellington and Bob Dylan made different kinds of history, and at the Woodstock Festival in upstate New York, where in 1969 half a million muddy kids did the same (bottom right).

STAN HONDA/AFP/GETTY

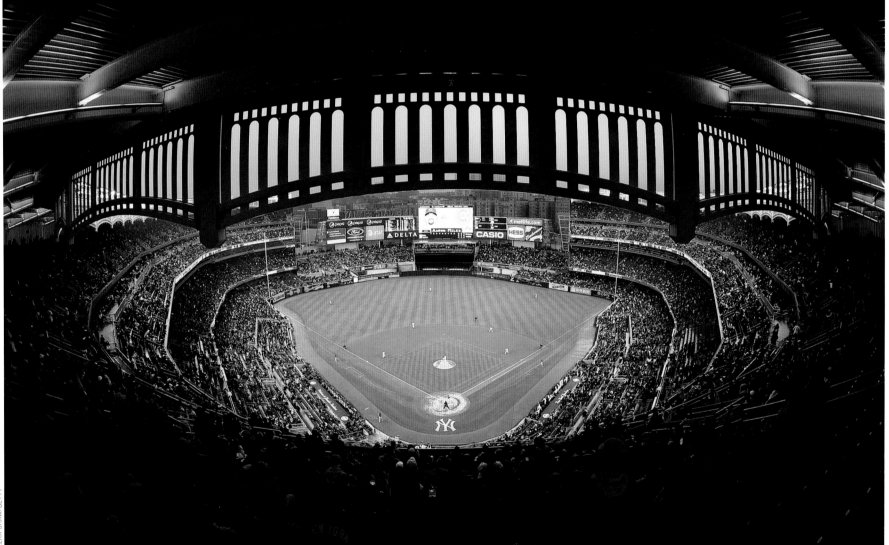

EZRA SHAW/GETTY

PLAY BALL

Baseball was not a purely American invention, having an obvious heritage in the English games of cricket and rounders, as well as in other stick-and-ball games, but it did capture the American imagination when it emerged from the sandlots of Hoboken, New Jersey, and New York City in the first half of the 19th century. (It was not, by the way, created upstate in Cooperstown in 1839 by Abner Doubleday, no matter what Major League Baseball's "official" 1907 commission decreed.) The National League was organized in 1876 and the American in 1901; and ever since 1903, the championship teams from each have met in the World Series. With the replacement of the old Yankee Stadium by the new (above) in the 2009 season, the number of venerable shrines to the game still in use in the big leagues was reduced to two: Boston's Fenway Park, where the Red Sox first took the field in 1912, and Chicago's Wrigley Field, built in 1914 and where the Cubs first played in 1916. While there is something to be said for astonishingly large Jumbotron screens and the availability of seventh-inning sushi, the charm of baseball is probably best captured in those old stadiums and, even more so, in the minor leagues or even in a local Little League. A true rarity these days is the pick-up sandlot game, an example of which, probably photographed in Washington, D.C., around the turn of the 20th century, is seen on the opposite page, top. Below is a co-ed contest from the same approximate period. Certainly no one is on steroids in those pictures. As for the players in the photo above, well . . .

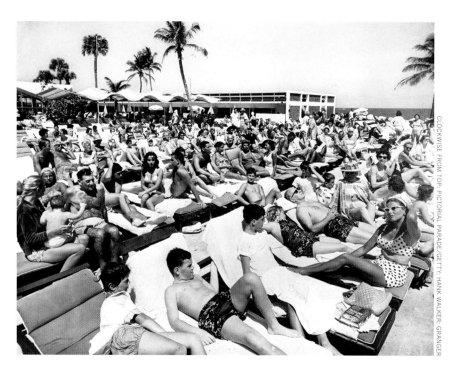

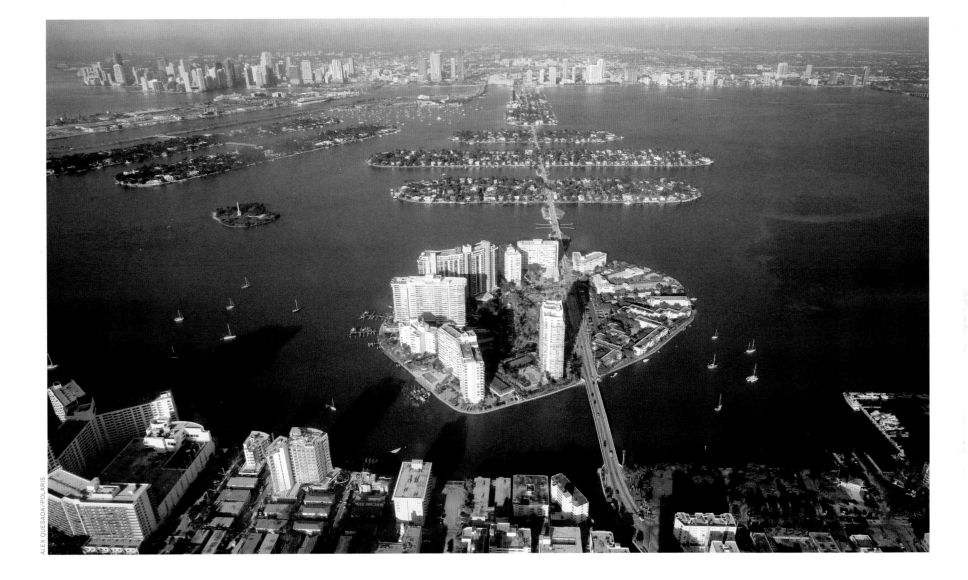

ALEX QUESADA/POLARIS

BEACHFRONT PROPERTY

American desires are manifested in many ways and in many things, among them: the manner in which we shape and develop the land to satisfy these desires. We want to ski, and so trails are cut, and then, within civic limits, condos are built to house the skiers. We want the majestic summit view in summertime, therefore railways are pushed up the mountainside to take us to the top. And we want to be close to the ocean for all sorts of reasons—to have easy access to maritime trade; to revel in the sights, sounds and feel of the waves and to breathe in the scent of the salt air. So cities grow by the seashore. The first great urban centers—Boston, New York and Philadelphia, which was once the second largest city in the British Empire after London—were founded where they were for practical and economic reasons, not merely because somebody *wanted* to be there. But later in American history, communities formed and people created cities simply because they thought one spot more pleasing—more beautiful, more manageable—than the next. In the Sunshine State a number of places are dedicated to the pursuit of, among other things, diversion. Where gleaming Orlando now sits, there was, before Disney imagined the future, a sleepy town surrounded by citrus groves. Daytona Beach and Fort Lauderdale on the east coast and Fort Myers on the west might well describe their principal industry as fun in the sun. And then there's Miami and the neighboring city of Miami Beach. If we can combine the two, together they represent one of the country's great municipalities—a sprawling metropolis that offers the full gamut of serious purpose and serious pleasure. Dozens of businesses are headquartered here and the largest concentration of international banks in the United States extends along Brickell Avenue. Meantime, tourism brings in $17 billion annually, and the sands and shops of South Beach are never empty. Miami, which was once just another Florida citrus center, has been criticized by some locals for having undergone a Manhattanization. Be that as it may, the city tells an American tale. Opposite, counterclockwise from top: South Beach circa 1910; older sailing vessels pressed into service to help overloaded railways supply burgeoning Miami are moored alongside Bayfront Park in 1925; Miami in 1959. Above: Downtown Miami as seen from Miami Beach in 2008. The bridges and artificial islands between were built in the '20s.

PLACES

THE 50th STATE

The United States was already well on the way to figuring itself out when it first developed an interest in a distant chain in the Pacific Ocean called the Hawaiian islands (Hawaii itself is the biggest of them; the capital and largest city, Honolulu, is on Oahu). Nothing America had assimilated previously was as foreign or exotic as this. Hawaii's culture was Polynesian; it had little in common with California, never mind Washington or New York. Just five years before the U.S. annexed Hawaii in 1898, it was ruled in its traditional manner by a monarch, Queen Lili'uokalani (below, top left); she was deposed in 1893 and succeeded by a "president" of the republic, S.B. Dole, he of the eponymous pineapple company (sugar cane and pineapples have long been staples of Hawaiian industry, along with coffee, rice and cotton). Tourism, which is now Hawaii's calling card, began in the 19th century and was growing apace by the 1930s, but this of course was interrupted during World War II, which was entered into by the United States after the infamous Japanese attack on Pearl Harbor on December 7, 1941. Hawaii was formally proclaimed the 50th state on August 21, 1959, and the push-pull between what it *now* was and what it *really* was grew even more intense. The United States, particularly its visiting citizens, wanted Hawaii to remain Hawaii—and yet be American. In the present day we have Volcanoes National Park on the so-called Big Island (bottom left, early 20th century visitors singeing their postcards at cracks in Kilauea's hardened lava), luaus at four-star resorts, world-class surfing tournaments on the north beaches (below, right, and opposite: riding the waves in the 1940s and today). Hawaii has changed in places and in certain ways. But on Kauai's Na Pali coast and in the backcountry wilderness of Molokai, little has changed except the traffic. The most exotic state in the union is exotic still, if altered.

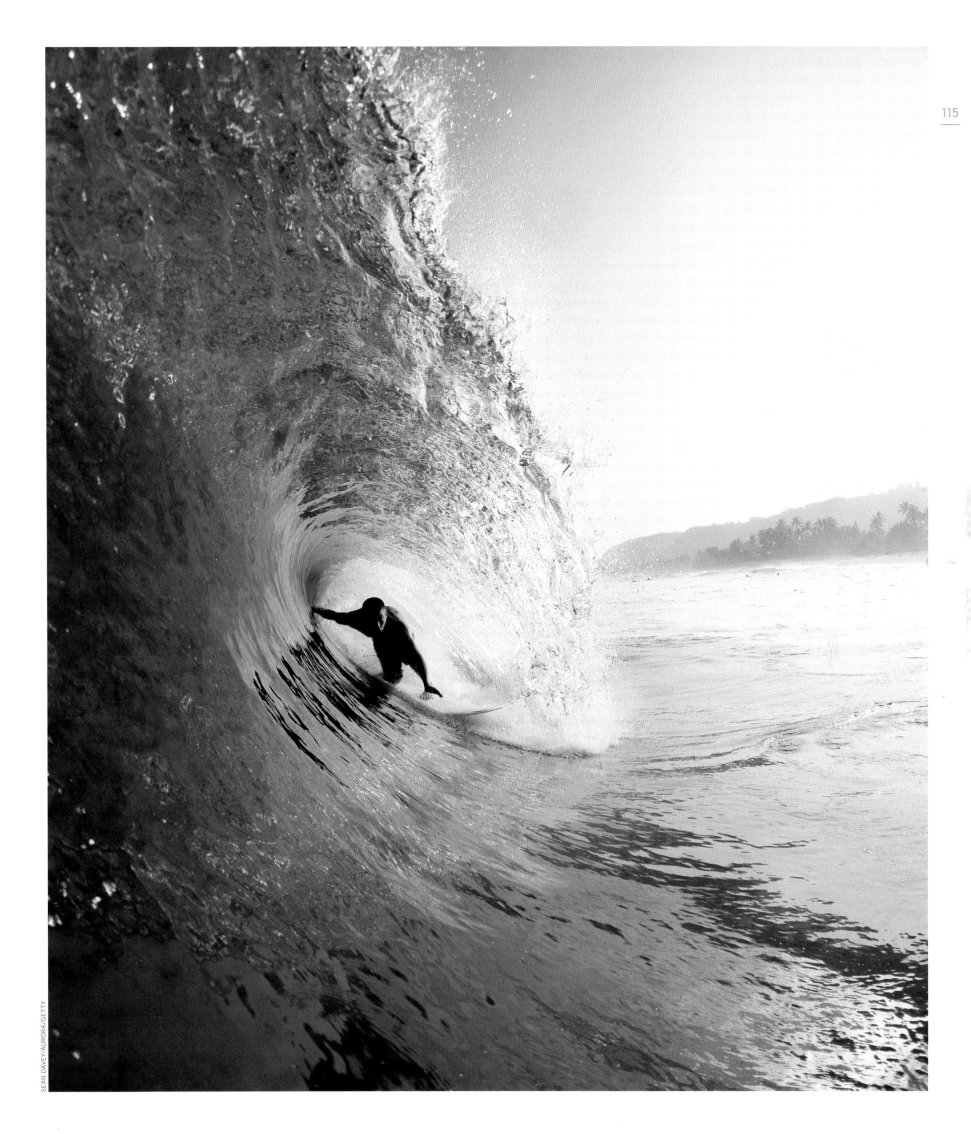

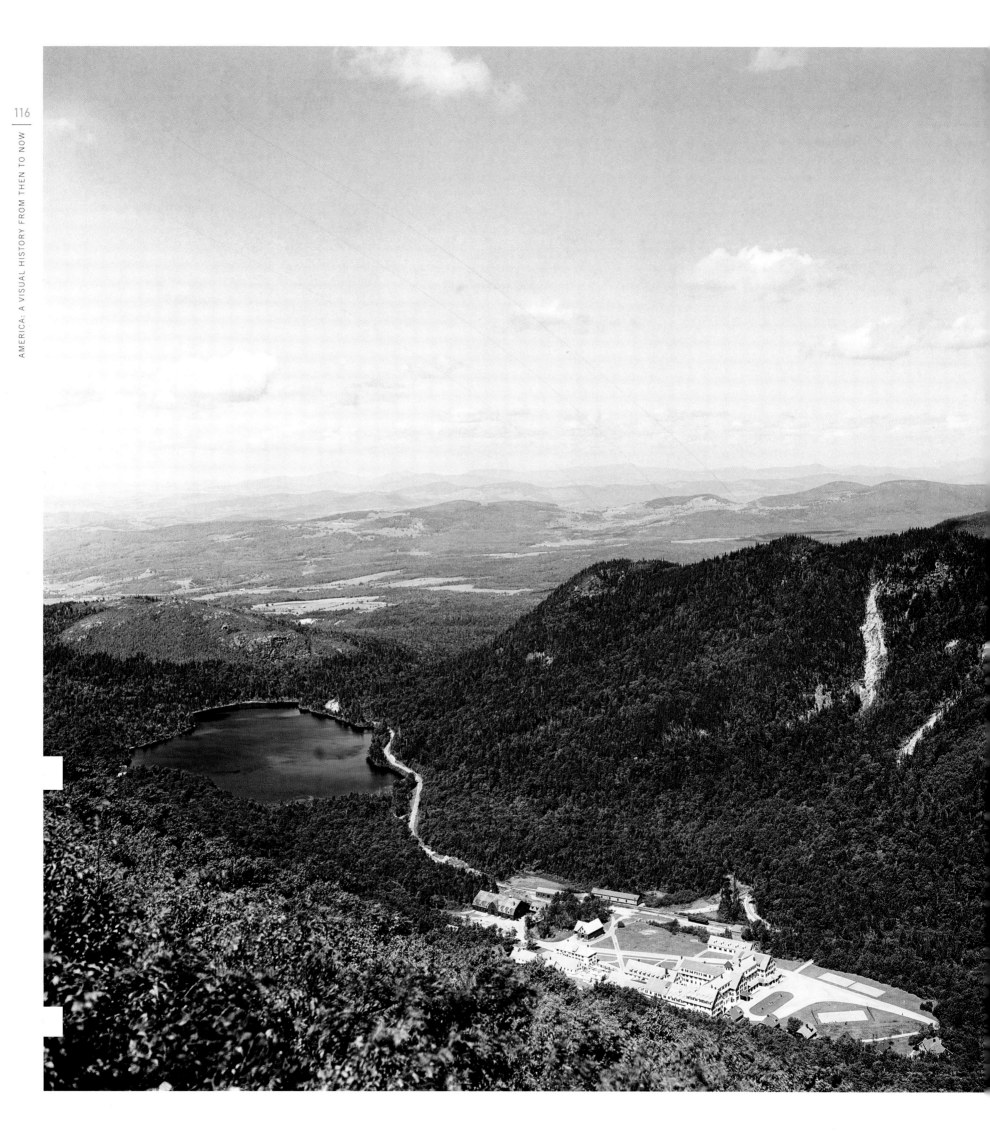

GRANGER

NATURE'S WAY

Having traveled the land, telling stories of sites preserved and sites transformed, we wend our way back to the Northeast, where the European experience in America took hold long ago, and where the nation was born with the shot heard round the world. In New Hampshire there had been, since time immemorial, a rather extraordinary rock profile that looked quite like a man. Nathaniel Hawthorne called attention to it in his story "The Great Stone Face," and Daniel Webster romantically saw it as a sign from God asserting that "in New Hampshire, he makes men." The Old Man of the Mountain grew in fame and became not only the state emblem but a tourist attraction of the highest order; folks from Massachusetts and beyond were more than willing to make the trip north not least because the Old Man was surrounded by so much attendant natural beauty in the canyon called Franconia Notch. To handle the influx of sight-seers, the high-end Profile House was established and thrived (left, circa 1900). Then, like too many other great hotels in the mountains, it was destroyed by fire in 1923. The owners put their 6,000 acres of property up for sale, and the likeliest bidders by a long shot were the logging interests. Clear-cutting had already denuded much of the gorgeously green New Hampshire woods, and friends of Franconia Notch rallied. They began a nationwide campaign—the Old Man again a potent symbol—and with schoolchildren pitching in pennies and women's clubs from all over the country offering more, $200,000 was raised in relatively short order. The Save the Notch campaign bought the land, and in 1928 it became part of a newly created state park. Today, it is all part of the National Forest system, and protected forevermore. Well and good . . . except for the fate of the Old Man himself. The great face, which had been known to be weakening, was buttressed for decades by steel cables and supports, but finally, overnight on May 3, 2003, it crumbled to the valley floor (below, left and right: before and after). It remains on the state emblem and on LIVE FREE OR DIE bumper stickers throughout New Hampshire. But, in fact, it no longer exists. Meanwhile, the trees it helped save grow taller.

FROM LEFT: JOSE AZEL/AURORA; JIM COLE

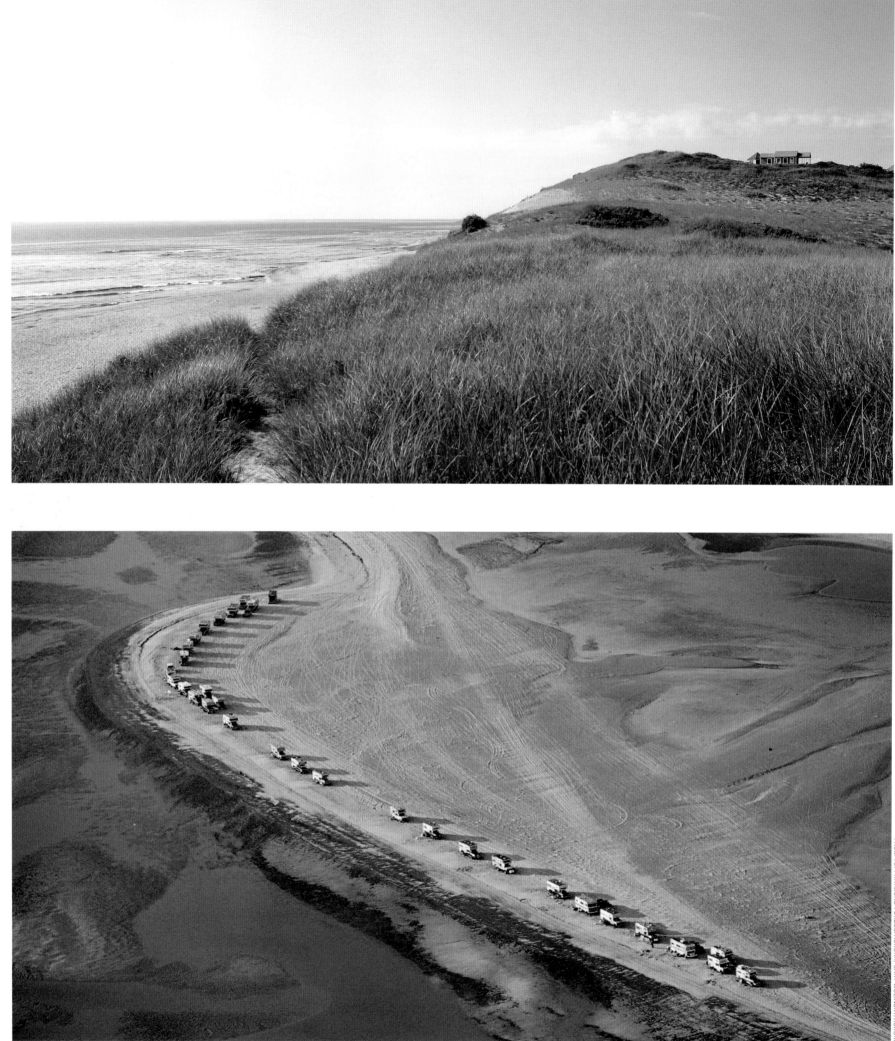

SOME THINGS HAVE
NEVER CHANGED

A stone's throw from where the Pilgrims landed is Massachusetts's Cape Cod, a northward curving peninsula with a protected inner harbor and a southern exposure to the Atlantic. Back when, the Cape was a desolate place. Today, the Friday evening traffic on the Bourne Bridge leading onto the Cape is simply not to be countenanced. And yet, the ocean-facing beach that is protected within the Cape Cod National Seashore is much as it has ever been. Yes, there are perils concerning luxurious houses built too high, peaking over the dunes at intervals. And, yes, as the naturalist John Hay pointed out in his book *The Great Beach*, the Cape changes daily with the tides and weather. But the beach that Henry David Thoreau described in the mid 19th century is much the same today, and the same intangible profits can be derived from a communion with it. Henry Beston, writing roughly halfway between Thoreau and Hay in his 1928 classic, *The Outermost House*, which is an account of a year spent living on the Great Beach, captured nicely what might be gained and what was certainly worth preserving: "Whatever attitude to human existence you fashion for yourself, know that it is valid only if it be the shadow of an attitude to Nature. A human life, so often likened to a spectacle upon a stage, is more justly a ritual. The ancient values of dignity, beauty, and poetry which sustain it are of Nature's inspiration; they are born of the mystery and beauty of the world. Do no dishonour to the earth lest you dishonour the spirit of man. Hold your hands out over the earth as over a flame. To all who love her, who open to her the doors of their veins, she gives of her strength, sustaining them with her own measureless tremor of dark life. Touch the earth, love the earth, honour the earth, her plains, her valleys, her hills, and her seas; rest your spirit in her solitary places. For the gifts of life are the earth's, and they are given to all, and they are the songs of birds at daybreak, Orion and the Bear, and dawn seen over ocean from the beach." Scenes from the Cape today: The beach at Truro (opposite, top); at Barnstable during a campers confab (bottom); and, right, at Chatham.

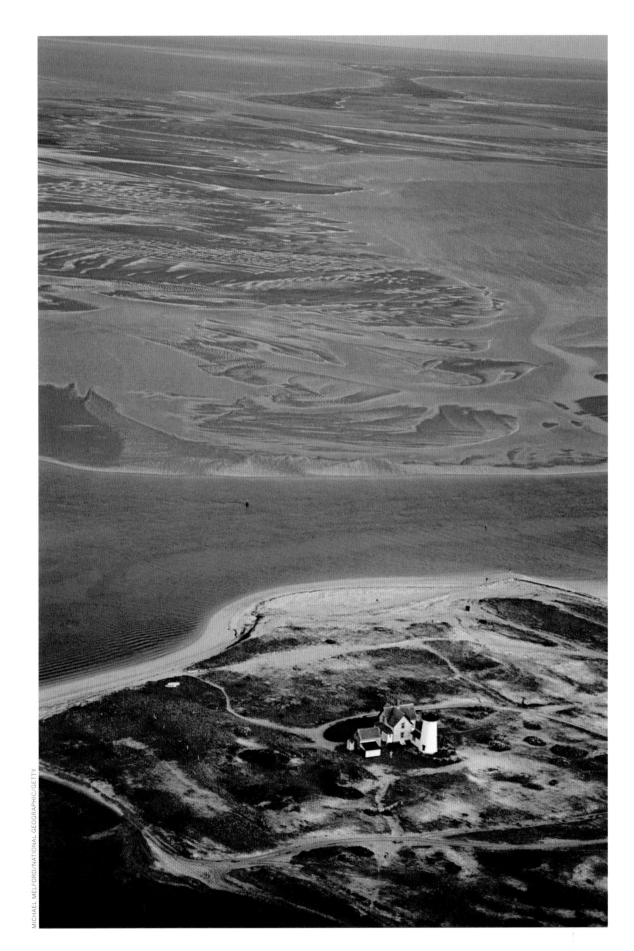

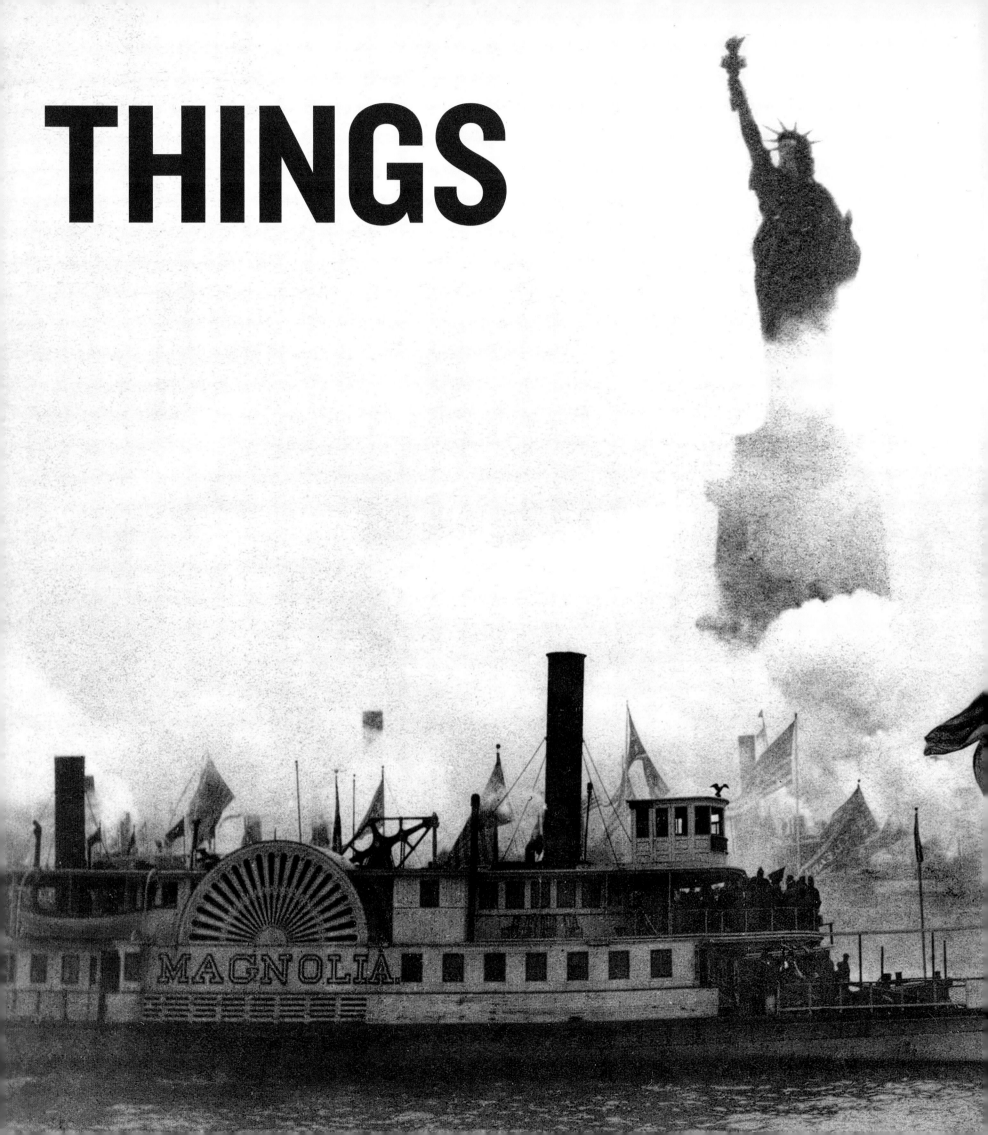

THINGS

MAGNOLIA

"Liberty Enlightening the World" was not a boastful title for the massive new sculpture in New York Harbor when this great symbol of freedom and democracy was dedicated on October 28, 1886 (the ceremony, seen here)—because, quite simply, the title was not bestowed by an American. The monument was a gift of friendship from the people of France, offered in appreciation of what the United States had, in their perception, already become.

THINGS

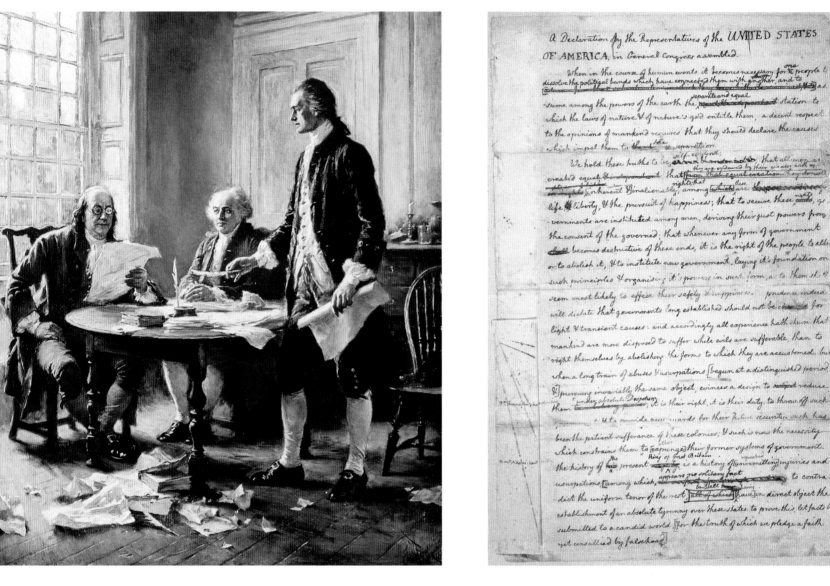

WORDS AND DEEDS

The 13 colonies had already been at war with Great Britain for more than a year when the Continental Congress adopted, on July 4, 1776, a document explaining why, two days earlier, the delegates had voted to formalize their split with the motherland. The Declaration of Independence, principally written by Thomas Jefferson (above left, at right), with the strong influence of Benjamin Franklin (at left), John Adams (in center) and others, is an eloquent, inspirational and never airy document, as strong on substance as on style. "We hold these truths to be self-evident, that all men are created equal, that they are endowed by their Creator with certain unalienable Rights, that among these are Life, Liberty and the pursuit of Happiness." From this general principle, the Declaration went on to enumerate complaints about the regime of King George III that, in the colonials' view, infringed upon those unalienable rights and made allegiance to the Crown untenable. Fifty-six delegates signed, most boldly the Congress's president, John Hancock of Massachusetts, whose elegant "John Hancock" was nearly five inches long. That signed copy of the Declaration is housed today in the National Archives; several other first-edition copies, including one that Jefferson kept and called the "original Rough draught" (above, with Franklin's edits), also still exist. The "fair copy" that had been submitted to Congress on June 28—the actual copy that was approved on July 4—is gone, maybe ruined in the printing process. While the Continental Congress was working in Philadelphia in 1776, George Washington was out in the field, leading the troops. Seven years later, with nationhood secured, Congress approved the erection of an equestrian statue to honor the great general, and in 1791 a site was selected for it in the Federal City plan that would lead to the creation of Washington, D.C. Lack of funds delayed the project over and over, new designs were drawn, the site was changed, the Civil War intervened, and the monument wasn't dedicated until February 21, 1885, more than a century after first being proposed. The 90,854-ton white marble–faced monument on the Mall (opposite, top, under construction in 1876; center, its spire in 1884; bottom, serving as a dirigible dock in 1932; and right, during the famous March on Washington for Jobs and Freedom in 1963) should mean the same thing to the world as do the words of the Declaration: liberty.

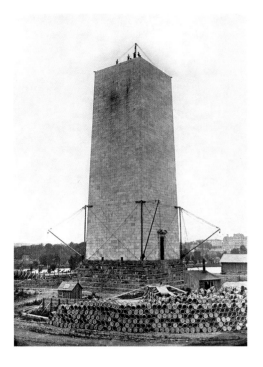

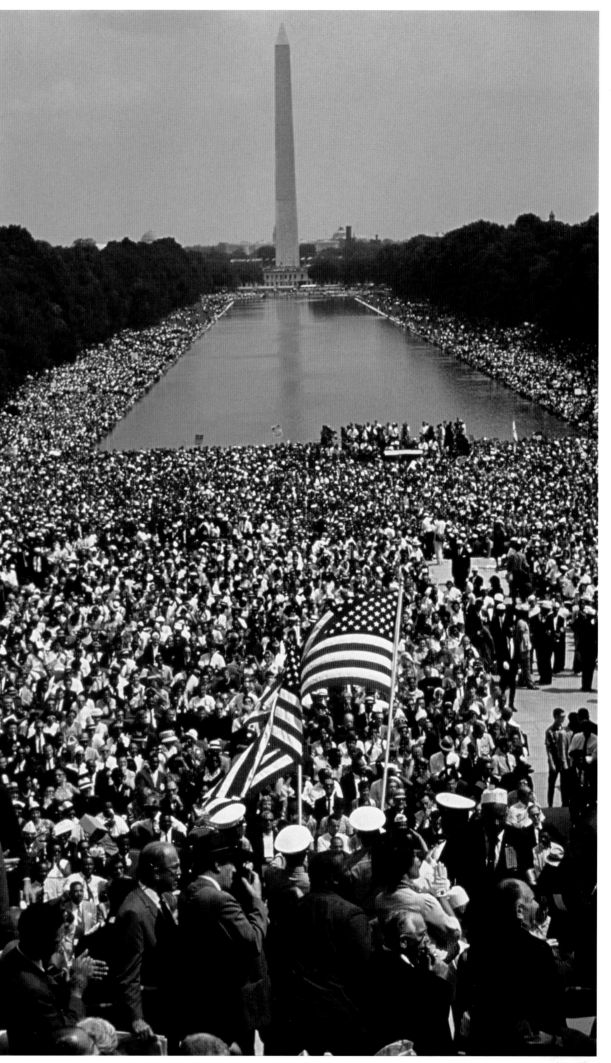

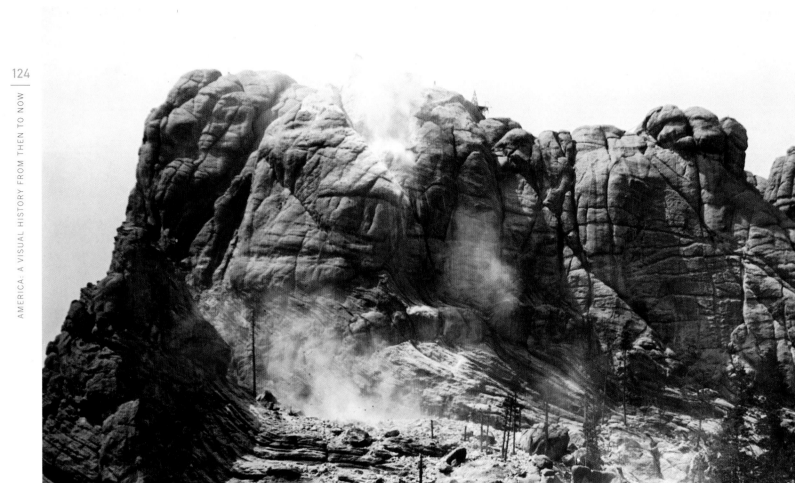

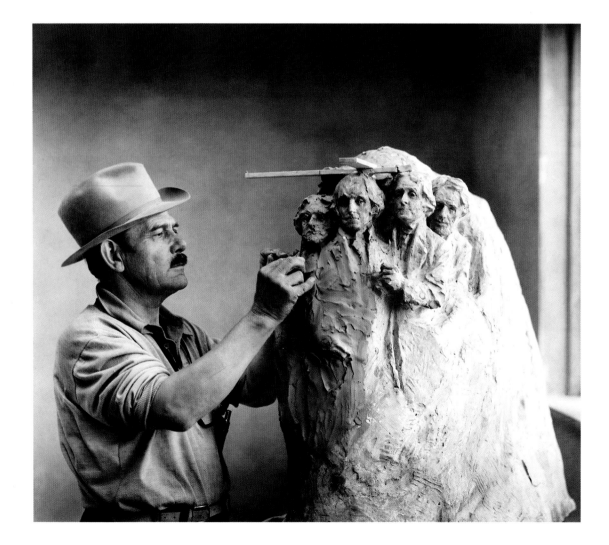

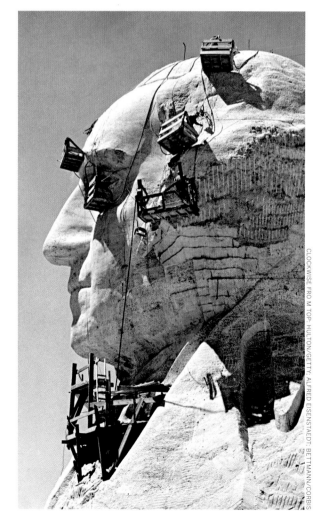

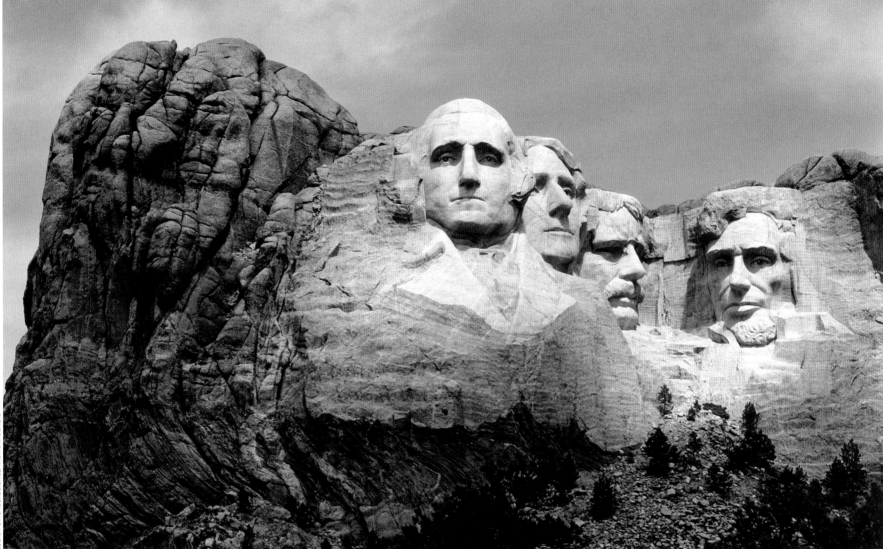

WHY IS IT CALLED RUSHMORE ANYWAY?

Doane Robinson of the South Dakota Historical Society had an idea for boosting tourism in his state: What if someone carved statues of Western heroes like Buffalo Bill and Lewis and Clark into the Black Hills? In 1924, he contacted the prominent American sculptor Gutzon Borglum, who had been influenced by Auguste Rodin while studying in Paris. Borglum became entranced but wanted to work on a national scale (opposite, bottom left, with his first model of the monument). George Washington came to mind. After the city that was named for our first President got involved, with Congress authorizing the Mount Rushmore National Memorial Commission in 1925, President Calvin Coolidge insisted that two Republicans and a Democrat be part of the assemblage. Lincoln seemed a natural (even though Borglum was a card-carrying member of the Ku Klux Klan) and Jefferson too. Theodore Roosevelt brought the sculpture into the 20th century. "The purpose of the memorial," said Borglum, "is to communicate the founding, expansion, preservation and unification of the United States with colossal statues of Washington, Jefferson, Lincoln and Theodore Roosevelt." (Apparently the fact that Roosevelt had proclaimed an earlier Borglum statue "first-rate" had absolutely nothing to do with TR's nomination.) The carving of Mount Rushmore—accomplished with dynamite (opposite, top, an early blast), jackhammers, drills and chisels—began on October 4, 1927, and finished shortly after Borglum's death in 1941. But during those 14 years, only six and a half years of work was done. Weather often interfered; also money kept running out and hiatuses were called. The project, which displaced 450,000 tons of rock and resulted in four distinctive 60-foot heads that can be seen 60 miles away—at present it's the biggest sculpture in the world—finally cost $900,000. Now the footnote: The largest single private donation to the effort was $5,000 made by a lawyer in New York City, one Charles E. Rushmore. He had been in the Black Hills in 1885 to check on some property titles for an eastern mining company. At one point, he had asked his guide, the prospector Bill Challis, the name of that impressive mountain over there. "Never had any," said Challis. "But it has now. We'll call the damn thing Rushmore." And so, with his contribution to the project, Rushmore was investing in his own immortality.

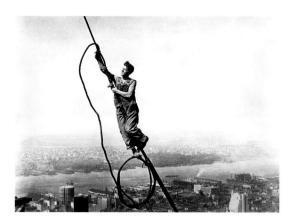

REACHING FOR THE SKY

As noted earlier, New York City has been home to a collection of skyscrapers, one after the other becoming, upon its completion, the world's tallest. Though no building in the Big Apple currently holds that distinction, a former champ still possesses its luster as one of the most wondrous structures ever built. We are not alone in that opinion. In 1996 the American Society of Civil Engineers, having conducted a worldwide survey, issued their list of seven wonders of the modern world, and retained the Empire State Building, rightly acknowledging that it had remained "the best-known skyscraper in the world, and was by far the tallest building in the world for more than 40 years." The ASCE added pointedly: "The building's most astonishing feat, however, was the speed in which it rose into the New York City skyline. Construction was completed in only a year and 45 days, without requiring overtime. [On this page are pictures from 1930 and '31, including one, top left, that shows a recently completed Chrysler Building, then the record-holding skyscraper, in the background.] Ironworkers set a torrid pace, riveting the 58,000-ton frame together in 23 weeks, while just below them, masons finished the exterior in eight months as plumbers laid 51 miles of pipe and electricians installed 17 million feet of telephone wire. The building was so well engineered that it was easily repaired after a bomber crashed into it in 1945. The precise choreography revolutionized the tall-building construction industry." Civil engineers are wont to gush over 58,000-ton frames and 17 million feet of wire, but a factor equal to the technological achievement in the building's fame has been its aesthetics. At its dedication, Depression-era masses cheered (and were cheered), and nothing in the intervening decades has served to diminish the tower's charisma. Sadly, it returned to its former status as New York's tallest building with the tragic events of September 11, 2001. Regardless, the Empire State Building would have always been the world's iconic urban tower, a skyscraper's skyscraper.

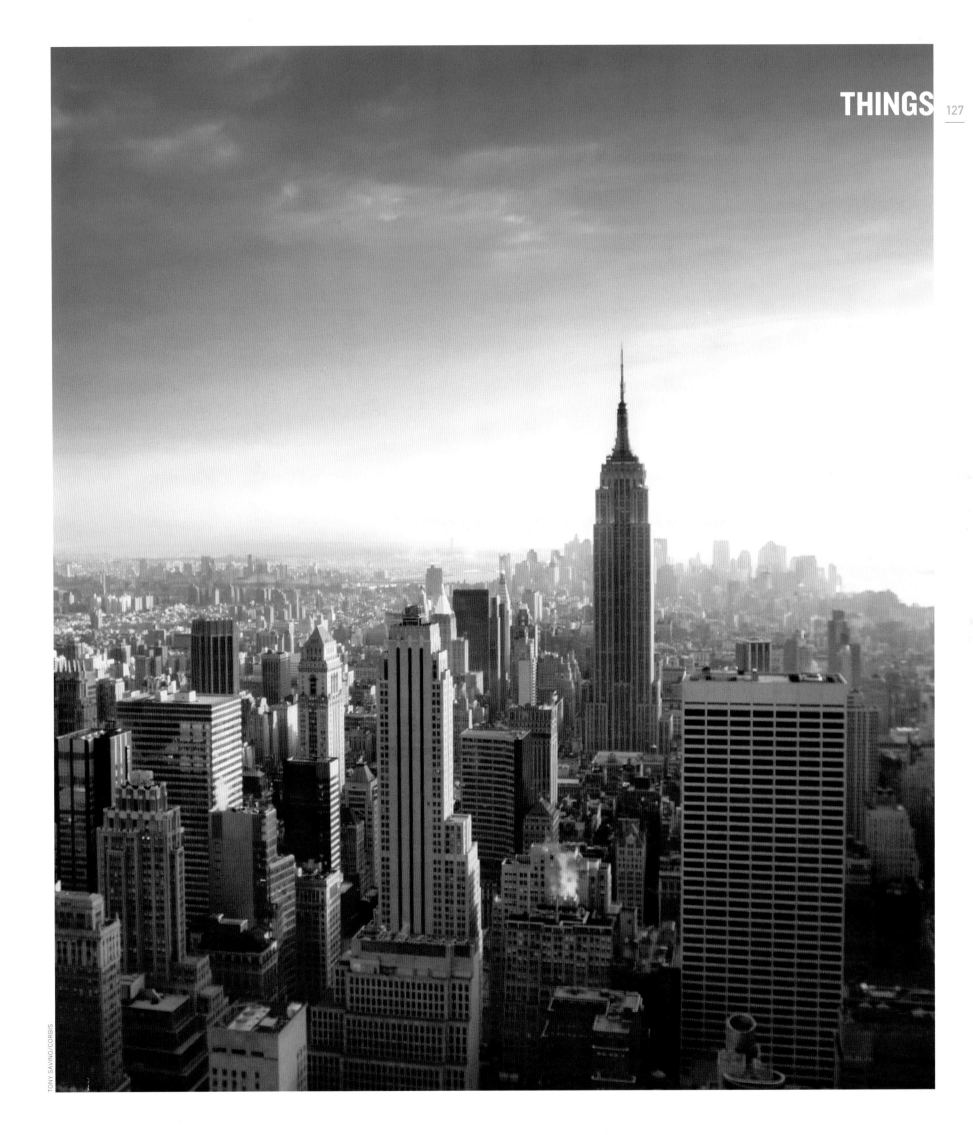

THINGS

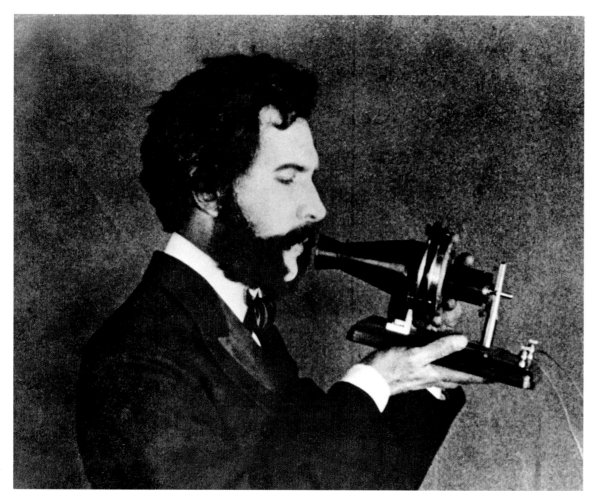

CAN YOU HEAR ME NOW?

Between the eras influenced by two great American innovators, Alexander Graham Bell (left, with his Centennial telephone at the Philadelphia Centennial International Exhibition in 1876; below, his lab in Boston) and Steve Jobs (opposite, unveiling Apple's iPhone in 2007), lies more than a century of evolution in the way Americans can and do converse that is nothing short of stunning in its scope. Even before Bell secured his "master patent" for his phone, considerable energy was being poured into experiments in voice transmission by a number of inventors, including Thomas Edison, who engaged Bell in quite a sprint to the finish line. Bell won this race (though, of course, Edison won plenty of others), and on March 10, 1876, when he uttered, "Mr. Watson, come here, I want to see you," the way humanity communicated was forever altered. The telephone became an essential device in the American household, and in modern times it has become something of a human appendage. With the recent explosion of computer and digital technology, this formerly straightforward device has changed by leaps and bounds on an almost annual basis. First there were cell phones replacing landlines, and then camera phones and music-playing phones and BlackBerries. Now, millions of phones sold each year are "smart"—some of them seem smarter than we are. Apple's iPhone was introduced by Jobs at the 2007 MacWorld Conference in San Francisco to extraordinary fanfare and has already sold nearly 25 million units worldwide. It can play you a Beethoven symphony or a Beatles album, summon an old episode of *The Sopranos*, tell you where you are and where you want to go, clue you in on the latest news from Afghanistan, take a picture of your puppy and send it to Aunt Agnes, dispatch a quick note to your daughter at college, launch a plethora of apps that can distract you for the rest of the day . . . and, oh yes, it can place a phone call. Alexander Graham Bell may not spin in his grave, but he surely boggles.

129

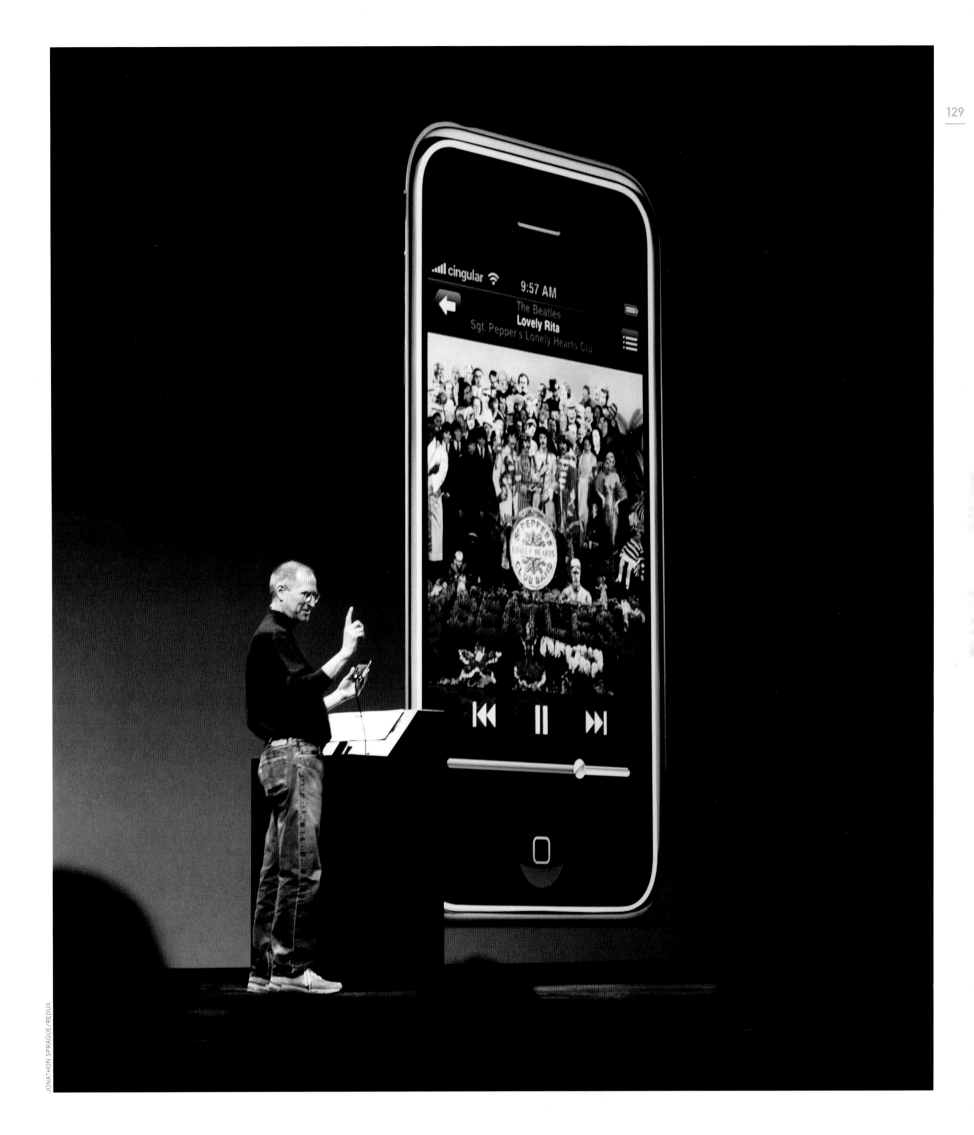

JONATHON SPRAGUE/REDUX

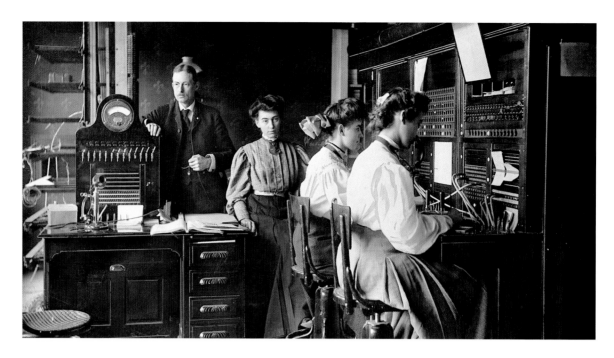

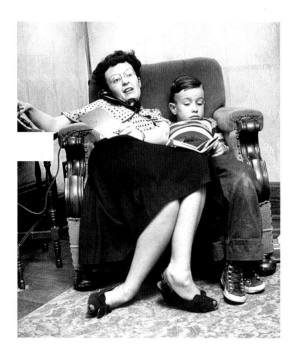

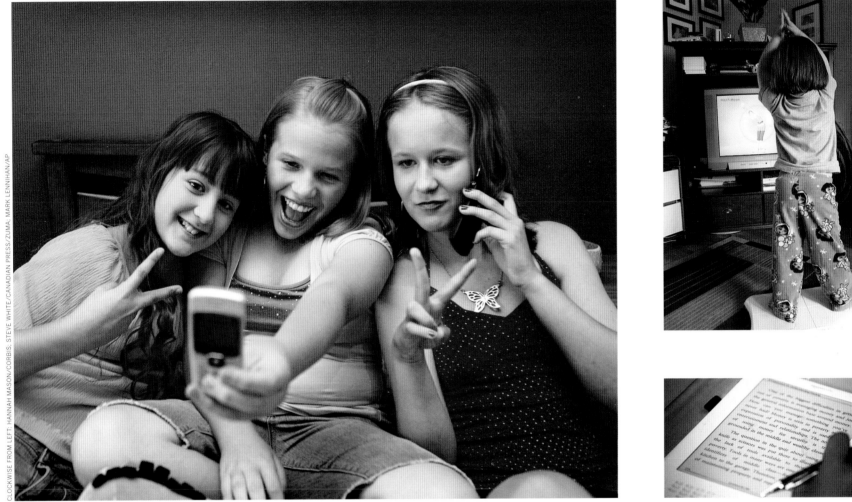

CLOCKWISE FROM LEFT: HANNAH MASON/CORBIS; STEVE WHITE/CANADIAN PRESS/ZUMA; MARK LENNIHAN/AP

TALK TO YOU LATER

The telephone has changed life in America and indeed throughout the world—slowly at first, and then thoroughly. On these pages we see a visual biography of the phone. One year after Bell called to Thomas Watson, the Bell Telephone Company was formed, and by the end of 1877 there were 3,000 phones in the U.S.; this was clearly a luxury device. By mid 1878, 10,000 phones were in use, principally in New England, and the first manual switching board, which allowed numerous phones to be connected through a shared exchange, became operative in New Haven, Connecticut. Its initial operators were teenage boys who proved to be too rude for the assignment and were replaced by "calm and gracious" women (opposite, top right, the telephone exchange for the village of Hamburg, New York, circa 1908). The innovation of the switchboard allowed phone service to travel west; meanwhile, Bell Telephone was winning a skein of lawsuits against competitors and growing into a mighty monopoly in urban centers, as independent networks cropped up in small towns and rural territories ignored by the company. By the turn of the century, there were 800,000 Bell phones in service in the U.S., as well as 600,000 independent instruments. Clearly, a boom was on, and there was no stopping a communication phenomenon that would become a part of life's essence worldwide (top left, a Victorian-era young woman is exercising a newly gained freedom to talk with a friend, unchaperoned, circa 1890, and center left, an American trains natives of Papua, New Guinea, in Morse code in 1962) for people from government leaders to business titans to, perhaps most intensely, teenage girls with essential information to convey. (Opposite, bottom left, Mrs. Glenn Carriker chats on the phone while her son reads in 1950, and the following year Toni Riddleberger, right, delivers the scoop on her latest boyfriend.) Even while phones evolved to ever more sleek, easier-to-use models, their essential utility remained the same, and no one could have predicted the astonishingly fast development in computers and communications technology in recent decades. After the Steves—Jobs and Wozniak—told Americans that everyone could and should have a personal computer with the introduction of the first Mac in 1984, everything changed. Today, people talk to one another via the Internet through their laptops, and many households have no landline phones at all, with each member having a personal cell (above, left, three Australian girls interact with their phones). Texting has replaced an actual phone call for many, and meantime, related digital-age advances have transformed the way we entertain ourselves (a young girl on a Nintendo Wii, top right) and even how we read (Amazon's Kindle DX, bottom right). Will books become relics? For that matter, will telephones?

THINGS

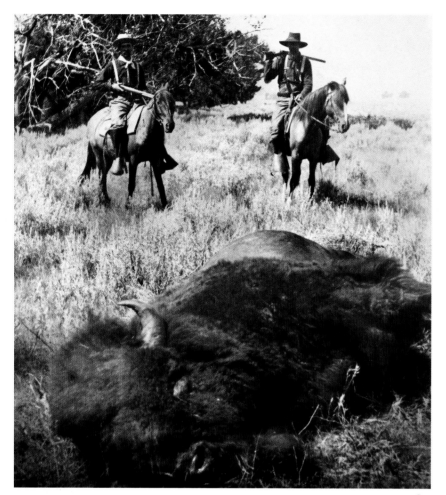

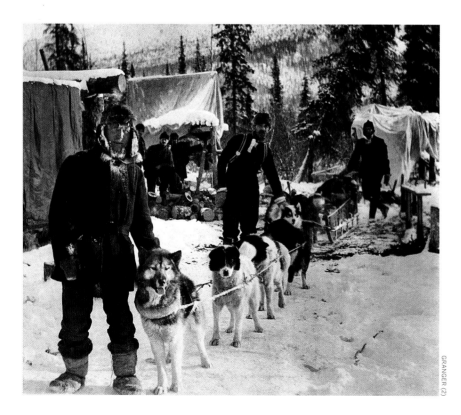

GRANGER (2)

MAN'S BEST FRIENDS

The evolution of the attitude Americans take to the other creatures that share our land has been remarkable. In a way, you can say it has come full circle—as Native Americans revered many specific animals that played important roles in their spirituality (still today, only Native Americans may legally possess eagle feathers in the U.S., an exemption that pays due deference to the status of that bird as a potent symbol in many tribal rituals). Back then, the Indians regarded animals highly, and today many millions of Americans do, to the extent that there are conservation laws on the books and the pet industry is a multi-billion-dollar enterprise. It has been, however, a long road for white America to this relatively peaceable kingdom. In the 18th and 19th centuries, animals were seen alternately as a nuisance, as a source of food or as beasts of burden. Consider the American bison, which once churned up thunderclouds of dust in the days when 100 million of them roamed the North American plains in massive herds, but which were, in the post–Civil War era, hunted to near extirpation (top left, an 1882 hunt in Montana). Consider the wild turkey, which was also hunted for its meat and hounded from its native habitat throughout the Lower 48 by human development; where once there were millions of turkeys coast-to-coast, the population had been reduced to perhaps 30,000 by the early 1900s. But consider also the happy lot of the dog, whose mission once was to pull the sledge (bottom, north of Arctic City, Alaska, circa 1900), guard the sheep or help in the hunt, and is now more often to serve as a beloved companion to us humans. So much has changed in the way we regard animals, and it can be said that the change began in the 1800s with the radical thinking of naturalists such as Thoreau; the twin notions of conservation and preservation became considerations in the way Americans regarded not only their green spaces but also their four-legged, furry or feathered friends. For some lucky species, efforts to save them came early enough, and extinction was avoided. Also, Americans of many stripes found that there was much to love in a companionable pet. Dogs and cats came into not only the home but the bedroom (and in the case of Paris Hilton's pooch, the purse). Today, the bison is back, even if its population in the U.S. is only 350,000, with perhaps as few as 3,500 roaming wild in a herd in Yellowstone; the turkey has returned to much of its range; and the dog is man's best friend. Retrievers that once would have been asked to compete in the field are now asked to do so against exotic species like the komondor (opposite, bottom left) on the big stage in Gotham's Madison Square Garden during the Westminster Kennel Club dog show, which of course is televised nationally. Giant pandas like Yun Zi (top) are born in U.S. zoos—in this case, the one in San Diego in 2009. Piano-playing cats like Nora (bottom right) become YouTube sensations and are awarded Cat of the Year honors by the ASPCA. Animals exalted!

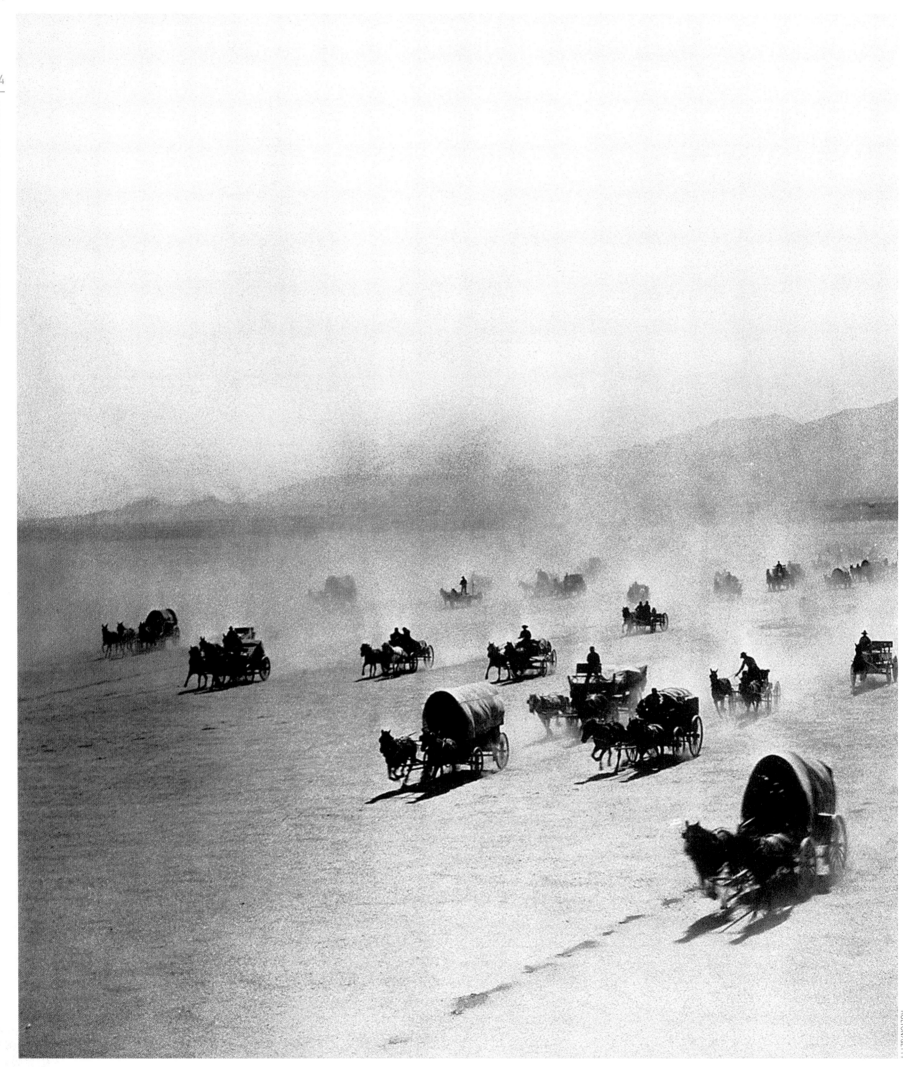

TOM ERVIN/GETTY

A HORSE OF A DIFFERENT COLOR

No animal was as important to the development of the vast United States and, today, plays such an altered role as the horse. For many decades, its twin raisons d'être were toil and transportation (which of course was, for the horse, another form of toil). The Spanish brought horses to America, and Native Americans became expert at training them. The domesticated North American horse, from the first, brought people from here to there. Then it pulled the coaches and the plows. It was the underpinning of the Pony Express mail service and was a crucial player in so many of the nascent nation's crucial industries and efforts: communications, farming, westward expansion (opposite, pulling the wagons in Oklahoma). It served in times of war. George Washington was a large man for his day, more than six feet tall, and he was among the finest equestrians in the land; it was said that he inspired confidence in his troops in part because, seen from a distance as he rode the rim of an encampment, he cut such an impressive figure on his horse. During a crucial battle in the Spanish-American War, Teddy Roosevelt charged up San Juan Hill on a steed as vigorous and strong as he was himself. The horse was the essential American animal. And then, suddenly, it wasn't. The piston engine was invented, and in a time frame that can be termed "almost overnight," the purpose of the horse in the United States became unclear. The animal drifted from the fore to the background of the American experience. It was still used by cowboys riding the range, to be sure—and still is today, to a lesser extent—and by mounted police in the big cities, but the horse's status as an everyday necessity that was just as important as the modern automobile or tractor or front loader was bygone. This noble animal does continue to provide weekend recreation for riders and competes every four years in the Olympics—and each spring, the three-year-old Thoroughbreds draw the nation's attention when the Triple Crown of American horse racing opens with the Kentucky Derby—but lost in time is the day when the great American hero and his horse were one. Above: In 2003 in Coconut Creek, Florida, a horse performs one of its most worthwhile contemporary tasks, offering therapy for eight-year-old Michael Dedrick-Dwyer, who has cerebral palsy and autism.

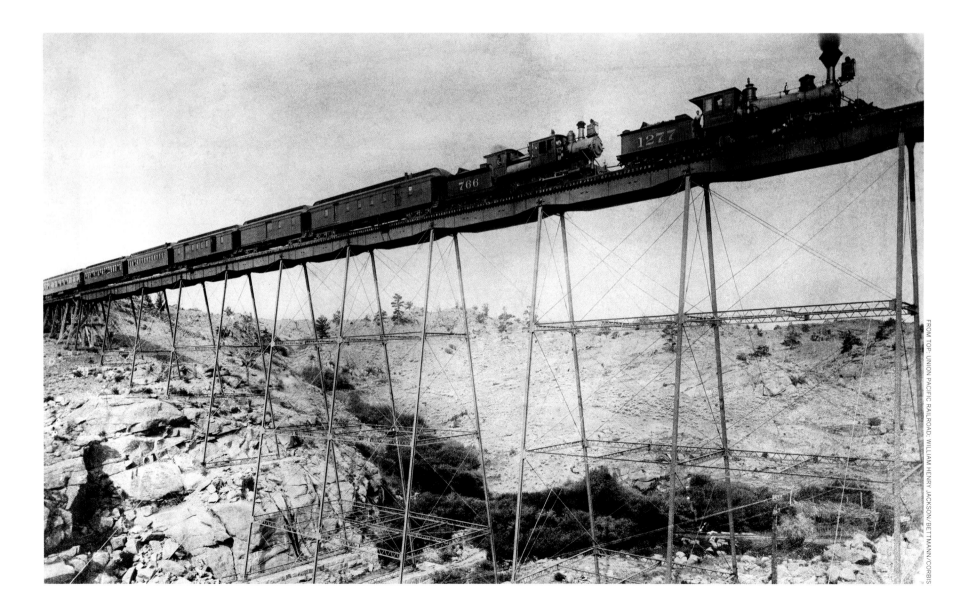

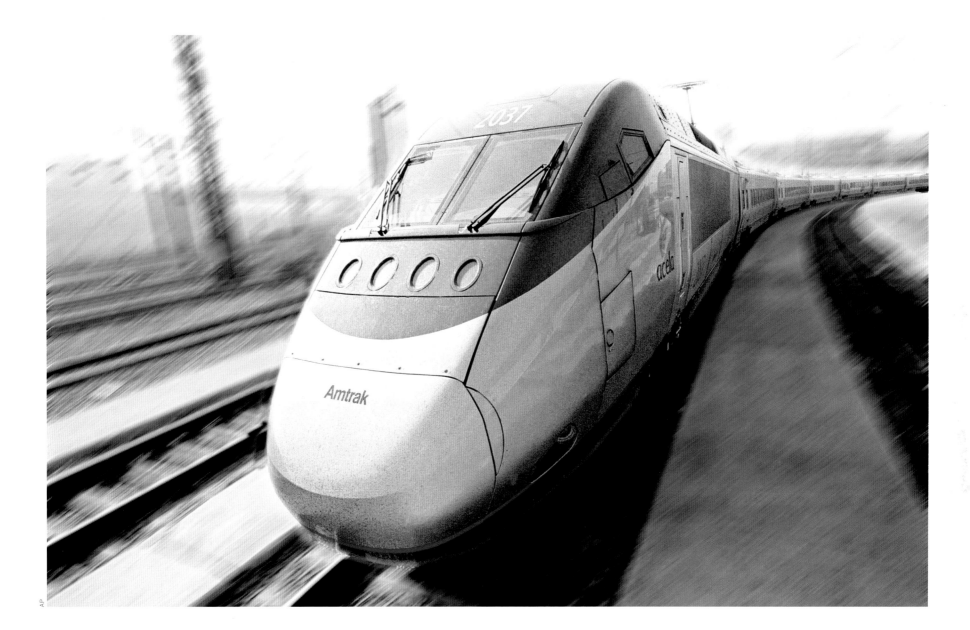

A COUNTRY ALWAYS ON THE MOVE

The first push was across the oceans by boat. Then, in the East, we marched and hacked our way over the Appalachians on foot. As we have just said on the previous pages, in the westward migration of European settlers, the horse was integral. America was a place constantly in motion in the 17th through the early 19th centuries; and then, in the mid and late 1800s, with constant new developments in power engines to propel trains and automobiles, things really shifted into a higher gear. By the 1830s, breakthroughs in rail transport had emerged in the United States, and in remarkably short order, tracks were laid everywhere; on May 10, 1869, the Golden Spike of the Transcontinental Railroad was driven in a commemorative ceremony at Promontory Point, Utah (opposite, top; at bottom is the Dale Creek Bridge in Wyoming, part of the Union Pacific Railroad, which was 150 feet high and sometimes swayed in strong winds). The subway system under New York City opened in 1904, almost 35 years after the debut of an elevated line. But Americans were an independent lot, and there was an itchy demand for something that the solo traveler or the family might employ for getting about. In the pre-Ford era, there were the Stanley twins, Francis and Freelan, who made and marketed their first car in 1897 and produced 200 more by century's end. In 1902 they started the Stanley Motor Carriage Company, which manufactured fire-tube-boiler-powered "steamers" that, when the Stanleys were hot, outsold all other gasoline-fueled cars. These were not necessarily putt-putt vehicles; a Stanley Steamer set the land-speed record for a mile in 1906 by traveling the distance in 28.2 seconds, or nearly 130 miles per hour. Production peaked at 500 cars in 1917, but the efficiencies of the rival internal combustion engine, then Oldsmobile's and Ford's assembly lines, doomed the Massachusetts-based Stanley Company, which was sold that same year and finally went under in 1924. Today's successor to the Transcontinental Railroad is Amtrak (above, its Acela Express high-speed train), a thousand commuter trains and, perhaps, the SkyTran commuter pods being dreamed up. As for the latest cars, the successors to the Steamer, please turn the page.

THINGS

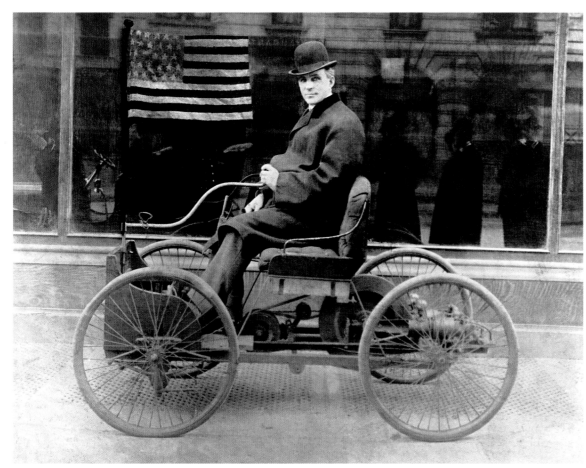

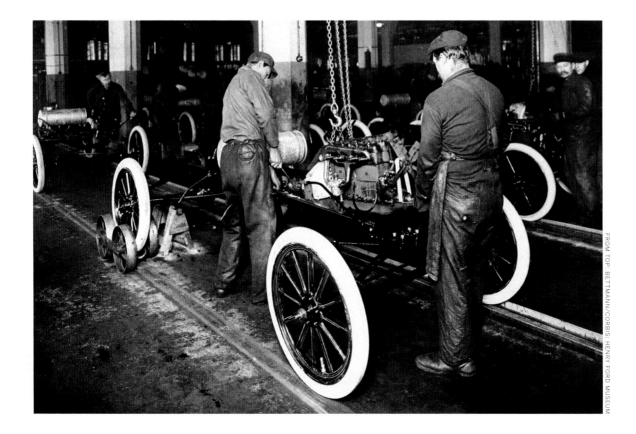

FROM TOP: BETTMANN/CORBIS; HENRY FORD MUSEUM

START YOUR ENGINES

The automobile, which in the 20th century was a quintessential emblem of the United States—American propulsion, American power, American pizzazz—was not an American invention, not by any means. Experimentation with steam-powered vehicles dates to the 17th century in China, and in 1801 British engineer Richard Trevithick rolled out his "Puffing Devil," regarded by many historians as the first steam-powered automobile. The Russians, the Swiss and others played around with early prototypes of the auto, and in 1886 the German Karl Benz patented a contraption powered by a four-stroke-cycle gasoline engine: arguably, the birth of "the car." We have already learned, on the pages immediately previous, of the American innovations of the Stanley twins. Once the century turned, they and other Americans took over. Ransom Olds developed a production line for his Oldsmobiles in 1902, and this concept was greatly ramped up by Henry Ford (top left). He had Model T's rolling out the factory door every 15 minutes (bottom, a Ford plant in Highland Park, Michigan, in 1913)—an eight-fold increase in productivity. Prices dropped, and before very long the automobile was an object of desire for every working American. Cars were quickly employed not only in utilitarian ways but in recreational ones—from sightseeing to racing; cars seemed to be what the growing nation had been waiting for. Styles came in and went out of favor: hardtop, convertible, big fins, streamlined, muscle cars, mini cars. In the 1950s and 1960s and after, drivers sought to define themselves by what they drove. In the modern era, various issues have reshaped the automobile. Questions of where our future gasoline supply will come from and what carbon emissions are doing to the environment have led to the development of hybrid cars and futuristic solar- or electric-powered cars. Opposite, clockwise from top: a Project PUMA (Personal Urban Mobility and Accessibility) prototype in New York City in 2009; a solar-powered car in Willits, California, in 1992; and the Jetson-esque Aptera 2e electric vehicle in Carlsbad, California, in 2009. Few doubt that the automobile of tomorrow has already been conceived. Now it needs its Henry Ford.

THINGS

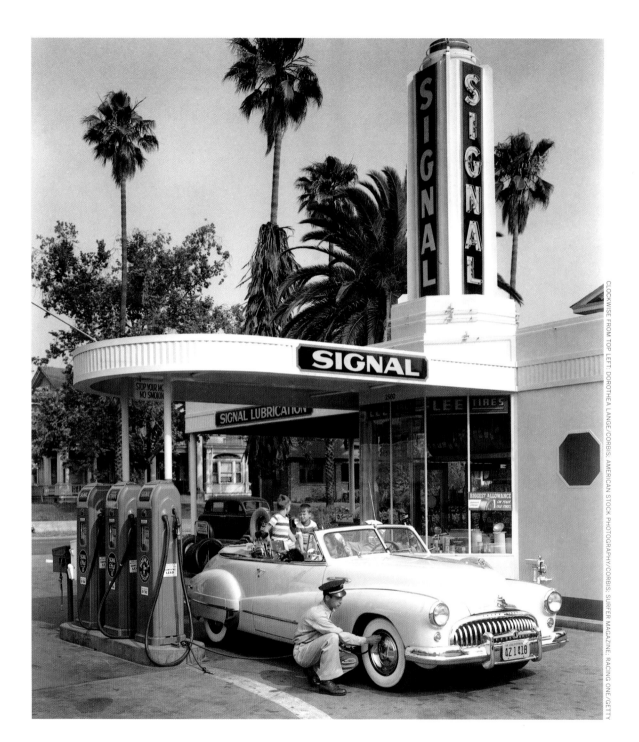

WHY THE CAR MATTERS

The automobile grew in the land of the free and the home of the brave to become a veritable pacemaker to the American heartbeat: It was not only an ingredient but a vital extension of the national spirit. For any consumer, the choice of car would reflect oneself as either a rebel, an outlaw, an aristocrat (Yankee version), a sensible person, a soccer mom, a soccer dad, or a forward thinker. Though not an American invention (as we have seen), it grew to be an American icon in its various incarnations as launched by Detroit in ensuing years. Le Mans was usually won by European cars, and German engineering came to be legendary; Swedish standards of safety came to be treasured by many American families; Japanese reliability stormed the barricades. But there was always a longing for the American sense of style, the coolness of our wheels. On these pages the car (or truck) at work and play: Oklahoma Dust Bowl refugees in 1937 with their mobile home (top left); Red Byron races his Olds on Daytona Beach in 1950 (center); a "woody" that same year (bottom); a family outing, again in 1950 (above, right); a 1959 Cadillac (opposite, top); a Ford Mustang at the center of a 1965 California beach party (bottom left); and a Humvee on San Francisco's Lombard Street (bottom right).

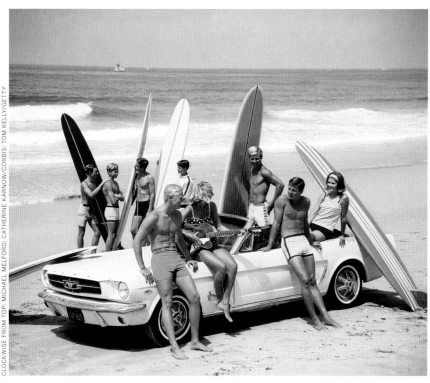

THINGS

ABOVE AND BEYOND

Wilbur Wright predicted in 1901, shortly after testing a glider that he and his brother Orville had built: "I don't think men will fly for a thousand years." Turns out Wilbur was wrong. He and Orville would open a limitless last frontier for mankind, a frontier that we, as a race, have only begun to explore. They were the proprietors of a bicycle shop in Dayton, Ohio, but it was their interest in aviation rather than cycling that would grow into an obsession. As early as the mid 1890s they were reading everything they could about the prospects for flight. The brothers were diligent, smart students, not to mention talented engineers and mechanics. One day, observing buzzards in flight, they agreed that the birds were changing the angle of their wings to balance in a shifting wind. It looked like a clue, and by 1899 the Wrights were putting their notion to work, fashioning kites with movable wingtips. In their gliders, which they began building the following year, control wires were connected from the pilot's position out to the wings. In the summer of 1901, the brothers put their glider through hundreds of trials over sand dunes near Kitty Hawk, North Carolina. The reason Wilbur spoke so pessimistically about the future of manned flight was that the glider could never be kept aloft more than a few minutes per day—total. Orville, the optimist, urged his brother to stick with it. In December 1903, Orville piloted a 600-pound plane named the *Flyer* (above)—made of wood, muslin and wire—at an average speed of 10 feet per second during a flight of 12 full seconds over the sands of Kitty Hawk. The rest, as they say, is history. It was one figuratively small step for man, but a giant leap for mankind, to set foot on the moon. (Opposite, scenes from America's space race, clockwise from top left: Alan Shepard strides toward the *Mercury* launch pad at Cape Canaveral, Florida, in May of 1961, ready to become his country's first man in space; *Apollo 11* lifts off on July 16, 1969, and then, four days later, Buzz Aldrin regards the American flag on the lunar surface.) Very serious thought is given in the 21st century to returning to the moon and to venturing on to Mars and beyond. What was once science fiction is now fact, and what today is fantasy is tomorrow's . . . well, only tomorrow knows.

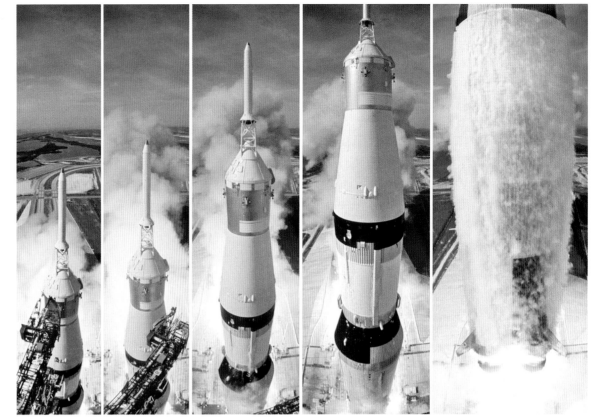

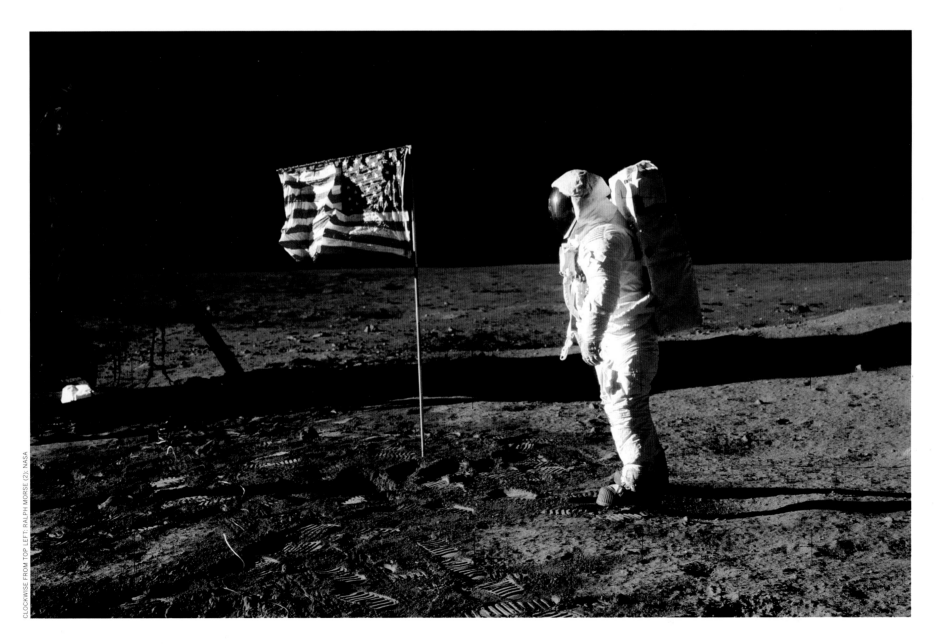

JUST ONE MORE

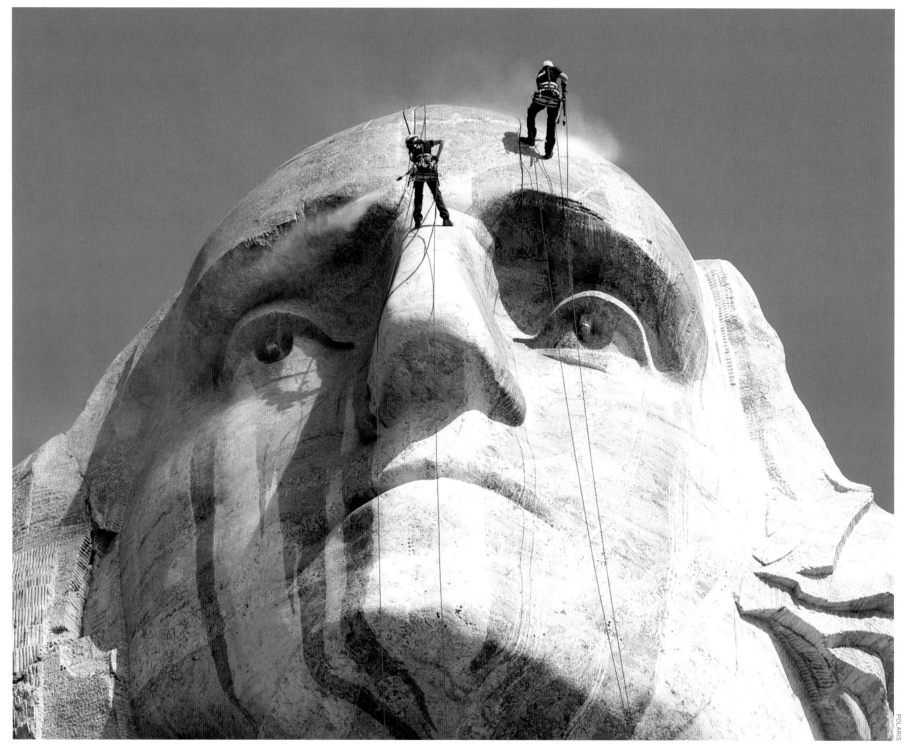

POLARIS

And now we return to the indispensable man, Washington, and see that, in our day, his image and legacy are still being burnished—literally by a cleaning crew on the monument at Mount Rushmore (above) and figuratively by his descendant countrymen—each and every day.

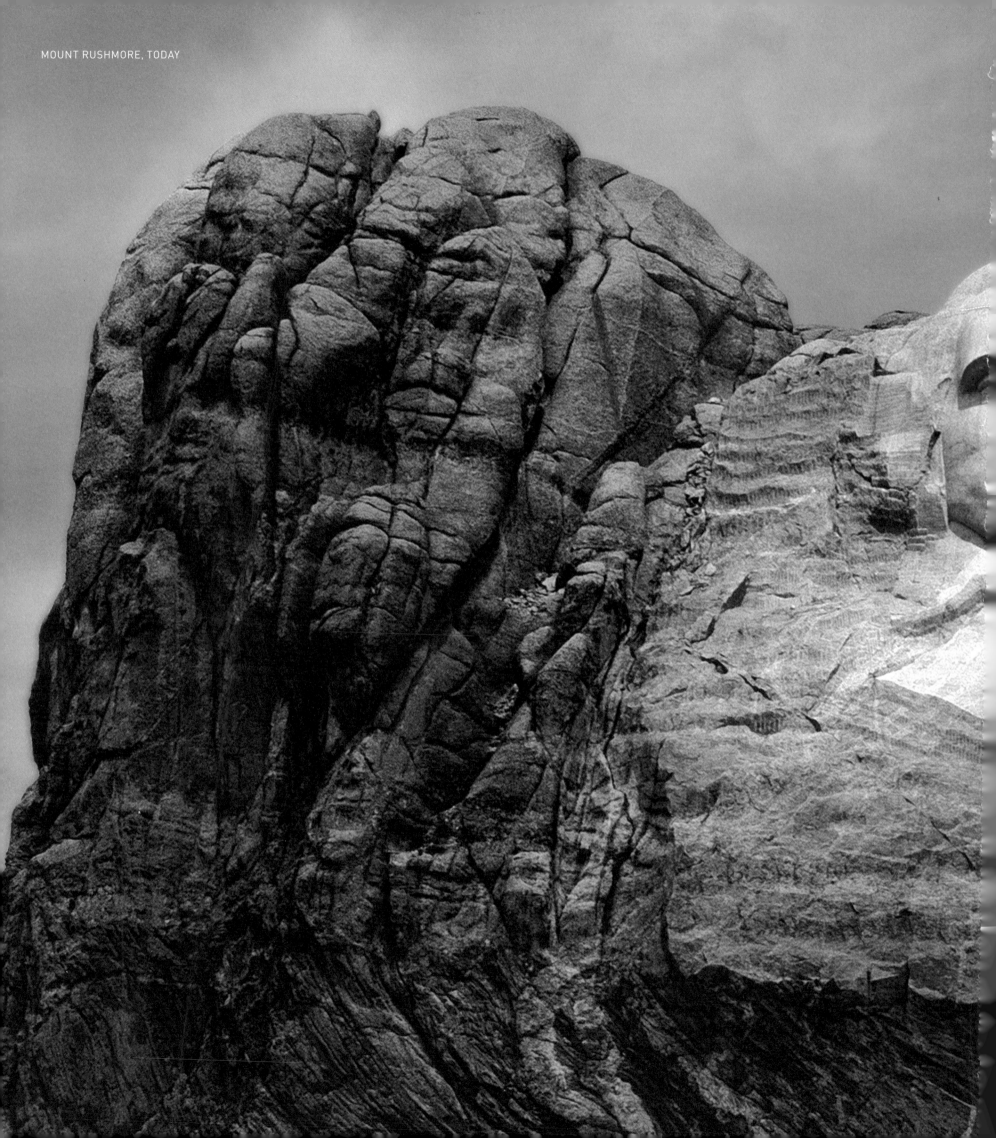